CPSIA information can be obtained at www.ICGtesting.com
Printed in the USA
LVOW07s0857170815

450402LV00004B/15/P

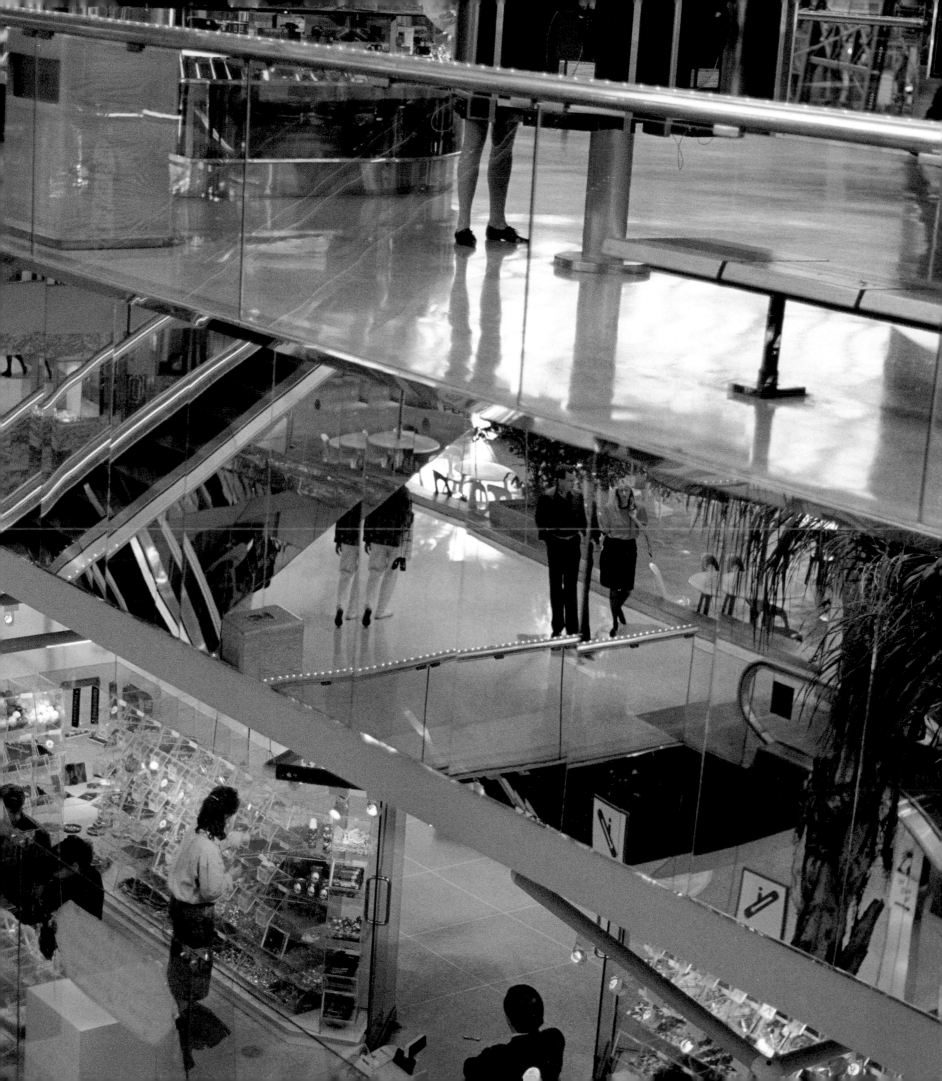

Vancouver
Artgallery Figure.1

Vikky Alexander

Extreme Beauty

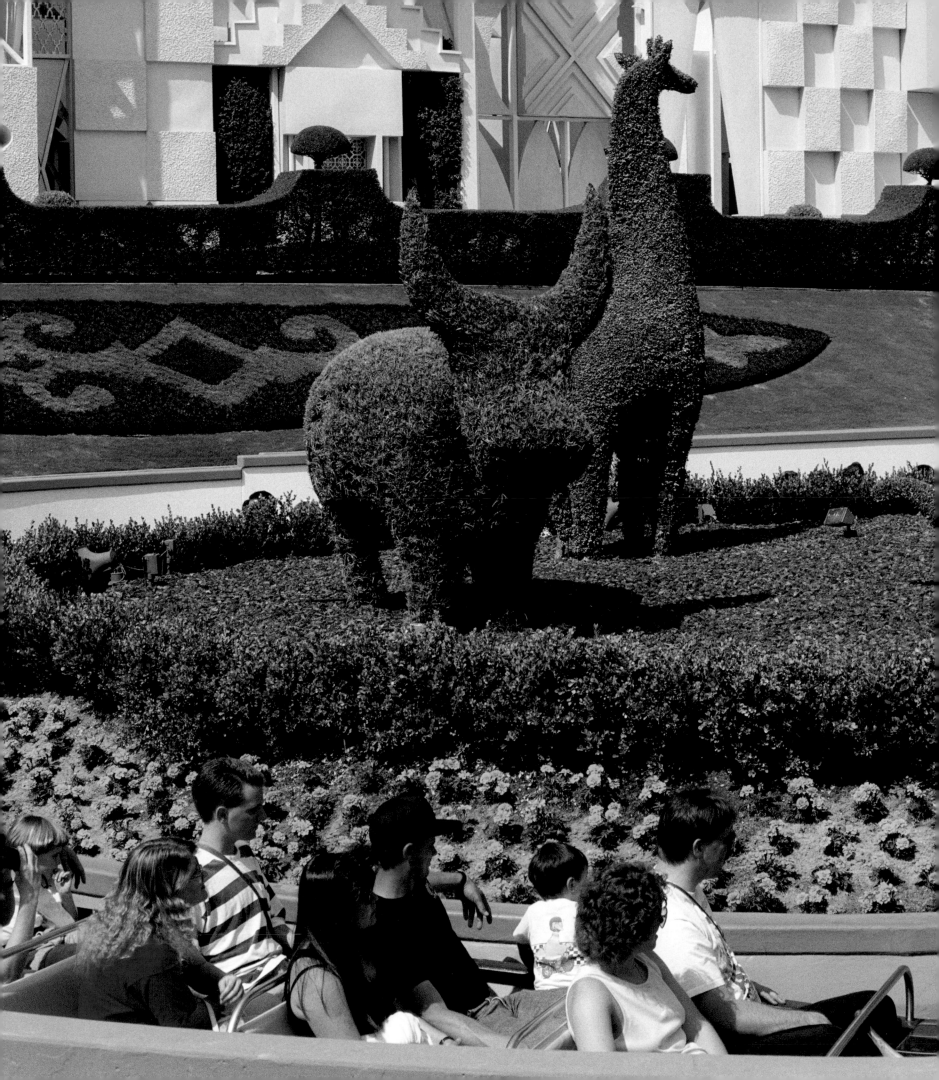

Director's Foreword
Kathleen S. Bartels

The Vancouver Art Gallery is thrilled to present *Vikky Alexander: Extreme Beauty*, the first retrospective of this notable Canadian artist. The exhibition features more than eighty photographs, montages, sculptures, collages and installations spanning more than three decades, including new work created especially for the exhibition that probes the artificiality of images and closely relates to the traditions of photo Conceptualism.

Alexander has strong ties to the Vancouver art community, having lived here from 1993 to 2016, and a long-standing relationship with the Gallery. In 1992, we presented *Lake in the Woods*, a large-scale photomural installation indicative of her ongoing interest in the often artificial ways we consume nature. It is one of nineteen works by Alexander in the Gallery's collection, a testament to our commitment to her practice.

This ambitious exhibition would not have been possible without the generosity of private collectors, institutions and galleries who have kindly lent works to this presentation. We thank them for their generous contributions to the success of this exhibition.

The Gallery is deeply grateful to the individual donors whose generosity was critical in realizing this exhibition and publication. Special recognition goes to Trustee Jane Irwin and her husband Ross Hill, and Trustee Phil Lind for their generous support. We also thank the Adelaar Family for their additional support. This catalogue is made possible with financial assistance from The Richardson Family, our Visionary Partner for Scholarship and Publications. I also would like to acknowledge funds from the Jack and Doris Shadbolt Endowment for Research and Publications, and recognize the special contribution of TrépanierBaer, Calgary.

It has been a great pleasure for the Gallery to continue its long relationship with Daina Augaitis, the Gallery's Chief Curator Emerita and guest curator on this project; we are indebted to her for steering this exhibition with such expertise. Our thanks also to Kelsey Blackwell of Studio Blackwell for the dynamic and elegant publication design. The Gallery is pleased to have worked with Figure 1 Publishing to produce the first monograph on Alexander's practice; Daina Augaitis, Vincent Bonin, Leah Pires and Nancy Tousley have offered insightful contributions to illuminate Alexander's practice.

I would also like to extend my gratitude to the Vancouver Art Gallery's Board of Trustees for their support of our programming, and to the extraordinary staff across the Gallery for their dedication to realize our ambitious programs. I especially recognize Senior Curator Bruce Grenville and Assistant Curator Emmy Lee Wall, who skillfully coordinated this exhibition as well as Emma Conner, Publications Assistant, who brought this book to fruition.

Finally, I offer my heartfelt appreciation to Vikky Alexander for her provocative and visually engaging work. Thank you for your poignant commentary on the visual imagery that surrounds us daily; your work — by turns enticing and revelatory — is an important reminder to look beyond the surface.

OPPOSITE AND OVERLEAFS: Details from *Obsession*, 1983, silver gelatin prints, vinyl type, Plexiglas, 91.5 × 61.0 cm (each)

3

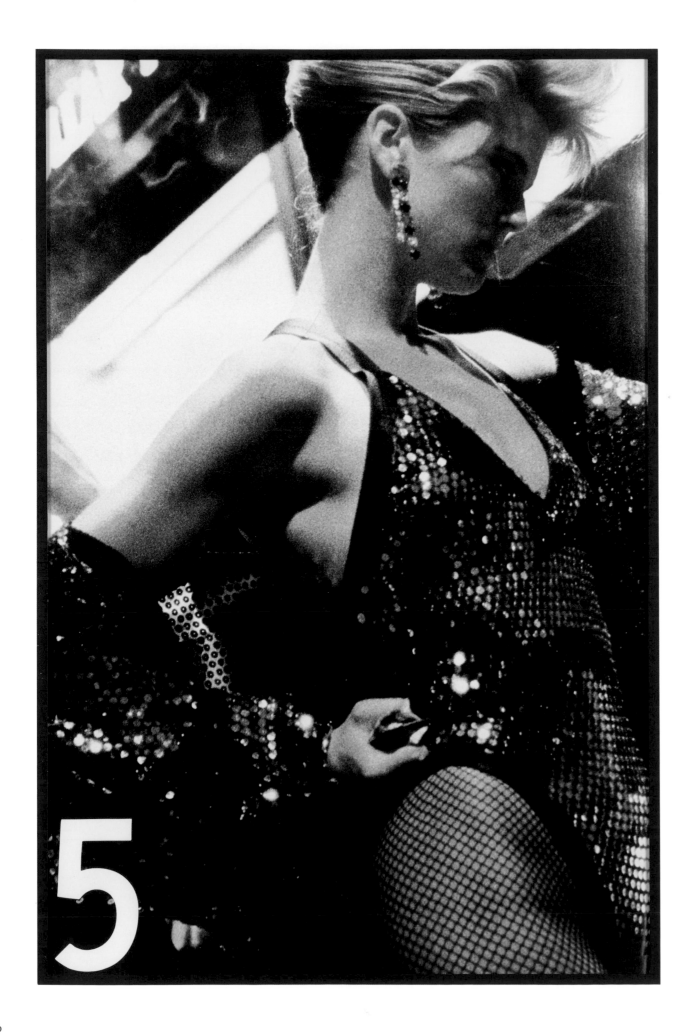

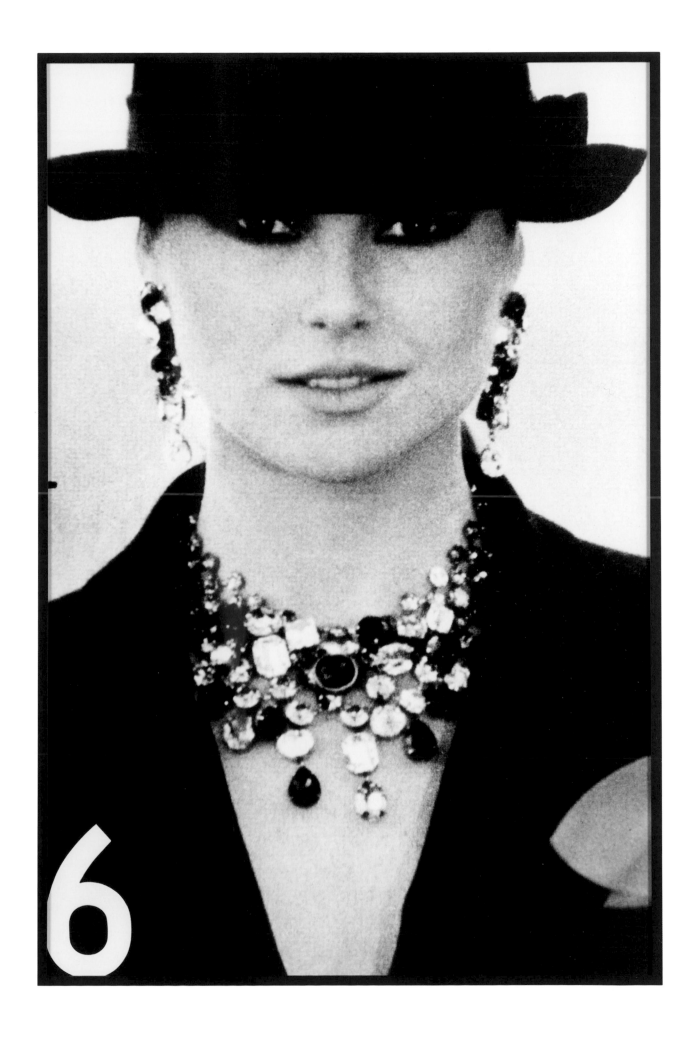

7

9

10

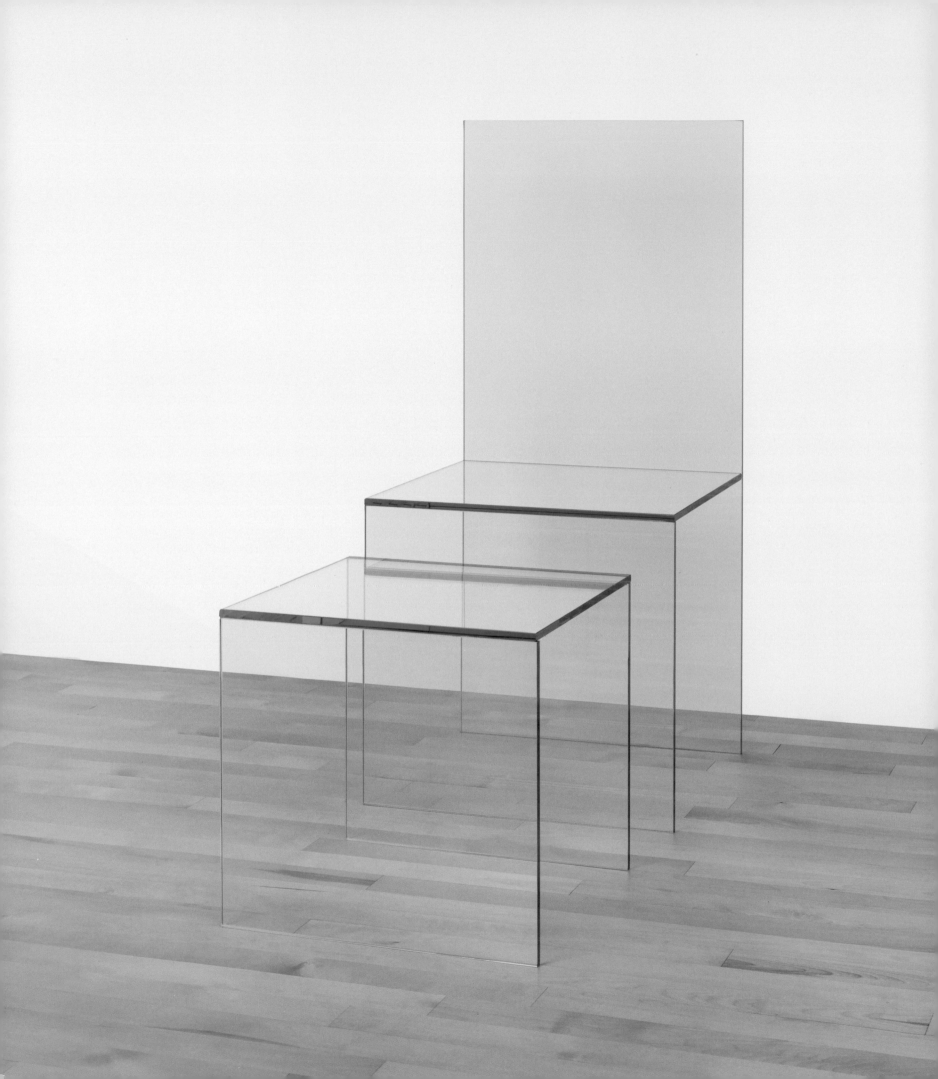

Vikky Alexander: Extreme Beauty
Daina Augaitis

How do aesthetic sensibilities get shaped? Teachers may parse out ideologies and methodologies for their students, mentors and fellow artists might further elaborate or debate these, and for Vikky Alexander the process that defines the tenor of her work also includes an artist's response to the specific conditions of their place and time. In reviewing the chronology of her career, Alexander initially became involved in the foundations of Western art as an adolescent, receiving positive reinforcement for her art projects in elementary school. While growing up in Ottawa, she was also fortunate to have the National Gallery of Canada as her local art museum and has recalled her inquisitive response to many exhibitions viewed there, especially Donald Judd's 1975 major exhibition. Even if the full meaning of minimalism may have eluded her at the time, the exhibition prompted a curiosity about this contemporary art movement as well as the post-minimal approaches that followed.[1] It would be years later that Alexander, as part of a generation of photo-based artists furthering a conceptual standpoint within the realm of vernacular culture, would nevertheless refer to minimalism's repetitive, geometric shapes and its industrial execution in her own sculptures such as *Glass Chair and Table* (1990).[2] By the mid-1980s, fully aware that the reductive minimalist aesthetic (but not necessarily its conceptual and perceptual tenets)[3] was being incorporated into the lexicon of vernacular design, Alexander was plucking from the world of popular culture, as she typically does (in this case referring to Nordic ice carving *and* minimalist design), to create her own simple but precisely constructed glass and mirror sculptures. These abstracted chair, bed and table shapes physically populated the exhibition spaces of her photographic works, which lay bare the devices of consumerism. The abundant reflective surfaces of her non-utilitarian furniture function metaphorically to break up the solidity of a singular overall image, disrupting the alluring and flashy spaces of consumption — the spaces of extreme beauty and wanton desire — that Alexander distills in her photography. Shunning the industrial references and objectiveness of minimalism, her geometries instead blur the distinctions between furniture and art but also invoke the fragilities of domesticity, reintroducing the possibilities of pictorial and subjective meaning previously eschewed by the minimalists.

Alexander's oblique references to minimalism — used as a jumping-off point from which to analyze its antithesis, popular culture — could only have come from someone with an inherently critical perspective. The Nova Scotia College of Art and Design (NSCAD), as it was known in the mid to late 1970s when Alexander attended it, was at that time a hotbed for the interrogation of art, vying with the California Institute of the Arts (CalArts) in Southern California as a leading North American school for the study of Conceptualism.[4] Under the leadership of Garry Neill Kennedy, who collaborated closely with his colleague Gerald Ferguson, this remote East Coast Canadian art school refocused its vision, becoming a degree-granting institution and building strong international connections, especially with New York (where the school maintained a downtown loft that Alexander and other students utilized). Kennedy and his faculty invited artists and critics such as Vito Acconci, Benjamin Buchloh, Eric Fischl, Lawrence Weiner and many others to teach and create projects in Halifax. For students, especially those who took advantage of this multitude of visiting artists who often came for

Glass Chair and Table, 1990, plate glass, 91.4 × 40.6 × 40.6 cm (chair), 35.6 × 35.6 × 35.6 cm (table)

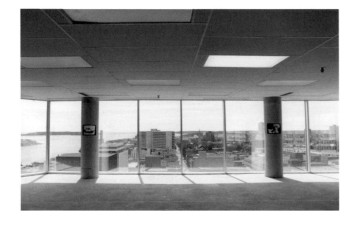
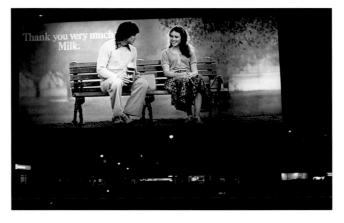

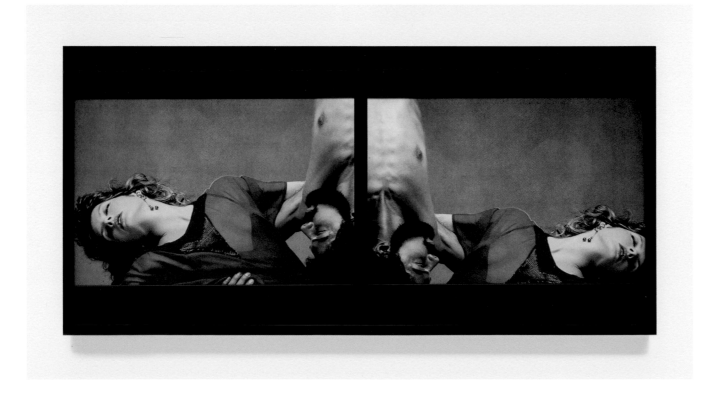

Dan Graham, *Figurative*, 1965, printed matter, magazine layout published in *Harper's Bazaar*, March 1968

Thank you very much Milk, 1980, chromogenic print, 60.96 × 91.44 cm

Descent, 1982, azo dye prints, 30.5 × 61.0 cm

Viewing Space, site-specific installation in a vacant office building, Halifax, 1978

an entire semester, NSCAD offered a rare opportunity to see professional artists at work, engage with them directly and even assist on their projects. Drawn to the photography studio, Alexander focused on learning the mechanics of the medium but, significantly, was also exposed through their visits to the ideas of Martha Rosler, who presented a screening of her iconic video *Semiotics of the Kitchen* (1975) with its searing feminist critique, and Dara Birnbaum, who was working on the initial version of her influential *Technology/ Transformation: Wonder Woman* (1978–79), a video painstakingly edited from appropriated television footage during the predigital era.[5] In response to conservative tendencies in modern art, these international artists in the late 1960s and 70s were reconsidering the image in art, especially in light of a renewed interest in photography as a tool for documentation, the emergence of performance, video and installation art and even the application of new approaches to figuration in painting. Significantly, these artists also brought an understanding of political, economic and cultural contexts to their work. Ultimately, it was Dan Graham, who made several visits to NSCAD, with whom Alexander had the greatest affinity — his conceptual approach, his developing ideas on architecture, his analysis of vernacular subjects from rock and roll to suburbia, his use of magazines for printing the content of his work and his use of glass and mirror all kindled Alexander's interest.

As a student at NSCAD, taking cues from Rosler's and Birnbaum's use of appropriated materials and Graham's engagement with the vernacular, Alexander began seeking out images that already existed in the everyday world. Initially, she photographed the screen side of television sets, making the surreptitious installation *Viewing Space* (1978) in the interior of a newly built and still unoccupied commercial tower in Halifax. Her still photographs of ABC News, with the TV captions appearing at the bottom of blurry images, were adhered at eye level to all the pillars throughout the unfinished office area. Upon entering this vast space, the viewer experienced the extensive urban vista visible through the surrounding windows colliding with Alexander's installation of televisual views, presenting an image of the world in which both the mediated and unmediated coexist. The artist went on to consider other spaces of mass media found in urban settings, taking photographs of large billboards to further examine the function of commercial media in its numerous manifestations. While most of these early works no longer exist, they set in motion Alexander's interest in advertising imagery that populates the everyday world as a type of readymade, as well as in deciphering and activating architectural spaces, especially those populated by consumerism.

Upon graduating in 1979, Alexander moved directly to New York, obtaining a sublet of Dara Birnbaum's Lower East Side apartment.[6] Working occasionally as Dan Graham's assistant, waitressing at Max's Kansas City[7] and at the World Trade Center, obtaining the occasional grant and finding other odd jobs to make ends meet, Alexander began making her own work in earnest. She did so in the context of a New York art world that was evolving from the rigours of pure Conceptualism into a scene driven by artists who would be defined in critic Douglas Crimp's seminal 1977 *Pictures* exhibition as a generation that returned to representation by recontextualizing imagery appropriated from their social and cultural surrounds.[8] Living within New York's excessive advertising environment, Alexander became even more engaged with the subject of the mediated landscape that she had begun to address in Halifax. She ultimately focused on magazines as the source for her imagery, considering them to be an instrument of advertising more personal than television and outdoor billboards, a vehicle that can infiltrate people's psyches in more intimate and direct ways. The glossy, large-format fashion magazines such as Italian and French *Vogue* that featured exquisitely staged photographs of famous models set in ample spaces with little text surrounding them were too expensive for her to purchase, so she borrowed these magazines overnight from a friend who worked at Spring Street Books, returning them to be sold after she had rephotographed quintessential images. Using a 35 mm still camera with a close-up lens and cable release, she would crop the images with the camera to her liking, taking her copy stand up to the roof of the residential building if more light was required. The colour film went to the lab for developing and printing, while back in her modest studio, prints were selected, sent for enlargement and eventually arranged into composite works comprising several related images.[9]

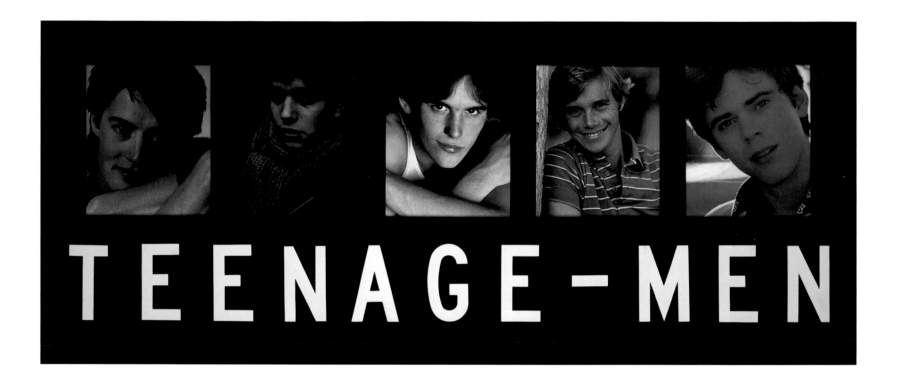

The magazines were a manageable format for making artworks in a small space, and they offered endless views of how women in particular are objectified. By isolating, cropping, blowing up, repeating and juxtaposing these images, Alexander made the manipulations of advertising even more visible; she relished, for example, the enlarged grain that made it perfectly evident these images were not her creations but generated from preexisting print sources. Alongside several other female artists utilizing a feminist critique in their recontextualizations of mass media,[10] Alexander focused on the exploitations by the fashion world, especially on how female beauty and its erotic potential are hijacked to generate desire that is rerouted to sell clothes, perfume and other commodities. While many of the Pictures Generation repurposed the banal in order to critique the power behind it, Alexander chose the most seductive images she could find: so plumped up and amplified by the strategies of advertising that, even when decontextualized, they resonate with a strong emotional impact.[11]

Amid consumerism's rapid growth in North America during the 1980s, New York was an epicentre. In several of her works of this era, Alexander's critique infers that shopping had become a new religion. She introduced the cruciform shape, suggestively titled works *Pieta* (1981) and *St. Sebastian* (1982), and used the centuries-old religious compositional form of the triptych — in essence equating the ecstasy of the consumer experience with a spiritual pursuit. For a subsequent series also sourced from periodicals (or album covers, in the case of *Grace* [1984]), she appropriated photos of male models and pop stars such as Elvis Presley, which she isolated, repeated and juxtaposed with similarly sized monochrome rectangles. With the figures essentially floating in empty space devoid of context, these works further unravel the contrived fetishizations of glamour. Another strategy the artist incorporated to illuminate the buttressing of stardom was adding implicit catchphrases in vinyl, such as "Teenage-Men" and "Entertainment," directly onto the work, mimicking the artifice of such culturally constructed images that seemingly shore up the empty glorification of these idols. From 1981 to 1984,[12] Alexander made approximately two dozen photo-based works, all of which reconfigure and repurpose mass media images as a way to uncover the strategies of advertising.

Throughout her career, Alexander has embraced situating her work in the public realm, leading her to place some of her rephoto-graphed images back into the public sphere, including on buses in Buffalo, New York, where she filled the areas designated for advertisements with her own semiotic "signs" of captioned TV news, emitting a different type of "real-life information," as she refers to it.[13] This public foray was followed soon after with a commission for the rear window of New York's New Museum in 1985, which then backed

Teenage-Men, 1984, chromogenic print, vinyl type, 66.2 × 152.4 cm

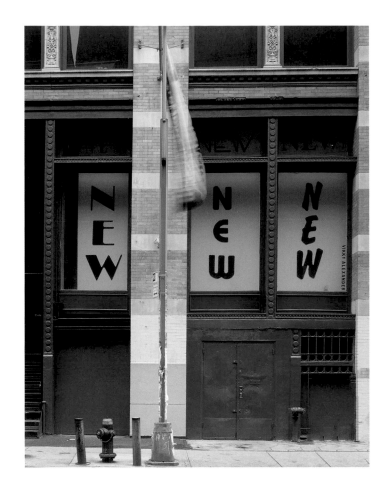

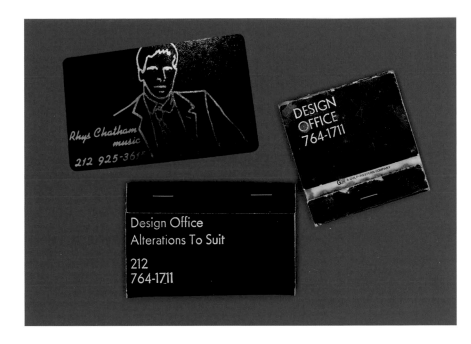

onto a prominent SoHo shopping street. Comprising six vertical signs, each spelling "NEW" in a different typeface, the work promoted the function and name of the museum but also cancelled itself out with its inherent ambiguity about what exactly was new and what, precisely, was being sold. As curator Brian Wallis describes it, "The eccentricity of the typefaces, the redundant repetition of the word 'new', and the absence of a product compel our awareness of the code itself...and the economic and aesthetic system in which the sign participates."[14]

In another endeavour to blur the terrain between art, design and the real world, Alexander established a collaborative project with musician and artist Kim Gordon, whom she had met shortly after moving to New York. A hybrid between art and business, Design Office was conceived as a type of production studio where the two artists would serve as consultants to produce creative design "solutions" in response to artists' "problems."[15] Each drew on their artistic networks, and for the duration of the project (1979–80) they came up with idiosyncratic propositions for the likes of James Casebere, Rhys Chatham, Isa Genzken, Mike Kelley, Gerhard Richter and others. This type of artist-initiated activity not only allowed a further inquiry into the system of signs that Alexander was deconstructing, but in a small way also ran parallel to the development of artists' spaces and other cooperative ventures that were taking hold in New York at this time as a means to test ideas and expose new work. It was through

Design Office that Alexander met James Welling, part of the wave of recent graduates from CalArts that had just moved to New York, and who was already noted for his explorations in photography. In 1981, they moved together to a SoHo loft and were married in 1982.[16] Both utilized the small darkroom that Welling constructed in the bathroom, which allowed Alexander to print her own black and white images. While the maximum print size was approximately 24 by 36 inches, she created larger works by assembling multiple images serially or in grid patterns. She often overlaid her black and white rephotographed images with coloured Plexiglas, adding another degree of separation and distancing in order to critique the stereotypically seductive and coercive advertising shots that lay beneath.

When it came to exhibiting in this burgeoning scene of the 1980s, young artists discovered that established galleries were not typically interested in their work as it still lacked a collector base, and new enterprises were required. Some artists were showing at more adventuresome commercial galleries appearing in SoHo and the East Village, while still others were initiating alternative spaces. Artists and supporters were also pooling resources, and in one such instance an accountant, Michael Bennett, swapped his services for artworks and offered up his loft on Broadway as a salon, inviting artists to organize small shows at what became known as A&M Artworks. It was a simple, friendly context, and Alexander showed

LEFT: *NEW*, site-specific installation at the New Museum, New York, 1985
RIGHT: A few projects produced by Design Office, a collaboration by Vikky Alexander and Kim Gordon, 1979–80

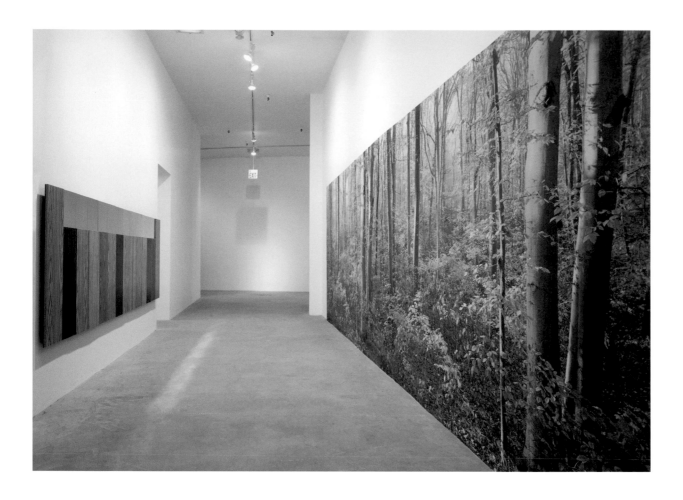

her new works several times as well as curating an exhibition there.[17] Her work also appeared in group exhibitions in private, public and alternative galleries in the New York area where current issues were assessed, such as at White Columns, 303 Gallery and Bard College's Proctor Gallery.[18] Most significant of these for Alexander was the one at Light Work in Syracuse, the 1983 exhibition *The Stolen Image and Its Uses*, curated by art historian Abigail Solomon-Godeau. During this period she and other notable critics such as Douglas Crimp and Craig Owens were questioning whether the "real" and the "original" could exist in a world of mechanical reproduction. For her exhibition,[19] Solomon-Godeau selected a group of New York artists who "refused traditional roles of authorship" and used the "readymade image from either advertising or the mass media" to continue "the tradition of art-making which views as its mission the unmasking of appearances by revealing its codes."[20] In discussing Alexander's and Barbara Kruger's practices specifically, Solomon-Godeau elaborates that in their work there is an "emphasis on the photograph as bearer of cultural mythologies," and in particular, Alexander's "fixation on the fashion model…is intended to so amplify the image's codes, so underscore its overdetermination, that the image in effect deconstructs itself."[21]

Other critics also noted Alexander's significance in reinvigorating photography with the use of appropriated imagery, sometimes writing about her work in association with others affiliated with the strategies of the Pictures Generation.[22] But it was her bold installation *Lake in the Woods* (1986) at Cash/Newhouse Gallery, New York,[23] that ultimately took Alexander's appropriation strategy another step further. She stopped rephotographing images and in 1985 began seeking out actual materials from the urban context. For *Lake in the Woods* (as well as *Morning Forest* pictured above), she set mirrors into woodgrain particle board and positioned them in the exhibition space to reflect the viewer's image into a wallpaper backdrop of a serene natural setting installed directly onto the gallery walls. This site-specific installation was made in the era of Jean Baudrillard's much-discussed concept of hyperreality, and the type of photomural wallpaper used by Alexander was commonly used to add drama to ordinary settings such as office reception areas and recreation rooms. Baudrillard was arguing that simulations of reality now stood in for true experience and in fact determined the real world, a belief that Alexander still holds. For her as a person living in an urban context where nature was something to be consumed vicariously from a safe, even melancholic distance, the commercially sourced woodgrain patterned particle board she used in *Lake in the Woods* was every bit as genuine as a finely hewn pine plank, and the wallpaper image of an idyllic lake every bit as authentic as an actual brook babbling through the forest — each of her materials expressed its own commonplace reality.

Installation view of *Morning Forest*, 1987, at Ace Contemporary Exhibitions, Los Angeles, 1987

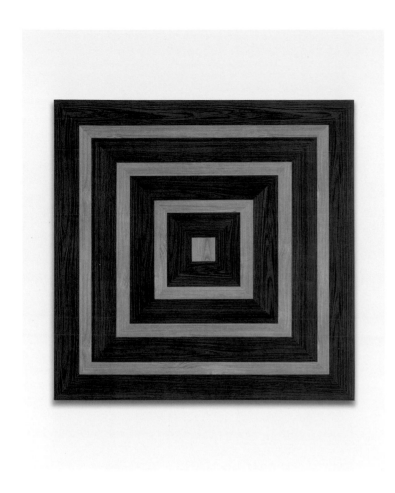

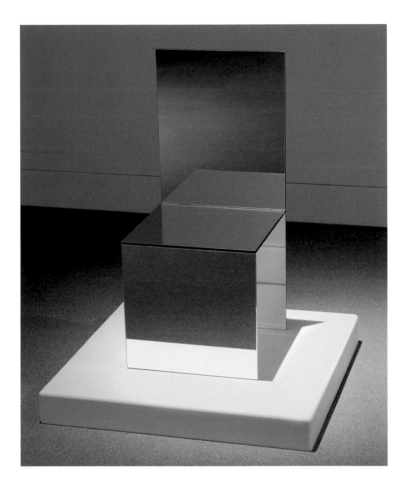

Alexander utilized this wallpaper and mirror pairing for a few additional installations,[24] including an enclosed architectural pavilion that, just like the dramatic nature it represents, seems impossible to enter, as well as several smaller standalone two-dimensional works. The exploration of the interplay between humans and nature (with the natural world typically represented through its dramatic flora, fauna and geological formations) is a subject that was introduced into the artist's practice in the early 1980s[25] and one that remains very pertinent for Alexander to this day.[26] In 1987, she further experimented for a few years with the sole use of simulated Mactac woodgrain as a sign of the landscape in abstract compositions she laminated in recti-linear patterns directly onto plywood bases. Incorporating her interest in decoding the commercialization of the time with her analysis of the artifice of nature, these works also reclaim the reality present in something that is only surface deep. Always operating on several levels, the ironic titles of these woodgrain abstractions provide additional commentary, such as *Industrial Iconography* (1987), which questions the industries that have appeared to serve up illusions of nature, and *Modern Ornament* (1987), which implicates the artist's own work in a query about the growing commercialization of contemporary art, especially when it functions merely as ornamentation for the wealthy.

It was also in the late 1980s — a decade recognized for its materi-alism, the consumer-driven taste of yuppies and growing social anxiety[27] — that the artist produced her aforementioned minimal glass furniture sculptures, which fittingly delved into the growing disenchantment with the conventional realm of female domesticity. The posh homes of the era were teeming with faux surfaces and synthetic imitations — the types of simulacra Alexander echoed in artworks that cast doubt on norms and stereotypes. Her woodgrain abstractions and glass sculptures in particular attracted the attention of New York independent curators Tricia Collins and Richard Milazzo. In exhibitions such as *Media Post Media* (1988), they featured a growing number of female artists working critically in what the curators defined as a "post-media environment" populated with television, MTV and movies.[28] In *Hybrid Neutral: Modes of Abstraction and the Social* (1989),[29] they further articulated a 1980s Neo-Conceptual approach (in 1986 called Neo-Geo, a highly debated and reductive moniker).[30] *Hybrid Neutral* brought together divergent forms of art dealing with hyperreality, simulation and new technologies — all centred on ideas of geometric abstraction — that maintained an underlying critique of consumerism during this uncertain period of Reaganomics. Alexander, who was included in these and several other of the curators' exhibitions, was certainly not alone in responding to a growing disillusionment with the promises of American consumer culture.

By the mid-1980s, the artist was also beginning to show her work at various Canadian galleries in Calgary, Halifax, Montréal, Saskatoon

LEFT: *Industrial Iconography #2*, 1987, contact paper on masonite, 121.92 × 121.92 cm
RIGHT: *Mirror Chair*, 2000–08, mirrored glass, 92.7 × 40.6 × 40.6 cm

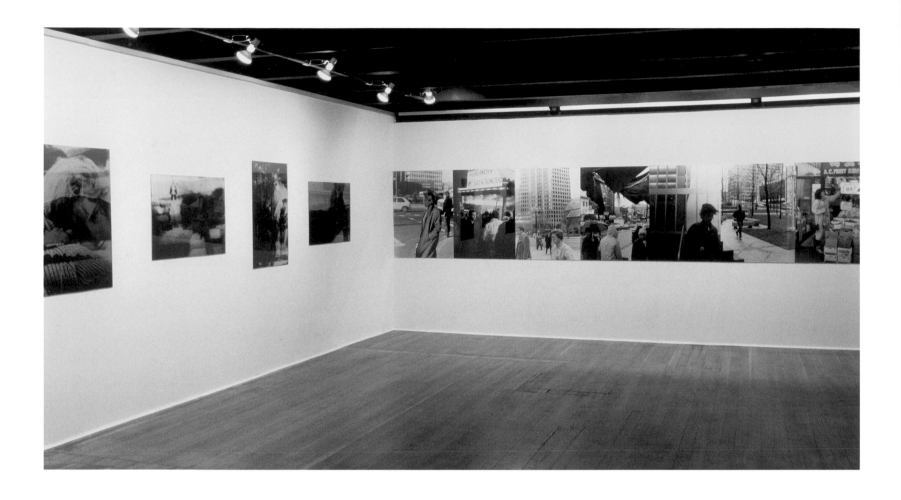

and Vancouver. Bill Jeffries, the director of the Vancouver photography gallery Coburg, contacted Alexander after reading about her work in Solomon-Godeau's seminal 1982 article on photography,[31] and he presented Alexander's now iconic *Obsession* in 1983, the same year it was made. When Jeffries contacted Alexander again to have a two-person exhibition at Coburg in 1986, she suggested teaming up with local artist Ian Wallace. His own conceptual explorations of documentary photography, which he eventually juxtaposed with minimalist painting in *Heroes in the Streets* (1986), provided a fruitful counterpoint to Alexander's elegant double exposures of seductive models (perhaps her own heroines) floating in captivating portrayals of nature in the series *Between Dreaming & Living* (1985–86). It is notable that before Alexander even moved to Vancouver, this exhibition set out some of the comparisons and contrasts between her poetic and alluring works that utilize beauty[32] with that of many of the Vancouver photographers who, at this time, were interested in a more prosaic use of documentary images of urban subjects.

While Vancouver would come to figure large in Alexander's life, becoming her home in 1993 after she took a teaching position at the University of Victoria, her first Vancouver connection was made well before, in 1979. During her final semester at NSCAD, Jeff Wall was a visiting artist there and introduced his ideas related to the cinematic image.[33] As she made more acquaintances and her curiosity about the

West grew,[34] Alexander and James Welling undertook an exploratory West Coast speaking tour in 1983, visiting Los Angeles, Seattle and Vancouver.[35] It was evident to Alexander that despite its isolation, Vancouver had a community of conceptually driven artists with shared sensibilities actively participating in an international dialogue. The work of the so-called Vancouver School, an informal group of artists who explored the possibilities of the image, had already defined itself through photography, with associations made to historical painting, literature, film and critical theory more readily than to the history of photography. Upon moving to Vancouver as an already successful artist, Alexander pondered, "How do I position my work in relation to what is here?"[36] Her affinities with these artists arose from a shared conceptual rigour to interrogate the meaning of the image, and while the Vancouverites were largely capturing their own images of the city, Alexander had until recently come to her work by re-photographing existing media images and using collage methodologies. In the course of making art in Vancouver after 1993 and exhibiting it nationally and internationally during the following two decades,[37] she shared a conceptual basis with her local contemporaries and was an intrinsic part of the dynamic photography scene of the city. Because she was not originally from Vancouver and was therefore not as tied to it, she did not focus on images of the city, nor did she capture the potential spaces of the "in-between," both of which were

Installation view of *Vikky Alexander and Ian Wallace* at Coburg Gallery, Vancouver, 1986

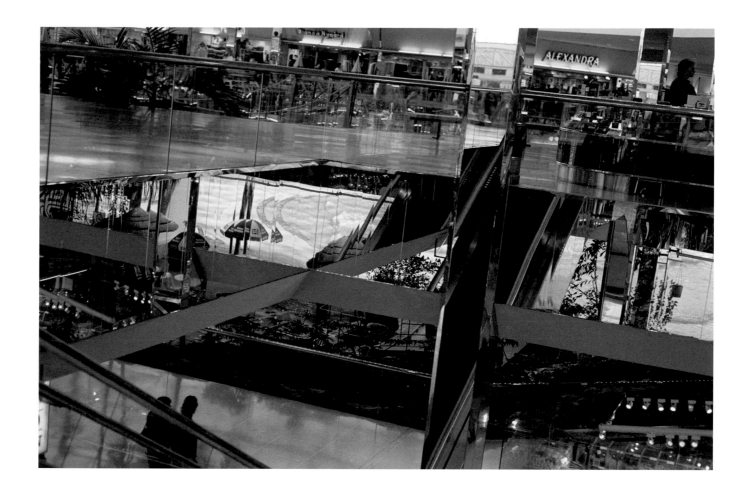

subjects of great interest to the mostly male photoconceptualists. Alexander was equally involved with an alternate group of slightly younger artists who were using photography and video to more stridently investigate and question the social realm, as represented in the works of Kati Campbell, Stan Douglas, Ken Lum, Judy Radul, Kelly Wood and Jin-me Yoon, to name a few. Rather uniquely, Alexander focused her critical analysis on consumerism and its associated utopias.

Alexander's geographical relocation in the early 1990s was accompanied by a remarkable shift in her practice: even before her actual move, she began to take her own photographs. For her, as for several other appropriators of the 1980s, the activity of rephotographing images in order to deliberate and critically view them had run its course. Neither did she want to be viewed solely as an appropriator.[38] What began for Alexander as small reference photos made for research purposes as she investigated storefronts, malls and theme parks later became blown-up, finished images. Furthermore, because of the presence of many photo-based artists in Vancouver with precise needs, there was an availability of commercial photo labs with skilled technicians who could produce high-quality prints.

With much still to explore around the fetishization inherent in consumerism, Alexander decided to further dissect actual sites of consumption and the architectures of desire. With a full-time job, she now had greater means to travel to locations of interest, often in tandem with exhibiting opportunities. Her first images of the West Edmonton Mall — the largest shopping mall in North America[39] — depict the seamless ways that mall architecture and decor themselves construct desire by positioning the shopper-viewer directly into the multiple reflections generated by various plate-glass windows, partitions and displays. It is nearly impossible to ascertain where the photographer is located within these disorienting layers of reflection in the *West Edmonton Mall* series (1990);[40] perhaps she is herself trapped and, by extension, also entangling the viewer in the webs of desire. In 1991 and 1995, she made visits to other fabricated attractions aimed at leisure and entertainment such as Disneyland in Anaheim, California, and the city of Las Vegas, respectively. In these highly mediated situations, she was drawn to representations of nature and animals in idealized or artificial forms, from topiaries shaped as elephants to real Bengal tigers. These locations proved so absurdly hyperreal that the photographer's task was fairly simple: to reveal the extravagant simulations and juxtapositions for what they are — spectacles of vicarious and unattainable dreams. Following those bodies of work, Alexander travelled to Europe to research some of its grand historical monuments. In France she sought out the Baroque château and gardens southeast of Paris as the source for

West Edmonton Mall #13, 1990, chromogenic print, 50.8 × 61.0 cm

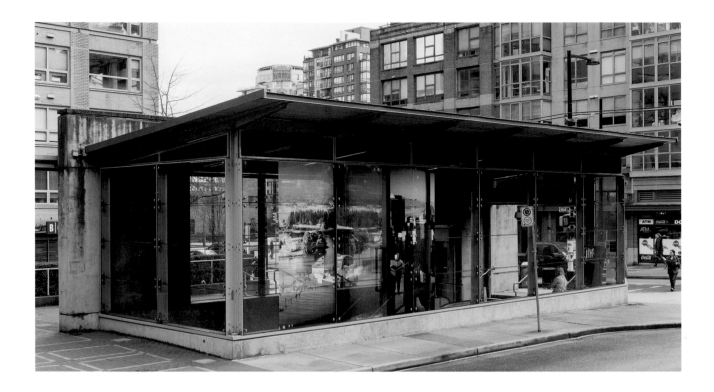

her installation of the same name, *Vaux-le-Vicomte Panorama* (1998). Though these locales were less kitschy than the North American attractions, she was keen to combine the world of European elegance with the mirrored entanglements of the mall. In this installation, a series of projected panoramas of the formal garden are reflected and re-reflected onto mirrored columns spaced throughout the gallery; the results parallel the disorientation one feels when actually walking through the château's vast parklands, which are much larger than one perceives,[41] as well as fragmenting the notion of a single perspective that is typically, but erroneously, advanced in the annals of history. These numerous series were but the beginning of Alexander's continued scrutiny of architectural spaces that embody some type of utopia.

Meanwhile, Vancouver was experiencing the real estate boom of the 1990s and was becoming a place where fantasies of a different sort were playing out. A number of local photographers were capturing this changing cityscape, especially its suburban transformations and human interventions.[42] In 1996 Alexander arranged to photograph a model display suite, typical of developers' pre-sale strategies, taking an overview image of the prototypical condominium, followed by images of the dining room, living area and bedroom, all of which were falsely back-lit with a bright photo display of the region's supernatural landscape and cityscape. In her frontal shots, which somehow situate the viewer between these rooms that are disrupted by reflections, the fabricated display suite comes to be understood as a slippery chimera promising a happy life in an aggrandized utopia. Originally made at a smaller scale, Alexander's *Model Suite* images were reproduced nearly a decade later in 2005 as large-format chromogenic prints, and she has more recently harnessed today's medium of choice for outdoor advertising — self-adhering vinyl — to attach this series directly onto gallery walls. As part of a subsequent public art project, these same images were again altered to suit the specificity of the site and adhered to the windows of a transit terminal, a public location where advertising might otherwise exist. This iteration served to expose these interior views, devoid of any identifying text, to the hustle and bustle of the external world as a more subtle but revealing "promotion" of the city's most renowned form of consumerism — the purchase of real estate.[43]

In the twenty-first century, consumerism has escalated to the degree that it seems absolutely essential to the contemporary lifestyle of the West: yet increasingly, it is viewed as excessive and contributing to planetary hazards. Alexander's further artistic inquiries during the 2000s have led to a scrutiny of more intimate shopping experiences: those prompted by boutique displays. For these works, she visited the high streets of Paris (2009), Istanbul (2013) and Tokyo (2014, 2018). Series of exquisite colour photographs emerged from each of these forays, strikingly beautiful but always featuring a new dimension of criticality. The round images of *Tokyo Showrooms* (2014) for example, in the photographs' rare inclusion of shoppers or their reflections as they linger to view the luxury items in window displays, suggest the voyeuristic presence of an anonymous flâneur — Charles Baudelaire's symbol of modernity. The stunning *Istanbul Showrooms* (2013) on the other hand, are mounted in light boxes, placing Alexander's irresistible images of commerce back into one of the standard apparatuses of advertising.

Model Suite (Sliding Door), site-specific installation commissioned by the Contemporary Art Gallery for the Yaletown–Roundhouse Canada Line Station, Vancouver, 2017

Tokyo Showrooms: Prada Couple, 2014, inkjet print, 40.6 × 40.6 cm

Istanbul Showrooms: White Stork, 2013, transmounted
digital print in light box, 71.1 × 101.6 × 8.9 cm

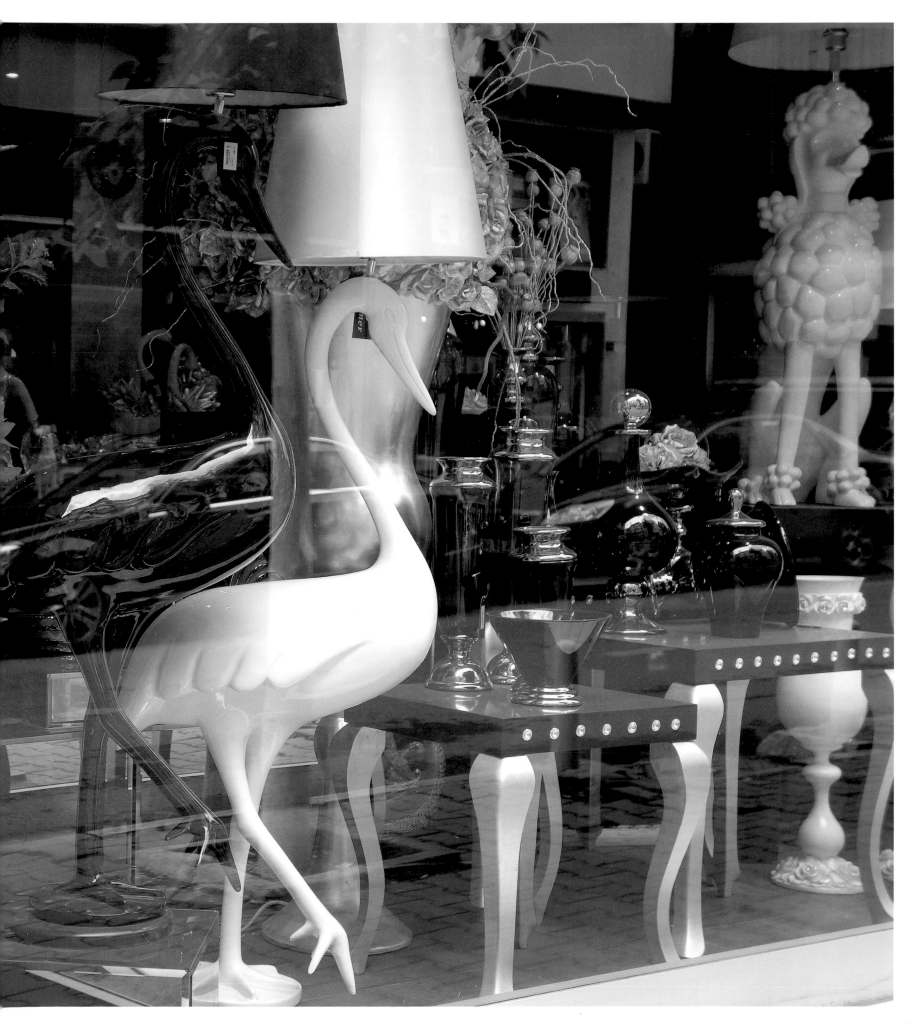

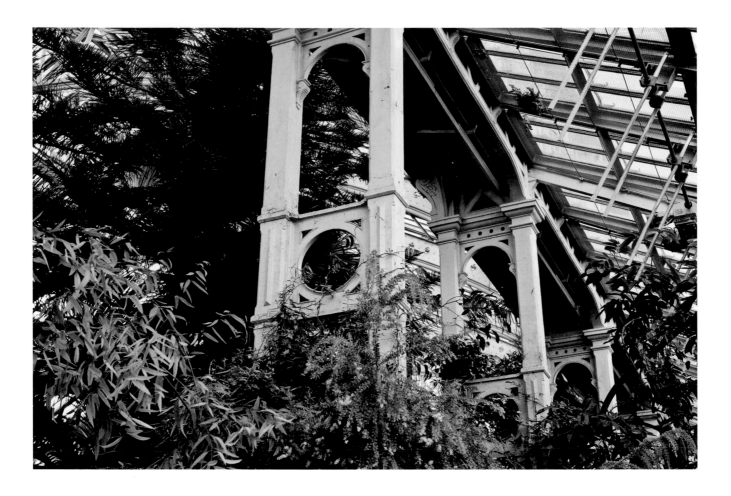

Still engaged with the international scope of her subject matter, Alexander travelled to London's Kew Gardens in 2010, finding not only a tourist site of great magnitude but also one that allowed her to return to an inquiry into the spectacle of nature, photographing the exotic specimens housed in Palm House, an iconic Victorian greenhouse. The tropical plant species growing there are thriving so well they appear to be forcefully exerting themselves onto and through the wrought-iron architecture that contains and constrains them. Photographed in black and white, the *Island Series* (2011) has a resulting historical aura that summons the colonial imperatives of exoticism and oppression; however, here the typical narrative of British colonialism is challenged by the vitality and rebellious growth of the imported species on display.

Also photographed in black and white and one of the newest works in the *Extreme Beauty* exhibition, the *Idyll Series* (2019) again takes up the subject of troubled utopias. The opportunity to create this work arose when the artist was vacationing in the Caribbean and chanced upon an architectural retreat made up of a series of small dwellings constructed directly into the face of an imposing cliff. After gaining permission to photograph this oceanfront location, which is built into and mostly made of earth, she focused on some of the picturesque views of the ocean and landscape as framed by the dwellings' gates, doorways and windows. With few signs of

human presence, the images document a remote space intended to erase the nature-culture divide, but one where even the light touches of human intervention are nevertheless evident and rather foreign, and where the potential of human integration with nature was never fully realized or sustained.

During her travels in the past two decades, Alexander has systematically collected postcards of iconic locations — Fontainebleau, the Wallace Collection, the Harrogate Turkish Baths, Kew Gardens — souvenirs of the grand spectacles and exoticisms of a largely colonial past. At the same time, she has also been collecting picture books of small animals. In 2013, she began cutting out a number of these creatures, freeing them from the page and collaging them onto the postcards, with the animals looking as exotic as their relocations. These collages were then photographed and enlarged to highlight the bewildering oddness, even humour, of the stark juxtapositions: a howling wolf in the interior of the Château de Vaux-le-Vicomte, a tall giraffe peering through a vaulted portal at Olana (the nineteenth-century home of the Hudson River School artist Frederic Church), gazelles perched at the edge of an impeccably tiled swimming pool. While human disassociation with nature was already communicated in prior works, in the current era of escalating natural disasters, this series announces itself with urgency, suggesting there is a price to be paid for unbridled wealth and accumulation. While the critique is

ABOVE: *Island Series: Overpass*, 2011, inkjet print, 103.0 × 152.3 cm
OPPOSITE: Installation view of *Green Leaf Ceiling*, 2018 (LEFT) and *Purple Patterned Edge*, 2018 (RIGHT), at TrépanierBaer, Calgary, 2018

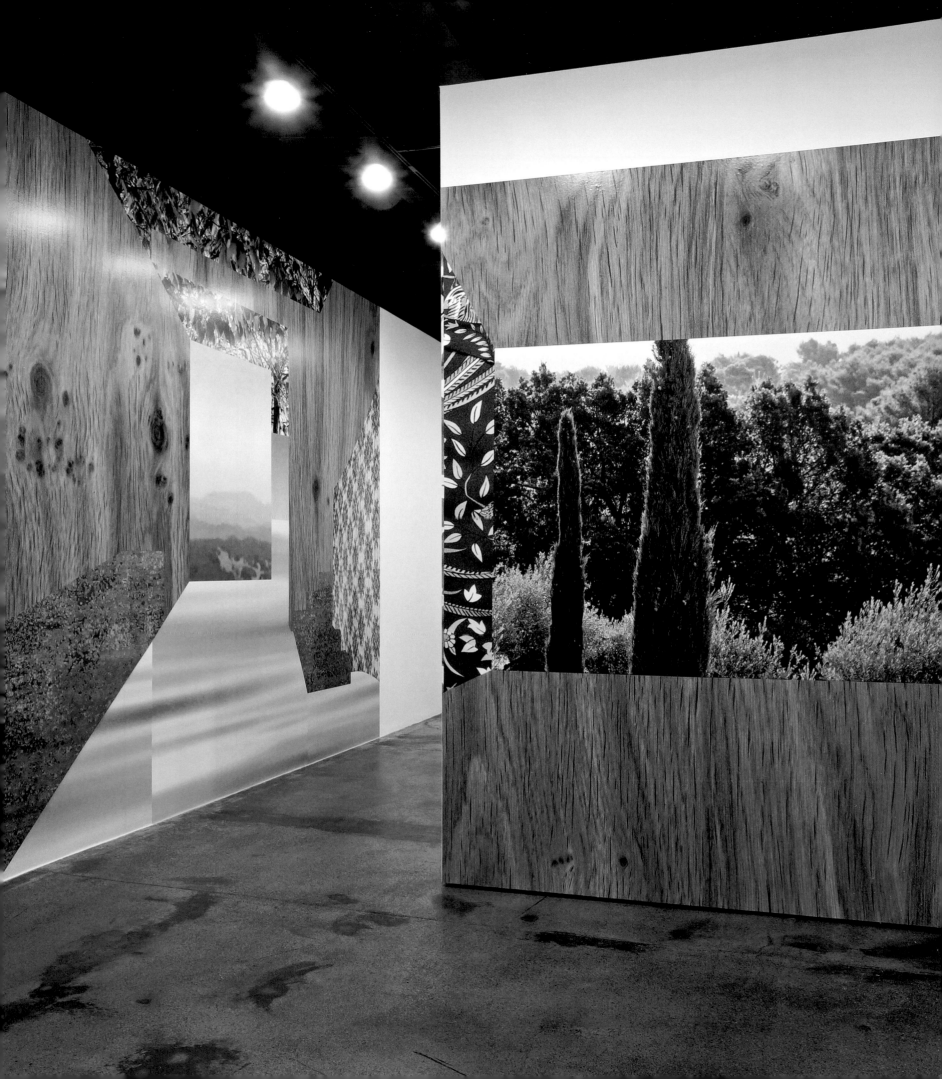

now more sharply pointed toward the need for environmental consciousness and action, the artist's technique is similar to one she used during the 1980s: found images, reconfigured.

While Alexander began photographing interiors and shop displays, she also began drawing them, sometimes copying architectural follies and at other times collaging them with origami or shelving paper to create her own imagined spaces. In 2000, after a year of such small-scale production, she scanned these collages and had them enlarged as digital inkjet prints on canvas. While her choice of a canvas ground was entirely practical in order to obtain a larger scale for her images,[44] it nevertheless incorporates a reference to painting. In this case, it might allude to the traditions of Canadian historical art, especially historical representations of the sublime or of "man conquering nature." Yet since dominance over nature has continued well beyond its historical origins, Alexander situates this perspective within slick renditions of present-day domestic architecture. In these works, the artist's modernist living rooms, corridors and other domestic settings (occasionally occupied by a pet dog) are awkwardly framed by excessively wild environments of forests, waves and sunsets — the near-perfect-but-also-constructed landscapes you might see in calendar art. Here the natural world is proportionately upscaled, looming larger than life, existing somewhere between fantasy and delusion and on the verge of wreaking havoc on the comforts of home. In a world where human conquests over nature are still widespread, and unlike the historical paintings they may allude to, Alexander's disjointed representations shift some control back to the forces of nature, as we endeavour to find our footing in these unstable environments.

Building on these inkjet paintings as surreal creations of the mind rather than real locations, Alexander's most recent works, made specifically for the *Extreme Beauty* exhibition, have continued to increase in scale. Produced in vinyl and installed like wallpaper directly onto the gallery walls, these large works appear as vicarious dream spaces that dwarf the viewer. The guideposts of reality are rather tenuous here, with only a few recognizable textures or illusory images to latch onto before delving into the limits of one's own imagination. With a few scraps and snips of found materials and bits of her own photographs that are then blown up as much as thirtyfold, Alexander takes us to the brink of a simulated world where we can consider and create a new, albeit murky, reality. But what would utopia look like today? Dare we even consider this

question as a guilty pleasure during a time when the planet is already reeling from too many grand visions?

Since retiring from her professorship at the University of Victoria in 2015 and moving to Montréal, Alexander has become more active than ever with exhibitions, the creation of new series and even the contemplation of working in virtual reality as a logical extension of the captivating environments she creates in vinyl. Throughout this prolific career beginning in the late 1970s, we have seen four persistent hallmarks of her practice:

- the appropriation of vernacular imagery and materials to consider how meaning is accrued and deployed;
- the investigation of consumer culture and its methods of display and enticement;
- the representation of architecture as a space containing utopian aspirations; and
- an abiding interest in nature, how it is represented and how we engage with and are estranged from it.

As Alexander has said about her process of inquiry, "My job as an artist is to figure out how things work."[45] As she continues her analysis, Alexander's aesthetic sensibility is shaped by finding ways to illuminate issues germane to the wonders and failings of Western society, especially as these grow more extreme in scale and impact. Her practice inspires those who come into contact with it, especially those who endeavour to ground their own unmoored positions in relation to the collective fantasies and dislocated realities of her photographs, sculptures, collages and installations.

NOTES

1 These and other early memories were recounted in an interview with the artist by the author on May 26, 2018.

2 The first glass sculpture made by Alexander was in response to an appropriated image she was working with of an ice cave filled with ice-carved furniture. She sought out a similarly transparent material — glass — for three-dimensional works that she placed adjacent to her initial use of this Nordic image at Stride Gallery, Calgary, 1988. As more of these glass sculptures were produced and installed parallel to her photographs of shop windows, they also doubled as "products" on display in a type of tableau. Formally, these works are in conversation with the designs of Judd but in contrast to his furniture that remains differentiated from his art. Alexander's work resembles furniture but remains sculpture, more closely aligned with Scott Burton's philosophy of blurring the lines between design and art. Vikky Alexander, interview by the author, December 13, 2018.

3 Ideas of theatricality and endlessness in relation to the objecthood of art are elaborated in Michael Fried's 1967 defining essay, "Art and Objecthood," available for download at atc.berkeley.edu/201/readings/FriedObjecthd.pdf.

4 While there were other significant conceptually based activities occurring in Europe and South America at this time, the conversations at NSCAD were primarily concerned with the North American context.

5 Vikky Alexander, interview by the author, June 4, 2018.

6 As the Canadian art scene was relatively small, Alexander did not consider moving to a Canadian city after her studies, believing that New York offered greater opportunities for developing a career as a contemporary artist. Vikky Alexander, interview by the author, May 26, 2018.

7 Max's Kansas City was a downtown New York nightclub from the mid-1960s to the early 80s that was a gathering place for artists, musicians and poets.

8 The *Pictures* exhibition was held at Artists Space, New York, September 24–October 29, 1977. Crimp's subsequent essay "Pictures" (*October*, no. 8 [Spring 1979]: 75–88) theorizes about the return of representational strategies taken up by a growing group of noteworthy artists, including some in this exhibition. The shifts in the New York art scene of this period are articulated in other historical sources such as Douglas Eklund's *The Pictures Generation, 1974–1984* and its related catalogue (New York: MetPublications, 2009) and in several essays in Rochelle Steiner, *Sarah Charlesworth* (Munich; New York: DelMonico Books/Prestel, 2017). Alexander's relationship to this scene is further described in Leah Pires' essay in this volume.

9 Vikky Alexander, interview by the author, June 4, 2018. Among other things, the artist recounted her early days of art making in this interview.

10 Female artists of a slightly older generation than Alexander included Barbara Kruger, Sarah Charlesworth, Louise Lawler, Cindy Sherman and Laurie Simmons, among others.

11 In his essay "Pictures," at one point Crimp describes how the "psychology of the image" is pertinent to the work of this generation, and he invokes Sigmund Freud's analytical writings about desire toward "a new understanding of how they might be useful for criticism."

12 The early 1980s was also the height of appropriation for Pictures artists.

13 Vikky Alexander, quoted in a press release for Metro Bus Show, CEPA (Center for Exploratory and Perceptual Art, Buffalo), New York, February 1984.

14 Brian Wallis, curatorial statement for *Vikky Alexander: Rear Window*, New Museum of Contemporary Art, New York, 1985. Likewise in 2017, Alexander participated in a public art project as part of the South Asian Canadian Histories Association's *Trauma, Memory and the Story of Canada* project, for which she was invited to work with the windows of a storefront in one of Vancouver's South Asian community neighbourhoods. As the building had been a former fabric store, Alexander made silk drapes, photographed them drawn shut, produced these images at a large scale in vinyl, and adhered them to the building's windows, suggesting the previous purpose and prominence of this site that was now in transition. See last image in this book (pp. 158–59).

15 Design Office is further elaborated in Leah Pires' text in this volume.

16 Alexander and Welling separated in 1992 when Alexander moved to British Columbia.

17 The exhibition Alexander curated, titled *Trouble in Paradise*, included colleagues Dan Graham, Sherrie Levine, James Welling and others. Additional exhibitions that Alexander curated include *Sextet* at Coburg Gallery, Vancouver, with photographs by Judith Barry, Ericka Beckman, Dara Birnbaum, Ellen Brooks, Barbara Ess and Kim Gordon in 1984, as well as *Altered States* at Bard College, Annandale-on-Hudson, New York, with photographs by John Baldessari, Ellen Brooks, David Cabrera, Sarah Charlesworth, Diana Formisano, Annette Lemieux, Allen Ruppersberg, Monique Safford, Oliver Wasow and Bing Wright in 1985.

18 Some of the exhibitions Alexander participated in during the early 1980s surveyed various contemporary issues, such as *Resource Material*, curated by Stephen Frailey, Proctor Gallery, Bard College, 1982; *Fashion Fictions*, White Columns, New York, 1983; *Seduction: Working Photographs*, curated by Marvin Heiferman, White Columns, 1985; *Photo Object*, Postmasters, New York, 1985; *Arts and Leisure*, curated by Group Material, the Kitchen, New York, 1986; *New New York*, curated by Bill Olander, Cleveland Center for Contemporary Art, 1986.

19 While Crimp's 1977 *Pictures* exhibition at Artists Space is a defining one, several other subsequent exhibitions in and around New York such as those at Clocktower, the Kitchen, Metro Pictures and Hallwalls as well as Solomon-Godeau's exhibition in 1983, further explored the major shifts in ideology represented by a new generation of artists.

20 Abigail Solomon-Godeau, "Winning the Game When the Rules Have Been Changed: Art Photography and Postmodernism," *Exposure* 26 no. 1 (Spring 1985): 12–13.

21 Abigail Solomon-Godeau, "Playing in the Fields of the Image," *Afterimage* no. 1-2 (Summer 1982): 11.

22 These include Andy Grundberg, "In Today's Photography, Imitation Isn't Always Flattery," *New York Times*, November 14, 1982; Therese Lichtenstein, "Fashion Fictions," *Arts Magazine* (March 1983); and Douglas Davis, "Seeing Isn't Believing," *Newsweek* (June 3, 1985): 68–70, among others.

23 *Lake in the Woods* was reviewed in *Artforum* (April 1986) and *Arts Magazine* (March 1986); referred to in Dan Cameron's "Post-Feminism" in *Flash Art* no. 132 (February/March 1987): 80–83; and earned a place in Cameron's annual roundup of the New York art scene for 1985–86 in *Arts Magazine* (Summer 1986).

24 Another related wallpaper installation, *Autumn/Spring* (1997), wraps landscape scenes of autumn and spring around a right-angled corner of the

gallery with adjacent store-bought mirrors serving to cast the viewer into the reflected landscape.

25 The subject of nature first comes up in *Yosemite* (1982) and *Portage Glacier* (1982), where the human figure is sandwiched between heightened views of supernatural nature. This was followed in the series *Between Dreaming & Living* (1985–86), where Alexander fuses black and white negatives of romantic views of people with scenes of nature, some of which were photographed by her (marking the very first time her own photography was used in her art).

26 This major theme is explored in much greater depth in Nancy Tousley's essay in this volume.

27 "The 1980s," History.com, accessed December 28, 2018, https://www.history .com/topics/1980s/1980s.

28 Collins and Milazzo's exhibition *Media Post Media* at Scott Hanson Gallery, New York, 1988, included Alexander and artists such as Holzer, Kruger, Levine and Sherman, among many others.

29 *Hybrid Neutral*, 1988, was organized by Independent Curators International (ICI) and toured throughout North America, including presentations at Canadian venues Alberta College of Art, Calgary, 1989, and Mendel Art Gallery, Saskatoon, 1990. Besides Alexander, it included John Armledder, Gretchen Bender, Ross Bleckner, Saint Clair Cemin, Sarah Charlesworth, David Diao, Robert Gober, Peter Halley, Jeff Koons, Jonathan Lasker, Annette Lemieux, Peter Nagy, Joel Otterson, Philip Taffe, Meyer Vaisman, James Welling and others.

30 See Grace Glueck, "What Do You Call the Newest Trend: 'Neo-Geo'... Maybe," *New York Times*, July 6, 1987.

31 Solomon-Godeau, "Playing in the Fields of the Image," 10.

32 Ian Wallace has significantly analyzed the use of beauty in Alexander's work: "If aesthetics is the science of beauty, she [Alexander] pushes it to the extreme.... The image of exalted beauty in her work evokes the sublime, but only as a mirage, an apparition that reveals itself as artifice." Ian Wallace, "Vikky Alexander: The Mirage of the Sublime," *Vikky Alexander: Vaux-le-Vicomte Panorama* (Vancouver: Contemporary Art Gallery, 1999), 19.

33 Just before Alexander moved to New York, she met Wall again in her hometown of Ottawa, where he was featured in a National Gallery of Canada exhibition, for which she assisted with photodocumentation of his installation. Vikky Alexander, interview by the author, June 4, 2018.

34 Alexander made the acquaintance of Rodney Graham and Ian Wallace through Dan Graham, and she socialized with them on their regular visits to New York.

35 According to an email from Ian Wallace, based on recommendations from Dan Graham and Judith Barry, who were part of his network, Wallace invited Alexander and Welling to lecture on their work in Vancouver at the Emily Carr Institute of Art, with an additional presentation at Simon Fraser University. As a curatorial student at Emily Carr, I attended their presentation and first met Alexander at that time.

36 Vikky Alexander, interview by the author, June 4, 2018.

37 During this period and beyond, Alexander has had numerous commercial gallery representations, including Catriona Jeffries, Vancouver; Galerie Brenda Wallace, Montréal; TrépanierBaer, Calgary; COOPER COLE, Toronto; Downs & Ross, New York; and Wilding Cran Gallery, Los Angeles, where she has exhibited regularly. She has also been included in major thematic museum surveys such as *Intertidal: Vancouver Art and Artists* at MuHKA, Antwerp, 2005, and several exhibitions at the Vancouver Art Gallery, among others.

38 Vikky Alexander, telephone conversation with the author, December 14, 2018, during which she described this shift from appropriation to taking her own images.

39 During a 1987 visit to the Banff Centre, where I included Alexander in the group exhibition *Reconnaissance* at the Walter Phillips Gallery (along with Roy Arden and Jamelie Hassan), I suggested that due to her interests in consumer culture, she might want to pay a visit to the newly opened West Edmonton Mall. The exploratory visit was successful and she returned one year later to formally photograph the mall.

40 These photographs were initially taken in 1988.

41 The vast hundred-acre gardens at Château de Vaux-le-Vicomte were designed by André Le Nôtre, who used an optical illusion of hidden distortion to make things in the endless garden appear more spectacular and closer than they actually are. In an interview with the author (May 30, 2018), Alexander recounted the history of the garden as a site of what was perceived as near-perfect harmony between nature and designed spaces. She also told how disorienting the experience of taking the images was, partly because merely walking the site took many more hours than anticipated.

42 It is difficult to generalize, but in the early 1990s Roy Arden was especially interested in the changing economy of the suburban landscape, while many of Jeff Wall's and Ian Wallace's urban images of the period make reference to urban inhabitants and their social interactions. Ken Lum's constructed images addressed issues of identity in a more direct manner, while Stan Douglas was keen on depicting human interventions on the landscape itself. Alexander's works of the time analyze built environments designed specifically as sites of consumption and generally do not include images of people.

43 While the images of identical suburban houses in Dan Graham's *Homes for America* (1966–67) — which promoted his preoccupation with vernacular seriality — would have been familiar to Alexander, she was interested in lifting the veil on advertising strategies used to sell condominiums in order to render a critique of the utopian visions that are summoned in the model display suites.

44 Many of these canvases are approximately 4 × 6 feet (1.2 × 1.8 metres), and some are even larger.

45 Vikky Alexander, quoted in Nancy Tousley, "Images of Desire" (review), *Calgary Herald*, April 19, 2003.

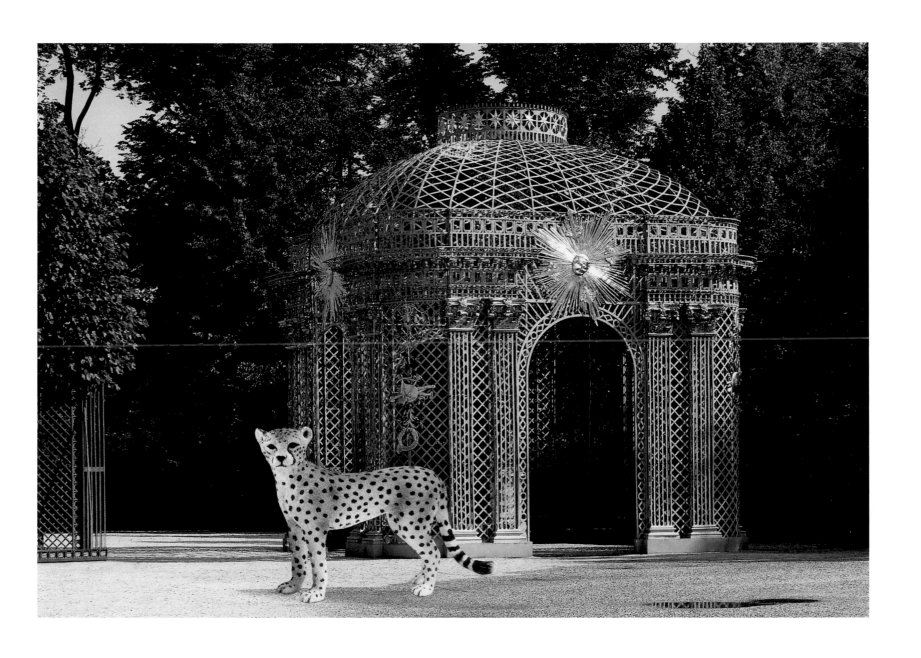

Cheetah at the Pavilion at Sanssouci, 2013, inkjet print, 74.9 × 105.4 cm

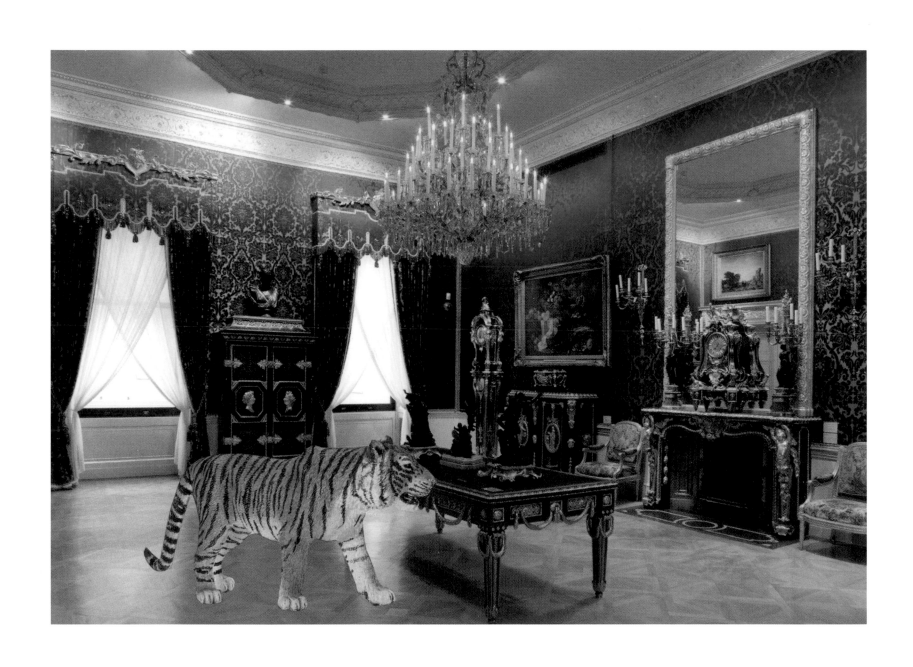

Bengal Tiger in Large Drawing Room, 2013, inkjet print, 74.9 × 105.4 cm

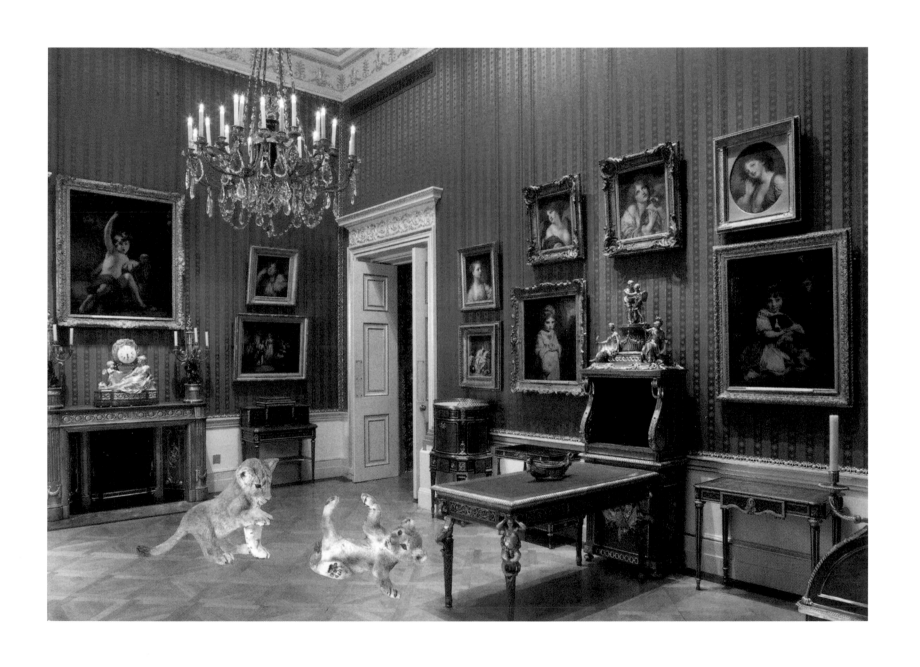

Lion Cubs in the Wallace Collection Boudoir, 2013, inkjet print, 68.6 × 105.4 cm

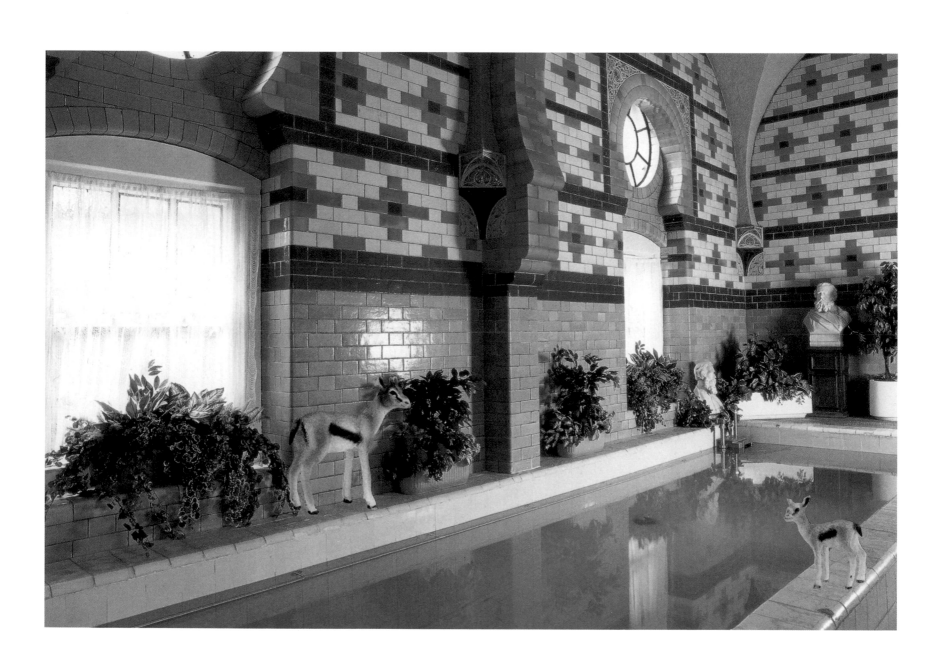

Gazelles at the Harrogate Baths, 2013, inkjet print, 74.9 × 105.4 cm

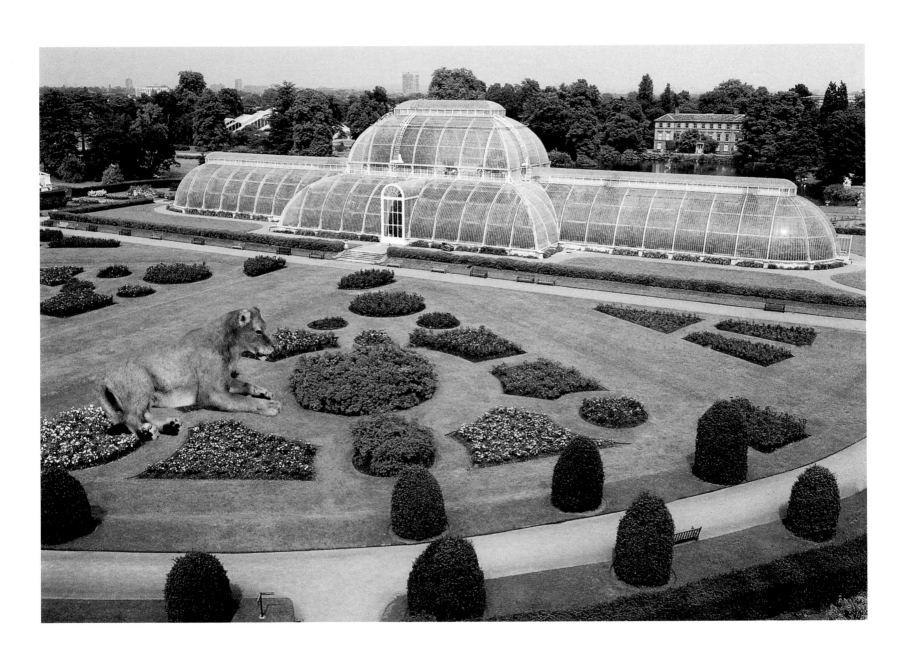

Lioness at Kew Gardens, 2013, inkjet print, 74.9 × 105.4 cm

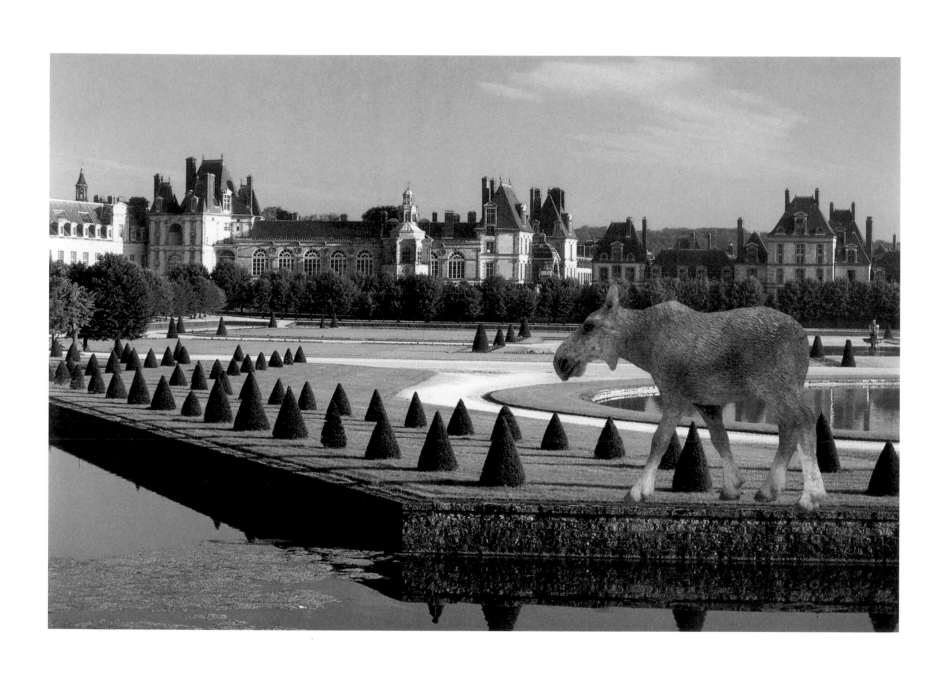

Moose Cow at Fontainebleau, 2013 , inkjet print, 74.9 × 105.4 cm

Between Dreaming & Living #3, 1985,
silver gelatin print, Plexiglas, 61.0 × 91.4 cm

Between Dreaming & Living #2, 1985,
silver gelatin print, Plexiglas, 61.0 × 91.4 cm

Between Dreaming & Living #4, 1985,
silver gelatin print, Plexiglas, 61.0 × 91.4 cm

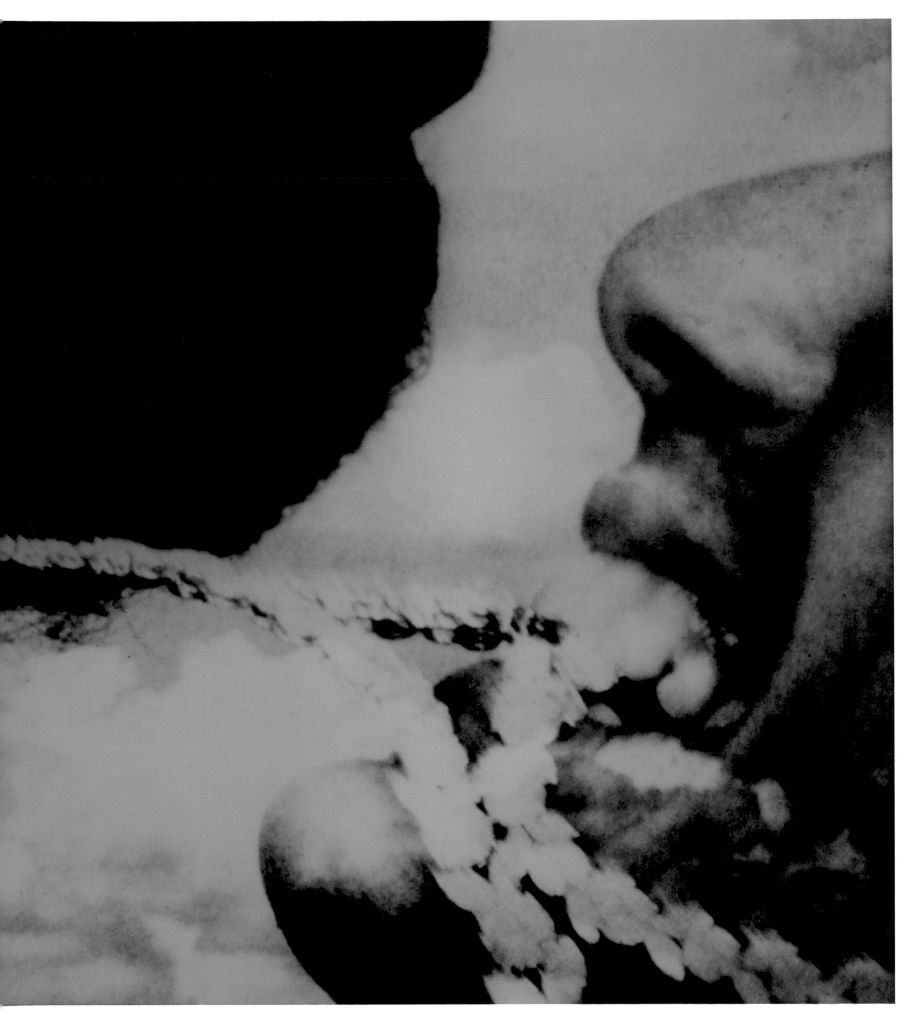

Between Dreaming & Living #1, 1985,
silver gelatin print, Plexiglas, 55.9 × 71.1 cm

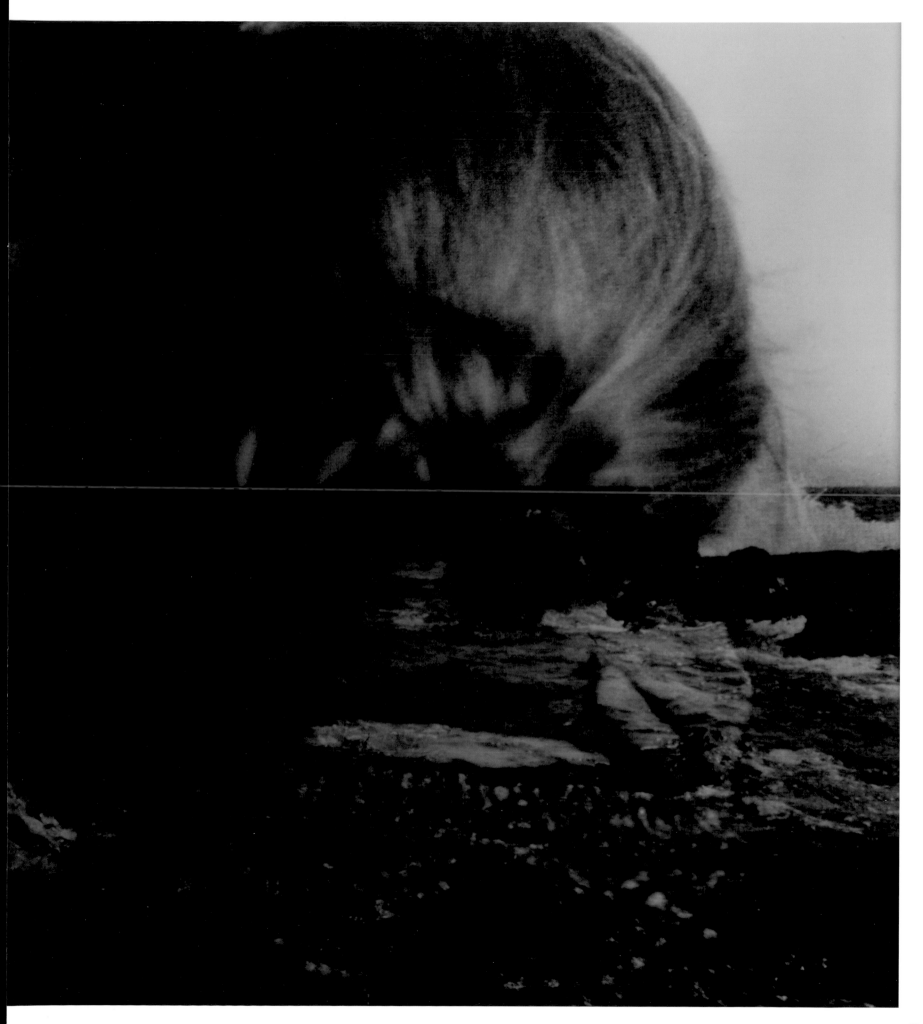

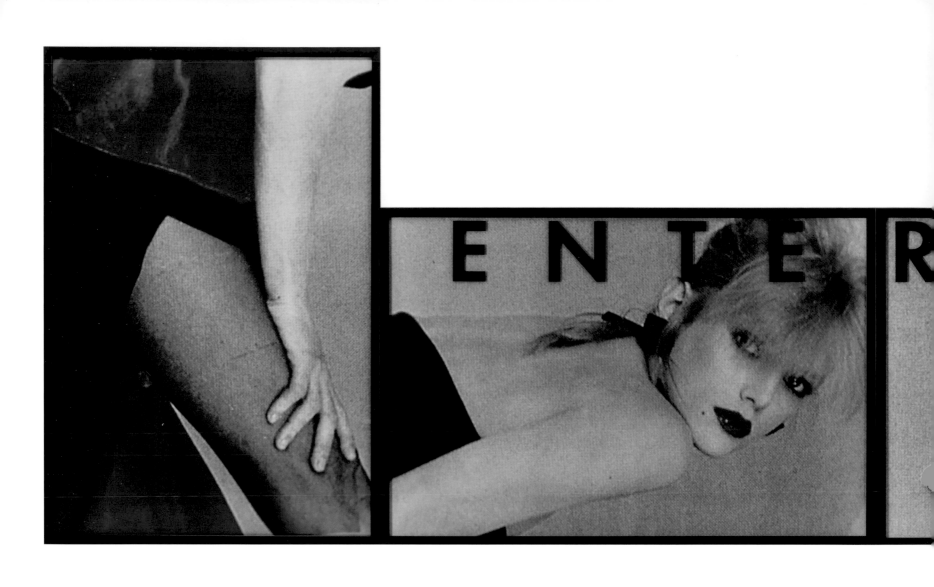

Entertainment, 1983, chromogenic prints, vinyl type, 88.9 × 335.3 cm

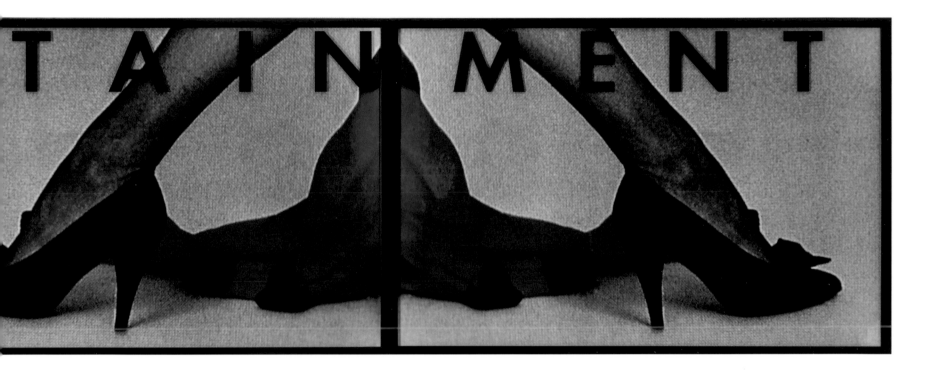

Double Takes

Leah Pires

What's behind an image?

Scene one: The word E N T E R T A I N M E N T, in black sans serif lettering, stretches across a set of glossy photographs. *Take one*: a slender thigh emerges from the triangular hem of a black and red gown; a hand rests above the knee. *Take two*: the frame captures a woman's head and shoulders in profile. She's clad in a strapless black top and chunky earrings, and her teased blonde hair, glossy maroon lips and smoky eye watermark the image to the 1980s. *Takes three and four*: a pair of mirror-image panels reveal other parts of the same figure — a black high heel with a bow, a cascade of red fabric and an outstretched calf posed against a white seamless backdrop. As fragments, these images offer glimpses of a fashion model. Taken together, they don't quite add up to a full picture.

Scene two, take one: A set is constructed within a photo studio, cleverly conjuring the illusion of an elegant living room from painted white plywood. *Take two:* a nude woman lounges on the set. She slips on a pair of high heels and reclines against a pile of colourful pillows — back arched, knees bent, toes in the air. The view pans across a tangle of studio equipment, landing on two men standing beside a camera on a tripod. One of them gestures to the model, indicating that she should change her position.

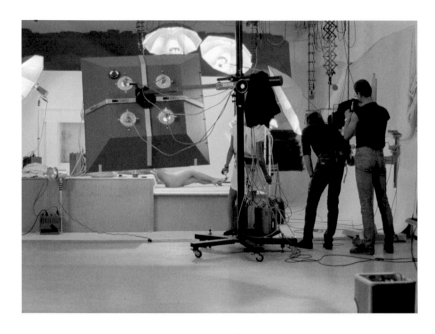

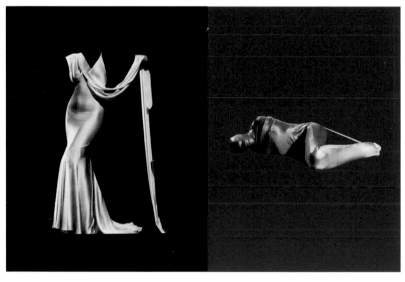

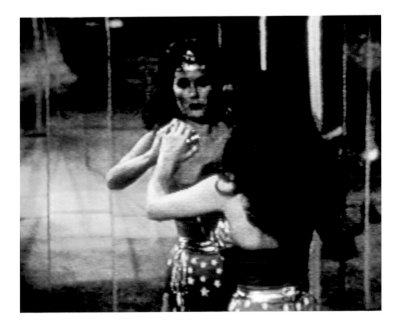

TOP LEFT
Harun Farocki, *Ein Bild*, 1983, 16 mm film, 25 min.

BOTTOM LEFT
Sarah Charlesworth, Figures, 1983, Cibachrome
prints with lacquered wood frames, 101.6 × 152.4 cm

TOP RIGHT
Cindy Sherman, Untitled Film Still #81, 1980,
silver gelatin print, 25.4 × 20.3 cm

BOTTOM RIGHT
*Dara Birnbaum, Technology/Transformation: Wonder
Woman*, 1978–79, colour video, stereo sound, 5:50 min.

They adjust their camera equipment; she adjusts her pose. *Take three:* two assistants fuss with the model's hair, adjust the placement of her hand, and rearrange the cushions that prop up her body from behind. She holds her pose until she can no longer conceal the strain. "It's uncomfortable," she explains. "Okay, so make yourself comfortable," the photographer replies irritably. But he deems her chosen position too unnatural, so the repositioning continues.

These two tableaux, both shot in 1983, capture opposing moments in the life of an image. The first is a photo-based quadriptych by Vikky Alexander titled *Entertainment* (1983). To create the image, Alexander rephotographed fragments of a European fashion editorial, strategically cropped and doubled the images and superimposed vinyl lettering over the top of the new composition. The second is from the German filmmaker Harun Farocki's short film *Ein Bild* (or *An Image*) (1983), which chronicles the creation of a centrefold for German *Playboy* from start to finish. The filmmaker captures the set design, styling, posing, test printing and interpersonal exchanges encapsulated by the four-day shoot. While Farocki's film seeks to reveal the hidden apparatus behind the production of glossy images of women for magazines, Alexander's photographs instead dissimulate and embellish upon them. Farocki offers a glimpse behind the curtain, while Alexander multiplies the smoke and mirrors.

In the late 1970s and early 1980s, images of women — and in particular, their political stakes within postmodern art and theory — were the subject of heated debate. A network of artists now known as the Pictures Generation (named after *Pictures*, an exhibition curated by Douglas Crimp in 1977) was at the centre of this conversation.[1] Their work appropriated ordinary images from mass media and everyday life and imbued them with new meaning through cropping, restaging and juxtaposition. Cindy Sherman dressed up in elaborate costumes and cast herself in imagined Hollywood films to produce her *Untitled Film Stills* photographs (1977–78); Dara Birnbaum, in the video *Technology/Transformation: Wonder Woman* (1978–79), recut footage from an episode of *Wonder Woman* to offer a different view of the iconic heroine; Barbara Kruger overlaid vintage portraits of women with phrases such as "Your gaze hits the side of my face" and "We won't play nature to your culture" rendered in bold, graphic text; Sarah Charlesworth excised objects of desire from magazines and dramatically restaged them against colourful, seamless backdrops. Though Alexander, nearly a generation younger, is rarely named among the pantheon of Pictures artists, her contemporaneous work

was developed in their midst and shares their hallmark strategy: recasting the meaning of mass media images through appropriation and recontextualization.[2]

The emergence of appropriation art placed the status of critique, so central to the modernist avant-gardes, newly in question. Critics were divided: could images of women cribbed from fashion, television and film take on new messages in the hands of artists who forged feminist polemics from the ruins of tired clichés? Or were the meanings of such images too firmly rooted in their patriarchal origins to become tools of emancipation and resistance? The critic Benjamin Buchloh, allied with the latter position, underscored the risks and vulnerabilities of appropriation and parody as critical strategies. He warned that they allow for "ambiguity and balance [that] can be tilted at any moment, and...can easily turn from subversive mimicry to obedience."[3] Drawing on the Marxist tradition of ideology critique developed by the Frankfurt School, he argued that critical art should reveal the false promises of media images, much like Farocki's filmic excavation of a *Playboy* centrefold. One should not be seduced by an image, he maintained, but rather unveil its ideology from a safe critical distance. Others, like the critic Craig Owens, were skeptical of the notion that it was possible — or desirable — to critique the mass media or patriarchal power from a remove. He saw appropriation art as a critique of representation that questioned the stable ground upon which meaning and subjectivity were thought to rest.[4] This analysis was informed by poststructuralism, psychoanalysis and feminism. In the eyes of many critics, the new approach to images developed by Pictures artists not only undercut inherited concepts of authorship and private property; it also critiqued the notion that gender or identity were based on a stable essence.[5] In other words, they undermined the belief that the meaning of an image might be the property of any one person, or that an image of a woman might reveal anything at all definitive about the category of "woman." The artists themselves rarely stated their aims so directly, instead favouring the kind of theory that is elaborated through practice.

At this moment, Alexander began mining the editorial spreads and advertisements of fashion magazines for images of women (and the occasional man). While many Pictures artists culled nostalgic images from the past as the raw material for their work, Alexander's references were insistently contemporary. She drew them from the latest international periodicals, resourcefully borrowed from a bookstore staffed by a friend, photographed at night and returned

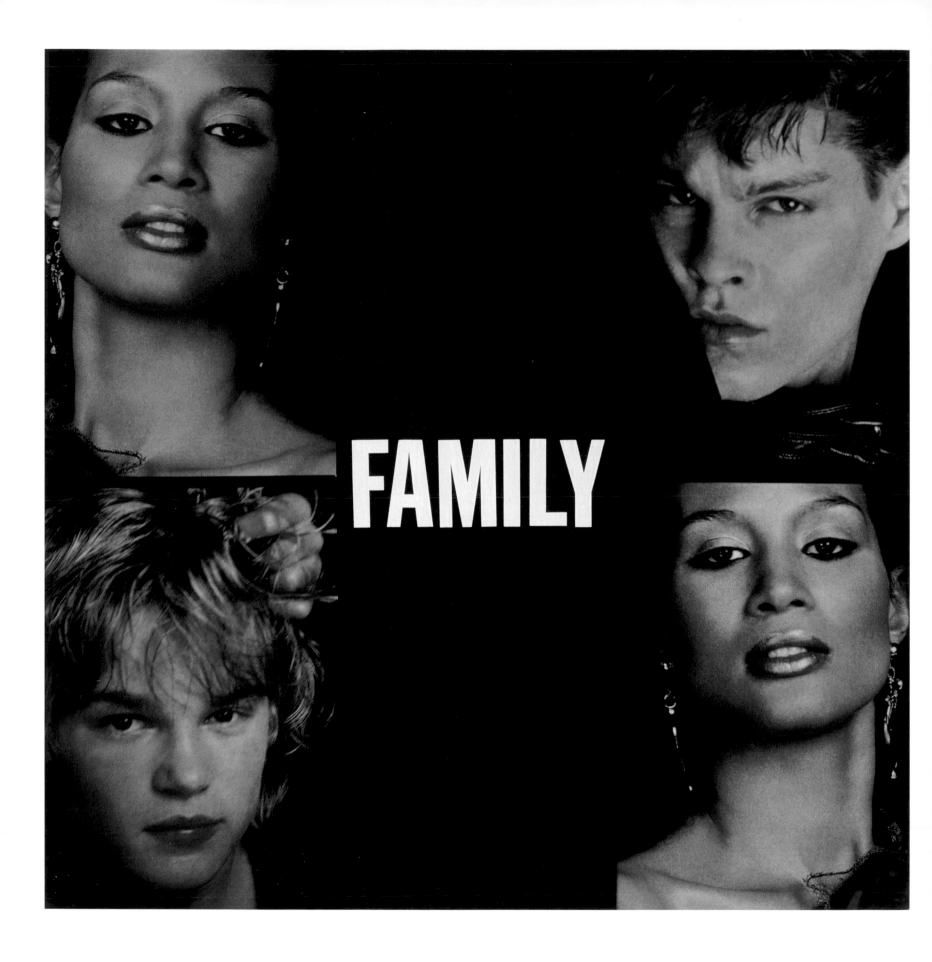

Family, 1983, azo dye prints, vinyl type, 121.9 × 132.1 cm overall

the next morning. Alexander used a copy stand mounted with a 35 mm camera and reproduction lens to capture fragments of selected images. She enlarged, cropped and multiplied the resulting photographs, at times overlaying them with vinyl lettering, to create new compositions from found materials. The images' secondhand status was betrayed by a skein of benday dots, the telltale sign of the magazine's halftone printing process, which enmeshed her photographs. Some of Alexander's photographs featured faces that conjured proper names — Christie Brinkley, Isabella Rossellini — while others, unnamed, masqueraded as the category "woman," inviting the possibility that you could be her, or she could be you.

Two such tableaux appeared in Alexander's first solo exhibition, *Family Entertainment*, mounted at A&M Artworks in downtown Manhattan in 1983. The artist described her modus operandi as "look[ing] at myself looking at other women" — in particular fashion models, described in the press release as "the post-industrial icon of Woman."[6] One of the two works on view, *Family* (1983), which appeared alongside *Entertainment* (the work described at the outset), features a grid of four close-cropped faces bifurcated by the word FAMILY. A pair of youthful white male models with tousled hair appear opposite two mirror-image portraits of a black woman, resplendent in iridescent makeup and long silver earrings. These three figures were, in their original context, part of a larger spread of models clad in leather and drapery; the chaotic pileup of bodies reminded Alexander of Théodore Géricault's painting *The Raft of the Medusa* (1818–19). (The titles of other contemporaneous works, such as *Pieta* [1981] and *Ecstasy* [1983], deliberately overlay fashion photographs with art-historical references). While the artist's visual edit lent the image a new compositional clarity, her insertion of the word FAMILY also brought questions of subjectivity and identity to the fore. In what sense are these figures family — are they partners, siblings, cousins or mother and son? Is the doubled image of the woman supposed to represent two different people, or two views of the same person? While these questions are purposefully left unanswered by the image, it offers an unmistakable challenge to the fantasy of white purity and separateness that haunts America, then as now.

Alexander had been introduced to conceptual and appropriationist strategies at the Nova Scotia College of Art and Design (NSCAD), where she studied under the instruction of such artists and critics as Vito Acconci, Dara Birnbaum, Dan Graham and Benjamin Buchloh from 1976 to 1979. Despite its distance from the art world's geographic

centres, NSCAD's forward-thinking faculty placed it on the cutting edge of contemporary art discourse at the time. Graham initiated a pioneering media art program that trained young artists such as Alexander in the analysis of mass media and culture, building on the insights of such invited guests as Birnbaum, Martha Rosler and Jeff Wall.[7] Upon moving to New York in the fall of 1979, Alexander found a collaborator and friend in Kim Gordon, an artist and musician recently transplanted from Los Angeles who later gained recognition as the frontwoman of Sonic Youth. As newcomers to the downtown scene, Alexander and Gordon's early projects took a decidedly D.I.Y. approach. They organized music shows featuring the likes of Nina Canal, Rhys Chatham and Robert Longo at Jenny Holzer's loft, and cofounded Design Office, a collaborative venture that sought to "provide (art as) a service incorporating…artists, clients, and a concept of design."[8] The pair advertised their services through an ad in the downtown periodical REALLIFE, gold-embossed matchbooks bearing the slogan "Alterations to Suit" and word of mouth. Active between October 1979 and May 1980, they netted an impressive list of clients, including Dan Graham ("Renovation consultations; personalized wallwork installation"); Jeff Wall (installation shots of his work *Picture for Women* [1979]); Mike Kelley ("Problem: redefinition of an image. Solution: clothing purchase order"); James Casebere ("Consultation for a storefront/living conversion"); and Gerhard Richter ("Design of 45 rpm record sleeve").[9] Yet Design Office was at least partly tongue-in-cheek. Sometimes Alexander and Gordon provided their services without waiting for an invitation or even asking for permission. For example, they offered a free "architecturally considered application of copper spray paint" to the exterior of three SoHo art galleries. The macho cool of their minimal facades "needed to be loosened up," Alexander recalls, so she and Gordon covertly covered them with shimmering graffiti flowers and then added the unwitting clients as a line on their resumé. You could say that Design Office specialized in makeover and rebranding services. But Alexander and Gordon's interventions went beyond the superficial — they implemented aesthetic adjustments that enhanced the cultural capital of their clients.[10]

Alexander's design services and magazine appropriations are united by their use of subtle, seemingly surface-level adjustments to forge new meaning from existing materials. She deliberately adopted the feminized media of fashion and decor as the raw materials of her early work. Even appropriation, now used as an artistic strategy, was

Pieta, 1981, chromogenic print, 165.1 × 68.6 cm

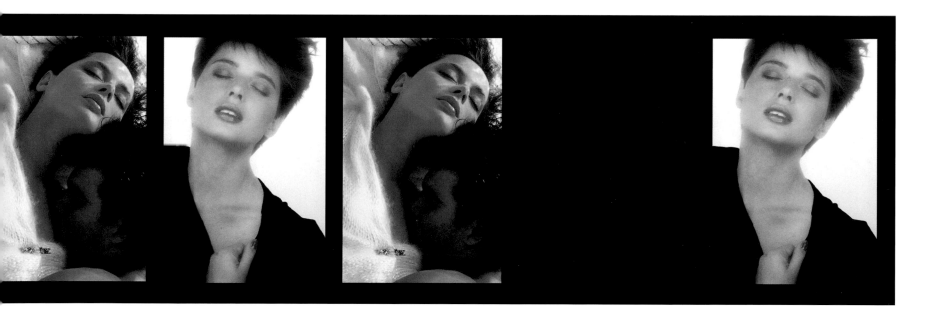

Ecstasy, 1983, type R print, 60.1 × 261.0 cm

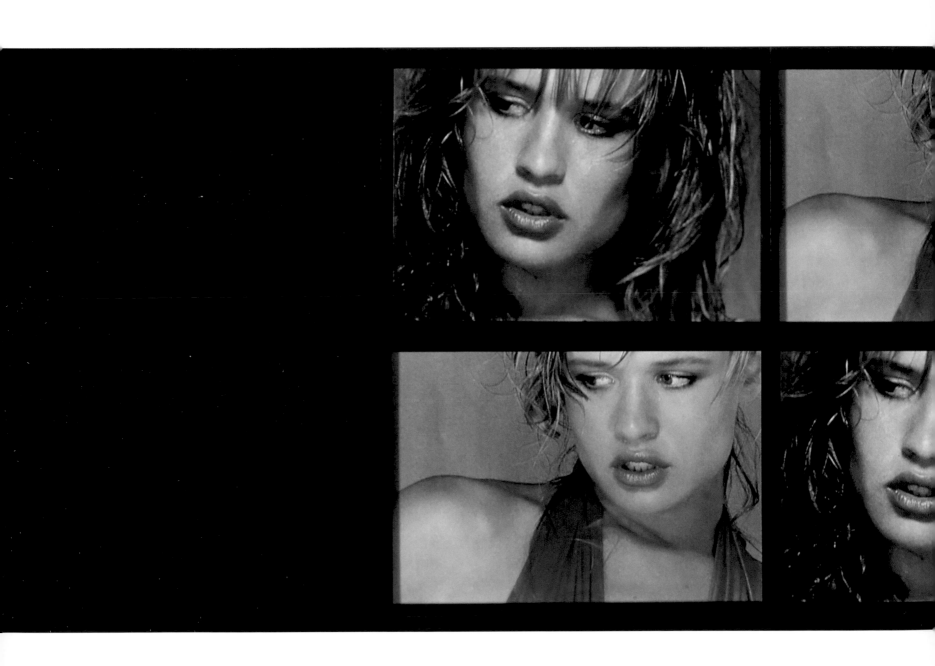

Numero Deux, 1982, chromogenic prints, 94.0 × 317.5 cm

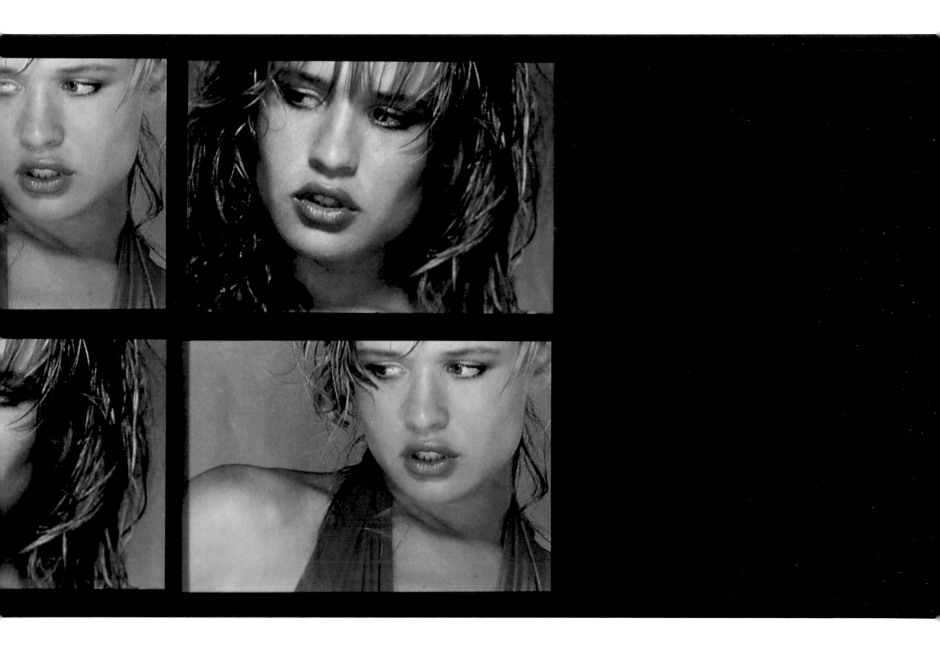

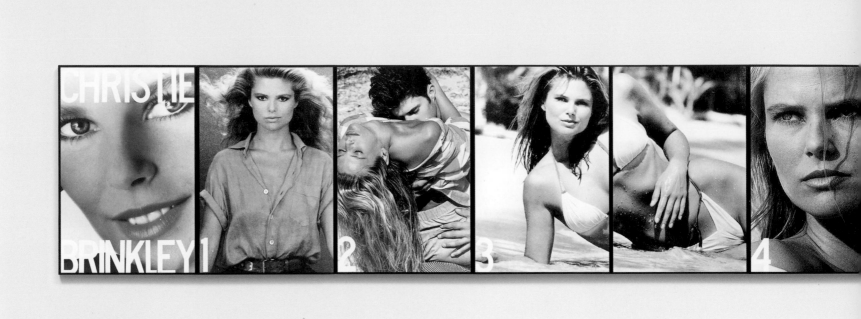

traditionally understood as feminine — the merely reproductive counterpoint to originary creation, which had been associated with a patently male archetype since at least the nineteenth century, if not the book of Genesis.[11] Surface appearance, masquerade and illusion — the hallmarks of fashion — have also long been associated with the feminine realm.[12] Dominant strands of modernist art and theory positioned themselves against these traits. Their emphasis on unveiling false ideology and exposing a "truth to materials" was premised on a distrust of surface appearances.[13] Vision was figured as a privileged mode of access to truth and knowledge within modernism because it was thought to function at a remove, allowing for critical distance.[14] Indeed, avant-garde culture's oppositional stance was premised on masculinist notions of autonomy and critical distance. Within this paradigm, mass culture was feminized and devalued as high culture's superficial, narcissistic Other.[15]

The emergence of postmodernism around 1980, and the increasing recognition of women artists who repurposed mass media images in their work, inaugurated a paradigm shift. The traditional divide between mass culture and high culture — which had always been a fantasy, albeit a curiously durable one — could no longer hold. Yet those who remained skeptical of appropriation art's capacity for critique still talked about "spectacle culture" — Hollywood film, television, fashion, advertising and the like — as a contaminating, destabilizing, boundary-dissolving threat; these are fears traditionally associated with the feminine.[16] Could one be sure that an image of a woman from a fashion magazine, cut up and reconfigured or overlaid with text, wasn't shoring up the same economy of false consciousness and patriarchal oppression as its source?

Alexander's work suggests otherwise. Like many women associated with Pictures and appropriation art, her photographs are immersed

Installation view of *Obsession*, 1983, at the Vancouver Art Gallery, Vancouver, 2019

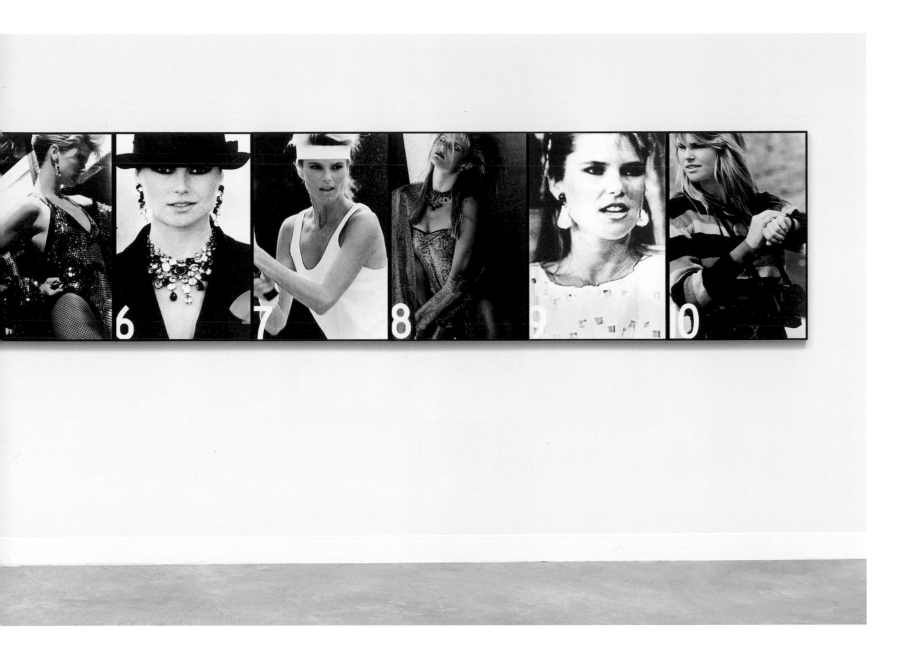

in the contradictions of pleasure, desire and subjectivity; they reject the imperative to resolve into a pure, unambiguous position. The artist has described her work of the early 1980s as "representational research."[17] Each image subtly transforms its source through cropping and doubling, yet it does not deny or obscure the allure of the original image. Alexander and her Pictures contemporaries refuse the false binary between complicity and critique, pleasure and analysis. "What's wrong with a lot of Frankfurt School theory is that it assumes that art is about power," Sherrie Levine once said, "[but] for me, art is about play."[18] Barbara Kruger declared her allegiance to "pleasure and laughter," and described her work as an attempt to "undermine that singular pontificating male voiceover which 'correctly' instructs our pleasures and histories or lack thereof them."[19] By wresting new meaning from existing images, these artists developed a critique of essentialism — the idea that an image or

word, like "woman," for example, has a stable essence or meaning. Rather, they understood that images and words are signs whose meaning cannot be separated from their *use:* their context, placement, position and pose. These artists also rejected the notion of a coherent, unified reality that could be revealed as if by drawing back a curtain; their work pointed out that one's sense of reality is inextricable from one's identity and one's position. In so doing, they carved out a space for agency and self-making that radically redefined inherited notions of gender and representation.

This is both the insight and the limit of those who, like Abigail Solomon-Godeau, describe Alexander's work as a "feminist critique of fashion imagery" that renders its "hidden codes…legible."[20] While this interpretation is persuasive, it's less often acknowledged that the work also does more than merely unveil ideology. It also underscores, on a material level, the insight that meaning emerges

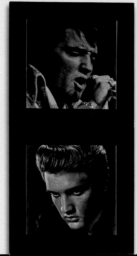
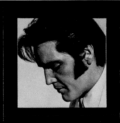
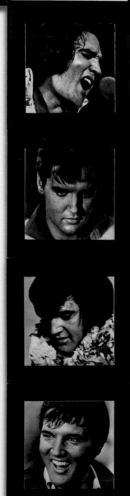

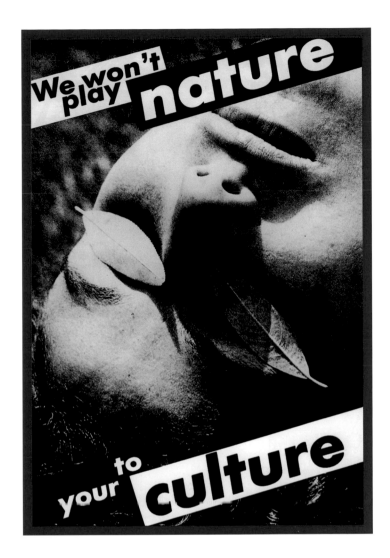

in the encounter between image and viewer. The polished, reflective surfaces of the artist's photo-and-text compositions overlay model and spectator, rendering the two visually inseparable. Alexander's appropriations also acknowledge the allure of their source images — the complex and ambivalent set of reasons that we are drawn to idealized images of women printed on the glossy pages of magazines. The appeal of a fashion editorial is hardly diminished by the knowledge that it represents but a single moment produced through elaborate stagecraft and artifice. Such images evoke aspiration, fantasy, identification, desire and pleasure, but also jealousy, hatred, self-loathing, disidentification. Alexander's work gives space to those responses, not seeking to ruin or unveil them but instead acknowledging and reflecting upon them. Her work is not about making the invisible visible, but about reshuffling the deck of gender and desire and dealing us a new hand.

Gender is a pose, after all — constructed and performed, not intrinsic and fixed, an insight that runs from Joan Riviere's "Woman-liness as Masquerade" (1929) to Judith Butler's *Gender Trouble* (1990) and beyond.[21] This is as true of models in magazines dressed up, posed and captured on camera as it is in everyday life. Yet artifice is not just a trap — self-making and self-fashioning can also be a source of agency. "[Posing] is neither entirely active nor entirely passive," Owens writes. "The subject poses as an object *in order to be a subject*."[22] The strength of Alexander's work, and that of other Pictures artists who recast images of women, is its synthesis of a critique of gender and a critique of representation; it shows that both gender and representation are constructed rather than natural.[23] The project of feminist image production, Teresa de Lauretis suggests, is to create "the conditions of visibility for a different social subject" — that is, "another frame of reference, another measure of desire."[24] Alexander and her Pictures contemporaries developed a critique of representation that understood desire and subjectivity to be at the centre of knowledge, not a distraction or an afterthought. Alexander's artworks pose and perform, too, in the sense that they operate differently depending on who is looking. Her photographs are not interchangeable with fashion editorials, nor are the doubled images that appear in her work simply copies of one another. Instead, they're decoys that generate agency through masquerade. "What is called reproduction — as women well know — is never simply natural or simply technical, never spontaneous, automatic, without labour,

without pain, without desire, without the engagement of subjectivity," De Lauretis writes.[25] Rather, images produce contradictions. As Alexander has pointed out, sometimes desiring an image is better than getting it. Her work lets you have it both ways.

NOTES

1 The term "Pictures Generation" is most often traced back to *Pictures*, an exhibition that took place at Artists Space in New York in 1977. Equally important in consolidating a group identity, I contend, was the gallery Metro Pictures, cofounded by Helene Winer (formerly of Artists Space) and Janelle Reiring (formerly of Castelli Gallery) in 1980; its roster included many of the artists now associated with the Pictures Generation. Many of them had studied at CalArts or had been associated with the alternative space Hallwalls at SUNY Buffalo before moving to New York and exhibiting at Artists Space in the late 1970s. The term "Pictures Generation" was developed retroactively; as such, it is porous and contested, and has been subject to revision by different interests. The exhibition *The Pictures Generation, 1974–1984*, featuring the work of thirty artists and curated by Douglas Eklund at the Metropolitan Museum in 2009, constitutes the most comprehensive historicization to date. Here, I use the term "Pictures artists" to designate a loose grouping of artists

OPPOSITE: *Grace*, 1984, record covers, vinyl type, 284.5 × 121.9 cm
TOP: Barbara Kruger, *Untitled (We won't play nature to your culture)*, 1983, photograph, 185.0 × 124 cm

who used strategies of visual and textual appropriation and exhibited at Artists Space, Metro Pictures and related venues in New York in the late 1970s and early 1980s.

2 Alexander is not a part of the "Pictures Generation" as it has been historicized; she was not included in *Pictures* (1977) or *The Pictures Generation, 1974–1984* (2009), nor did she study at CalArts or exhibit at Hallwalls, Artists Space or Metro Pictures, though she knew many of these artists. Her immediate peers were a younger generation of artists that congregated in the East Village around galleries such as Nature Morte, International with Monument and Cash/Newhouse, including Alan Belcher, Jennifer Bolande, Annette Lemieux, Peter Nagy, Julia Wachtel, Meyer Vaisman and others. That said, Alexander's work has affinities with that of Pictures artists such as Sherrie Levine, Richard Prince and Barbara Kruger, and it was exhibited and discussed alongside theirs (see for example *The Stolen Image and Its Uses*, curated by Abigail Solomon-Godeau at Light Work, Syracuse, New York [1983], and Solomon-Godeau, "Winning the Game When the Rules Have Changed: Art Photography and Postmodernism," *Screen* 25.6 [November 1984]: 88–103). Here, I analyze her work in relation to the strategies and concerns of appropriation art and postmodernism, which have been strongly linked to the pioneering work of Pictures artists though are by no means limited to it.

3 Benjamin H.D. Buchloh, "Parody and Appropriation in Francis Picabia, Pop, and Sigmar Polke (1982)," *Neo-Avantgarde and Culture Industry: Essays on European and American Art from 1955 to 1975* (Cambridge, MA: MIT Press, 2000), 364. See also Benjamin Buchloh, "Allegorical Procedures: Appropriation and Montage in Contemporary Art," *Artforum* 21 (September 1982): 48–50.

4 Craig Owens, "The Allegorical Impulse: Toward a Theory of Postmodernism," *October* 12 (Spring 1980): 67–86; Craig Owens, "The Discourse of Others: Feminists and Postmodernism (1983)," *Beyond Recognition: Representation, Power, and Culture* (Berkeley: University of California Press, 1992).

5 Such interpretations were advanced, in various forms, by Douglas Crimp, Rosalyn Deutsche, Hal Foster, Rosalind Krauss, Craig Owens, Howard Singerman and Abigail Solomon-Godeau, among others.

6 Vikky Alexander quoted in Isabella Smith, "Rewriting the Language of Fashion Photography," *Another Magazine*, May 24, 2016, http://www.anothermag.com/art-photography/8717/rewriting-the-language-of-fashion-photography. The press release quotes Abigail Solomon-Godeau, "Playing in the Fields of the Image," *Afterimage* 10, nos. 1–2 (Summer 1982): 10–13. Vikky Alexander, press release for *Family Entertainment*, A&M Artworks, May 4–June 4, 1983. Archive of Vikky Alexander.

7 Garry Neill Kennedy, *The Last Art College: Nova Scotia College of Art and Design, 1968–1978* (Cambridge, MA: MIT Press, 2012), 364. Buchloh and Graham also brought key players from the New York Pictures scene to the college for lectures and panel discussions in 1977–78, including Jack Goldstein, Matt Mullican and Helene Winer as well as influential practitioners of conceptual and critical practices, including Michael Asher, Daniel Buren, Isa Genzken, Yvonne Rainer and Gerhard Richter.

8 Vikky Alexander, "Design Office," typewritten statement, undated. Archive of Vikky Alexander.

9 Archive of Vikky Alexander.

10 Design Office formed at precisely the same time as the artist-run consulting firm The Offices of Fend, Fitzgibbon, Holzer, Nadin, Prince & Winters, and the two groups share significant affinities. Both publicized their services through advertisements in the March 1980 issue of *REALLIFE* magazine. For an analysis of The Offices and the confluence of service and artistic labour at this moment, see my essay, "Pleasure/Function: Aesthetic Services circa 1980," *Brand New: Art & Commodity in the 1980s*, ed. Gianni Jetzer, exh. cat. (Washington, DC: Hirshhorn Museum and Sculpture Garden, 2018), 62–73.

11 Hillel Schwartz, *The Culture of the Copy: Striking Likenesses, Unreasonable Facsimiles* (New York: Zone Books, 1996), 186–87, 191, 277.

12 See Emily Apter, "Unmasking the Masquerade: Fetishism and Femininity from the Goncourt Brothers to Joan Riviere," *Feminizing the Fetish, Psychoanalysis and Narrative Obsession in Turn-of-the Century France* (Cornell University Press, 1991), 65–98.

13 The historical avant-gardes (Soviet Constructivism, Dada and Futurism) and theorists associated with the Frankfurt School (Theodor Adorno, Max Horkeimer, Siegfried Kracauer and Herbert Marcuse) and those working in their post-war legacy best exemplify these tendencies.

14 Rosalyn Deutsche, "Agoraphobia," *Evictions: Art and Spatial Politics* (Cambridge, MA: MIT Press, 1996), 294.

15 Andreas Huyssen, "Mass Culture as Woman: Modernism's Other," in *After the Great Divide: Modernism, Mass Culture, Postmodernism* (Bloomington: Indiana University Press, 1986), 44–62.

16 See for example Benjamin H.D. Buchloh, "Documenta 7: A Dictionary of Received Ideas," *October* 22 (Fall 1982): 105–26. On boundaries and the feminine, see Anne Carson, "Dirt and Desire: Essay on the Phenomenology of Female Pollution in Antiquity," *Men in the Off Hours* (New York: Knopf: Distributed by Random House, 2000), 130–57.

17 Vikky Alexander, conversation with the author, October 2018.

18 Sherrie Levine quoted in Paul Taylor, "Sherrie Levine Plays with Paul Taylor," *Flash Art*, no. 135 (September 1987): 56.

19 Barbara Kruger, "Incorrect (1982)," *Remote Control: Power, Cultures, and the World of Appearances* (Cambridge, MA: MIT Press, 1993), 221.

20 Abigail Solomon-Godeau, "The Stolen Image and Its Uses," *Lightwork Contact Sheet* 35 (April 1983): 1.

21 Joan Riviere, "Womanliness as a Masquerade," *The International Journal of Psychoanalysis* 10 (1929): 303–13; Judith Butler, *Gender Trouble: Feminism and the Subversion of Identity* (New York and London: Routledge, 1990). My use of the term "pose" is indebted to Craig Owens, "Posing (1984)," *Beyond Recognition: Representation, Power, and Culture*, ed. Scott Bryson et al. (Berkeley: University of California Press, 1992), 202.

22 Owens, "Posing," 215.

23 See Owens, "The Discourse of Others: Feminists and Postmodernism (1983)," for a thorough analysis of the intersection between feminism and postmodernism in their work.

24 Teresa De Lauretis, "Imaging," *Alice Doesn't: Feminism, Semiotics, Cinema* (Bloomington: Indiana University Press, 1984), 68.

25 Ibid., 55.

Between Dreaming & Living #05, 1985, azo dye print, 60.96 × 50.8 cm

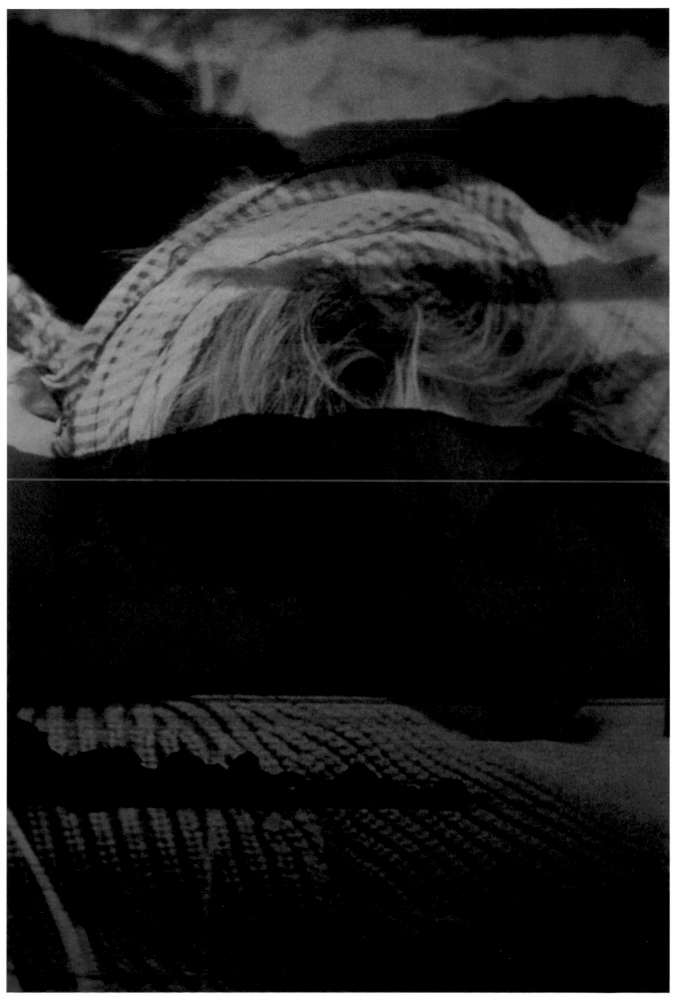

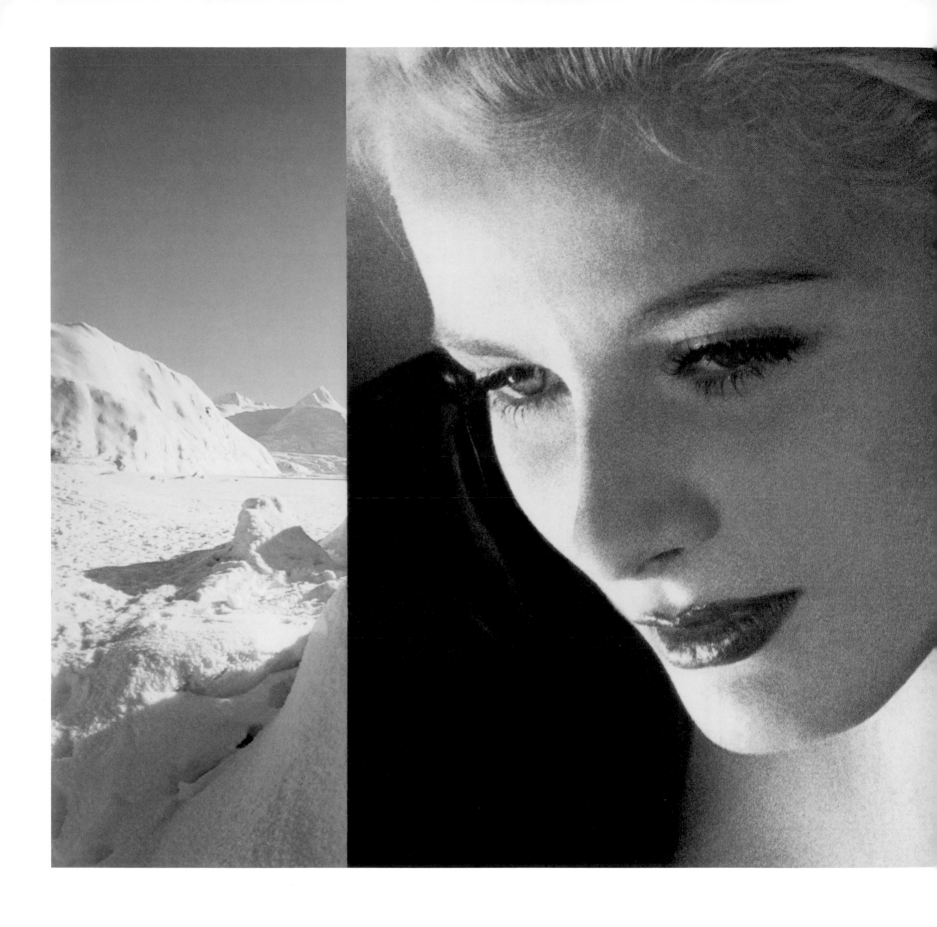

Portage Glacier, 1982/2017, inkjet print on metallic paper, 45.7 × 101.6 cm

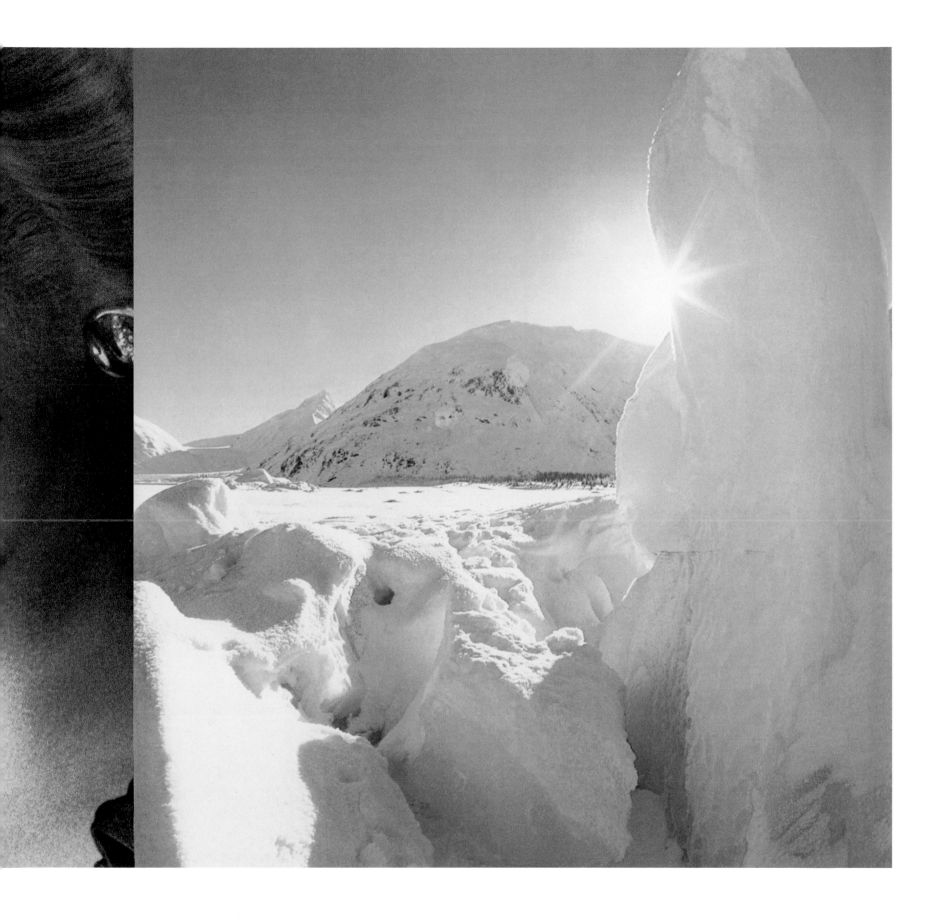

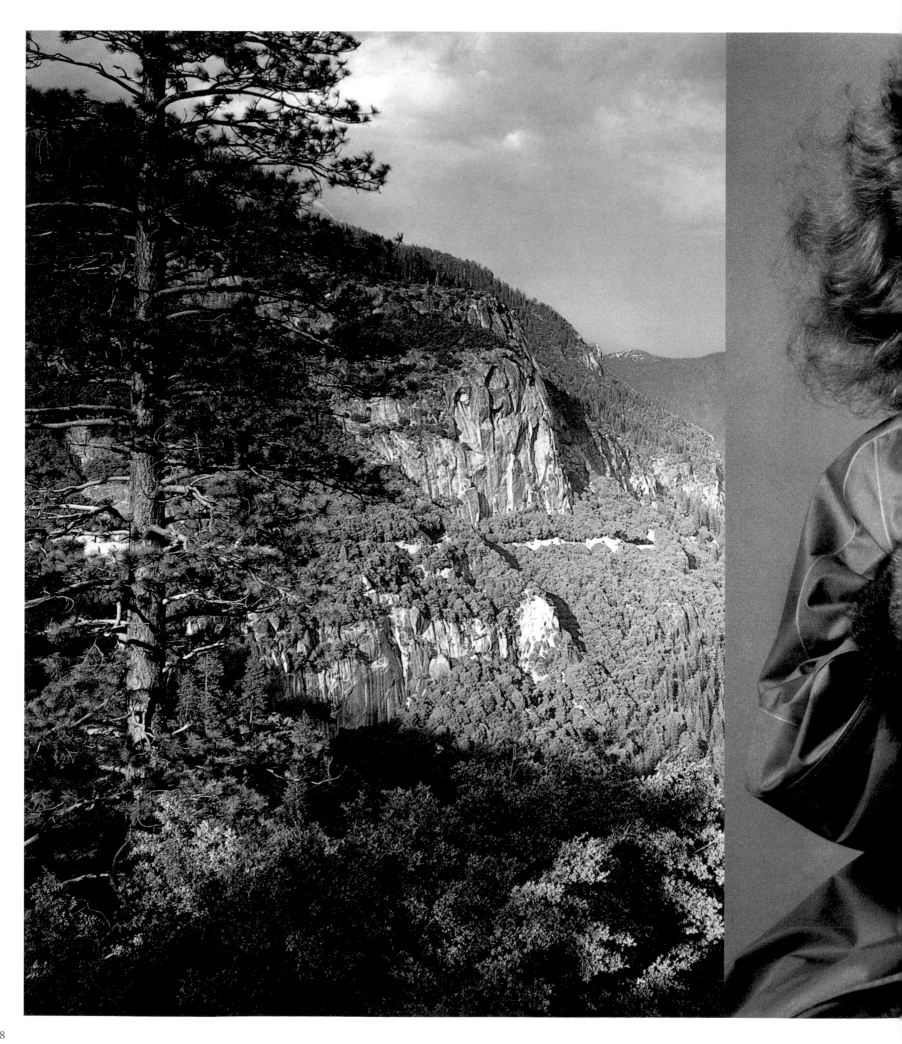

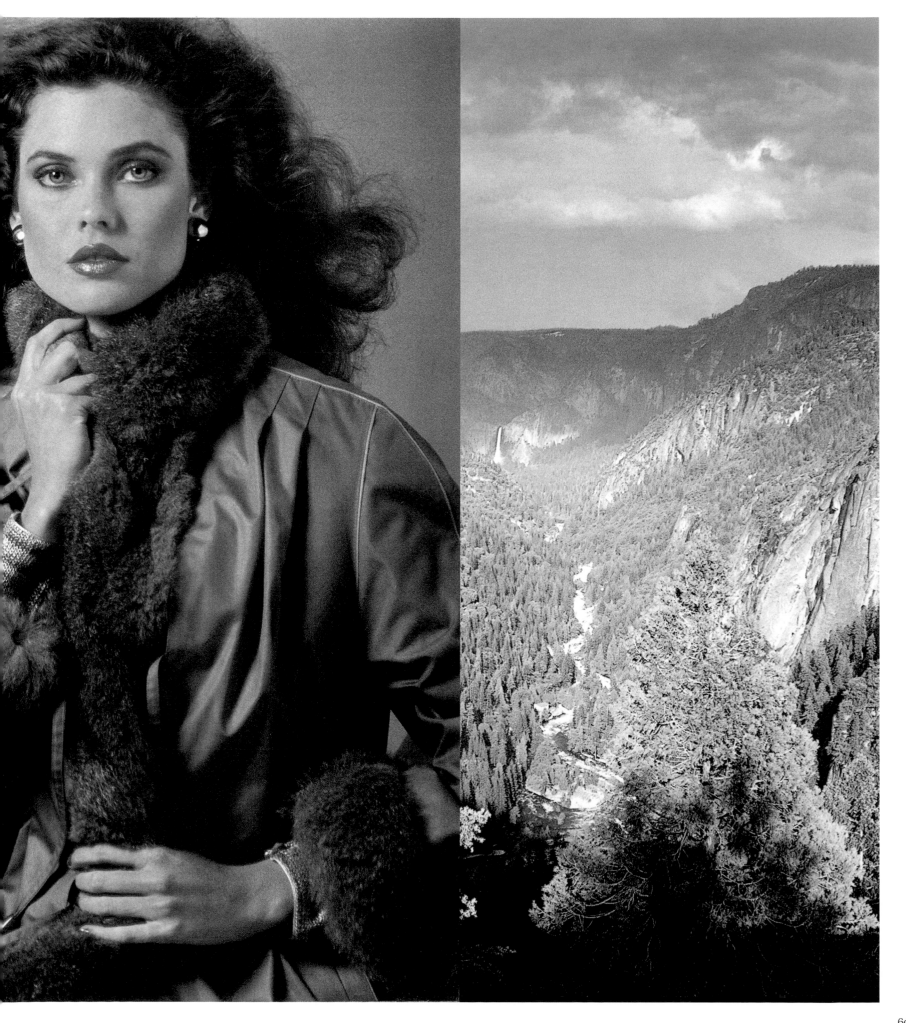

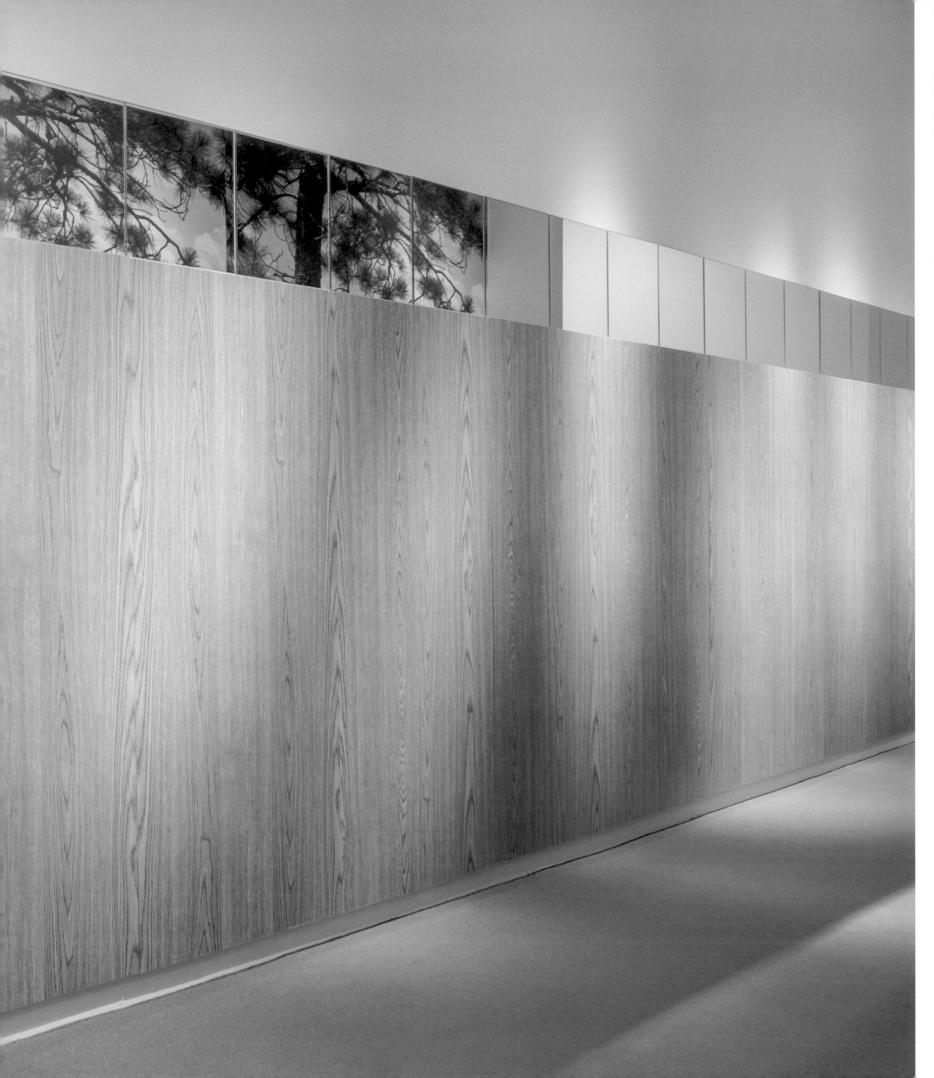

Allegory and Paradox in Vikky Alexander's "Nature"
Nancy Tousley

Four words — *Between Dreaming and Living* — aptly describe the space in which Vikky Alexander positions her work and her viewers. It is the space of the waking dream. The twelve atmospheric images in this series of mid-1980s montages meld alluring models or model couples with oneiric landscapes in romantic fantasies born of advertising, so that our relationships to each other and to nature are seen through the simulations of contemporary consumer culture. Nature is now, at our alienating remove, artificial — a generative idea Alexander has addressed in her work from the 1980s to the present. A seemingly inevitable invention of culture, product of the overarching technical apparatus that philosopher and literary critic Walter Benjamin referred to as "other nature" or "second nature," its pervasive socioeconomic presence circulates through mechanical reproduction and the digital ether.[1] It is an urban phenomenon. We absorb artificial nature or simulations of nature through newspapers, magazines, billboards, TV, film and the internet as well as in theme parks, decorated interiors and the confines of non-places we simply pass through such as superstores, waiting rooms, hotel rooms, shopping malls and airports. The cultural presence of artificial nature is seen in fashion, art, decorative arts, popular culture and the windows of shops.

Artificial nature is a decoy, a collective wish image that attempts to obscure our lack of connection to nature with dreamlike illusions, phantasms of the natural world. With Benjamin's *Arcades Project* (1927–40) as a touchstone, Alexander addresses the ways in which nature, presented as a hollowed-out commodity on display, affects how we think and live.[2] She embodies the viewer, in the gap opened by allegory between signs and their referents, as a conscious figure suspended between desire and the inability to fulfill it.

The ever-growing transformation of nature into culture in the expanding image world of the 1980s was felt acutely by a number of artists working in North America. Artificial nature appears early in Alexander's oeuvre in appropriation works made in that decade in which she was associated with artists of the Pictures Generation.[3] In two triptychs from 1982, *Yosemite* and *Portage Glacier*, Alexander placed the photograph of a fashion model, detached from any accompanying text, between the two halves of a majestic landscape. To fill the split in a valley view of *Yosemite,* she chose the image of a glamorous brunette in a fur-trimmed leather coat that was its equal in visual weight. In like manner, in the snowy wastes of *Portage Glacier*, she placed a profile view of the half-lit face of a serenely seductive blonde at the centre of the triptych, which suggested a visual route, or portage, across the two halves of the landscape. Alexander rephotographed the models from magazine pages and the landscape views from picture calendars. In the way that she re-presented them and in their new context as art, their images, already encoded via their origins in the fashion world, took on additional layers of association.

Yosemite and *Portage Glacier* draw on iconic subjects of sublime painting and photographs of the wilderness dating from the exploration era of the nineteenth century. However, Alexander revises these and other references behind the two triptychs. The construction of the montage with each model's image set into a divided landscape suggests a revision of the Romantic tradition of painting in which

OPPOSITE: Installation view of *Lake in the Woods*, 1986, at the Vancouver Art Gallery, Vancouver, 2008
OVERLEAF: Installation view of *Lake in the Woods*, 1986, at Cash/Newhouse, New York, 1986

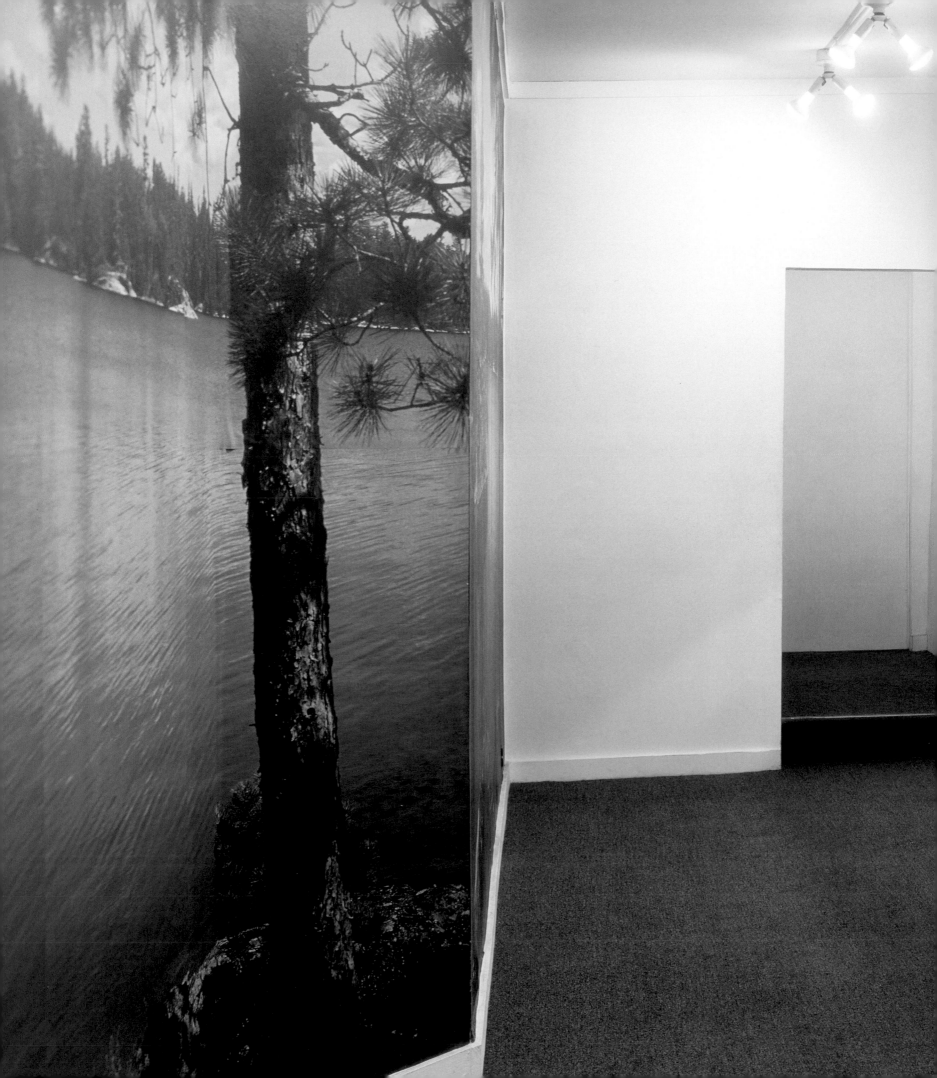

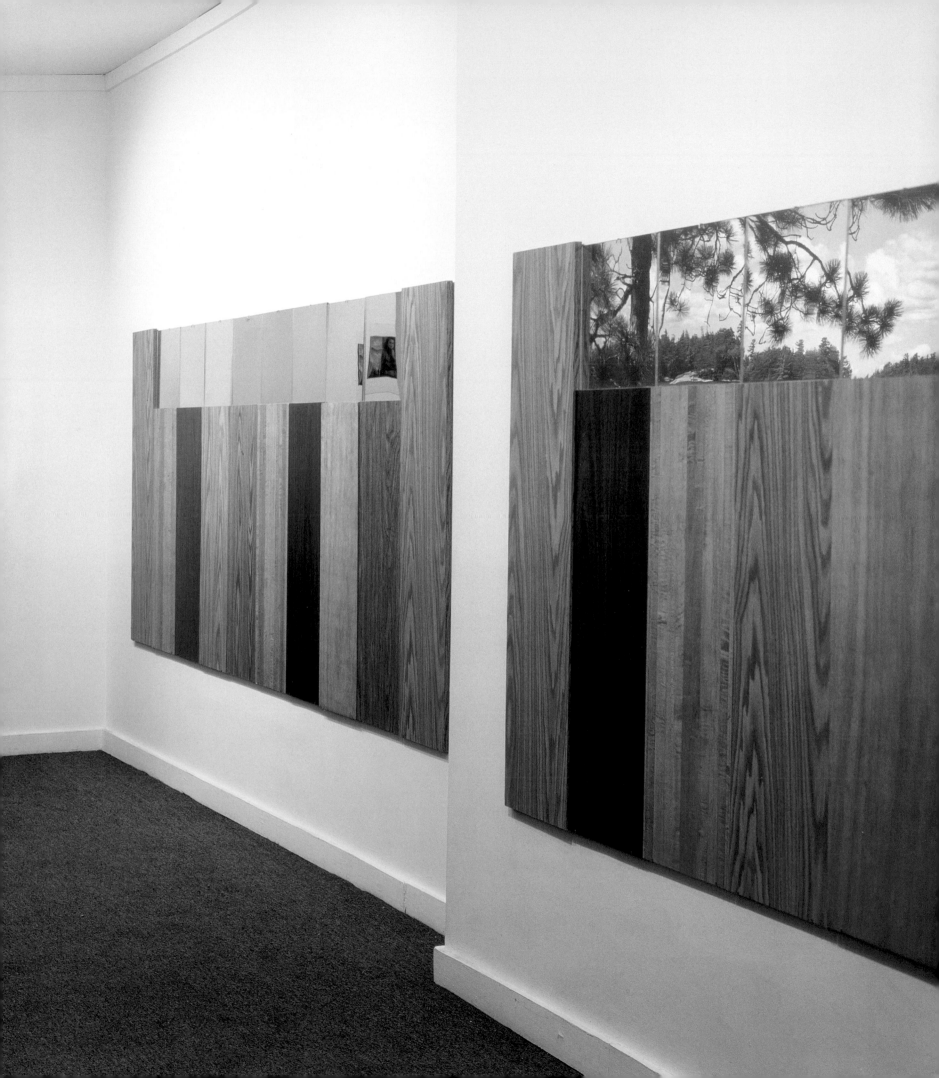

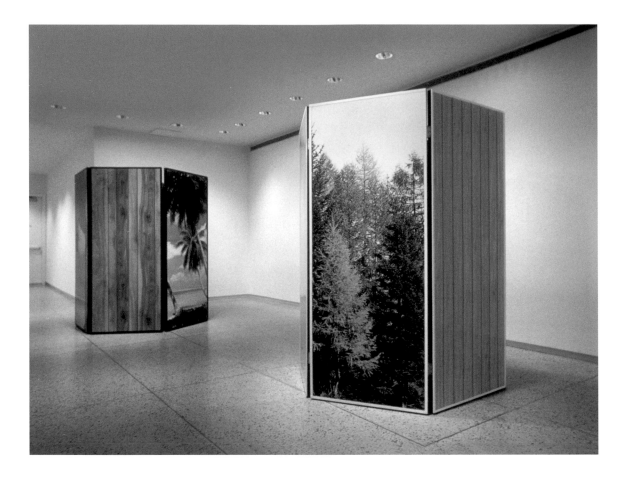

a figure, small and alone, is set against nature's awe-inspiring vastness. Reduced and fragmented, nature flanks but can no longer contain the model and both are represented as commodities. The fashion model's goddess-like appearance could be an object of male pleasure, referring to Laura Mulvey's theory of the male gaze, but it attracts the desiring female gaze as well.[4] The tripartite form of the montage alludes to the medieval altarpiece, with a sacred icon at the centre and two side panels. Here, however, worship is a secular devotion focused on commodities, objects of desire and the appurtenances they imply: beauty, wealth, luxury, the good life, connection to nature and so on. To visualize either landscape as a whole, it is necessary to ignore the central image, which is all but impossible to do. The subtext of these works is how culture affects nature — it fragments and distorts our view of it, separates us from it and renders it familiar yet exotic or strange and ungraspable as an entity.

The long horizontal installation *Lake in the Woods* (1986), made four years later, displays a major shift in Alexander's attention from the figures of appropriated imagery to images without figures that give rise to an embodied viewer, accompanied by a significant change in her materials and methods. This seminal work is constructed so that panels face each other to create a passage through which its viewers walk. On one side is a scenic panorama of an idyllic tree-lined lake, made of two spliced scenic murals. Opposite the panorama

are two shorter, discrete sections of woodgrain composition board shelving arranged vertically in a fencelike row. Atop the vertical panels are square mirror tiles that bisect the landscape and reflect the viewer standing amidst the work. When the viewer approaches the mirrors close up, she sees herself and the mural landscape behind her. She becomes the figure in the landscape, or more precisely, the figure displaced within it by virtue of the otherness of her mirror image and the installation's address to the body. If she turns toward the panorama, its large-scale presence invites her to feel as if she could walk into it, while the confining passageway exerts some pressure to do so. However, the illusionistic depth of the scene is nothing more than a surface effect on a solid wall. On the other side of the passage, the image-fracturing mirrors, which Alexander also uses here for the first time, offer a deeper spatial illusion of what lies behind her, but the hoarding-like woodgrain panels present a visual barrier to imaginative entry. The viewer stands marooned in the in-between.

While the female figures in the appropriation-based series *Between Dreaming & Living* (1985–86) are suspended in the atmospheric layers of a dream world, in *Lake in the Woods*, Alexander puts the viewer inside the work physically, but limits imaginative and psychic access to what it represents. "The true method of making things present is to represent them in our space (not to represent ourselves in their space)," Benjamin writes in the *Arcades Project*.[5] The viewer completes

Installation view of *Interior Pavilion #1* and *#3*, 1988, at the Whitney Museum of American Art, Downtown at Federal Reserve Plaza, New York, 1989

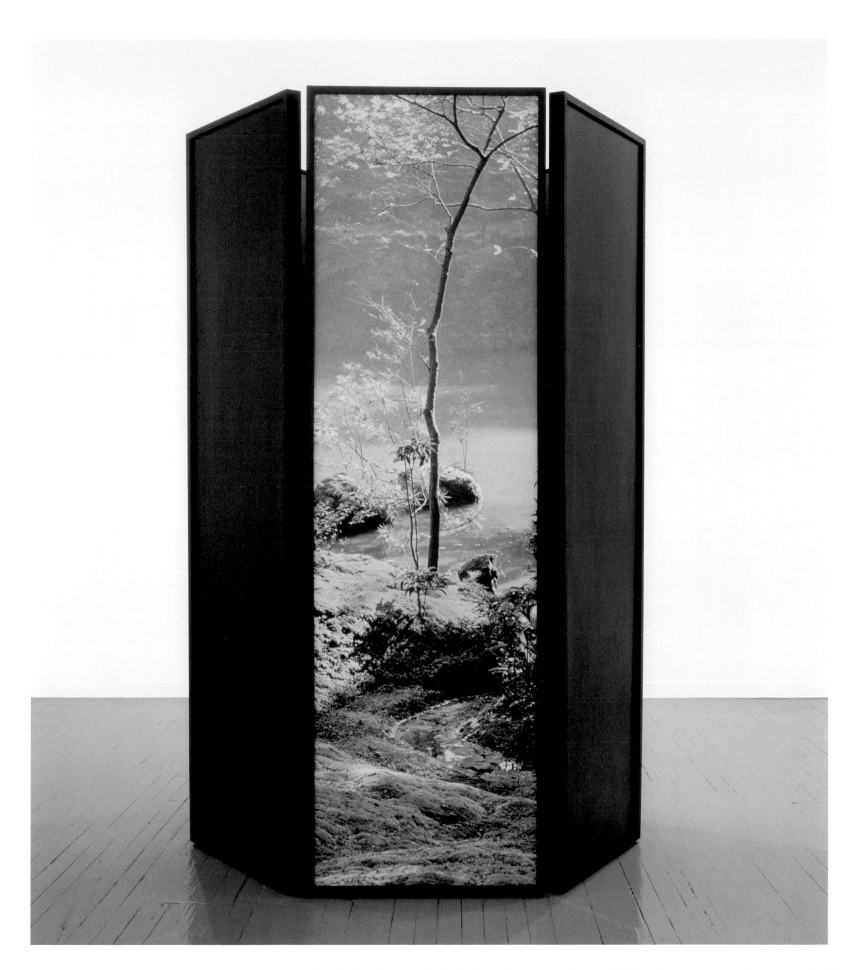

ABOVE: *Interior Pavilion #4*, 1989, birch plywood, photographic mural, 6 hinged panels, 213.4 × 63.5 × 4.4 cm (each)
OVERLEAF: Installation view of *Autumn/Spring*, 1997, at the Pittsburgh Center for the Arts, Pittsburgh, 1997

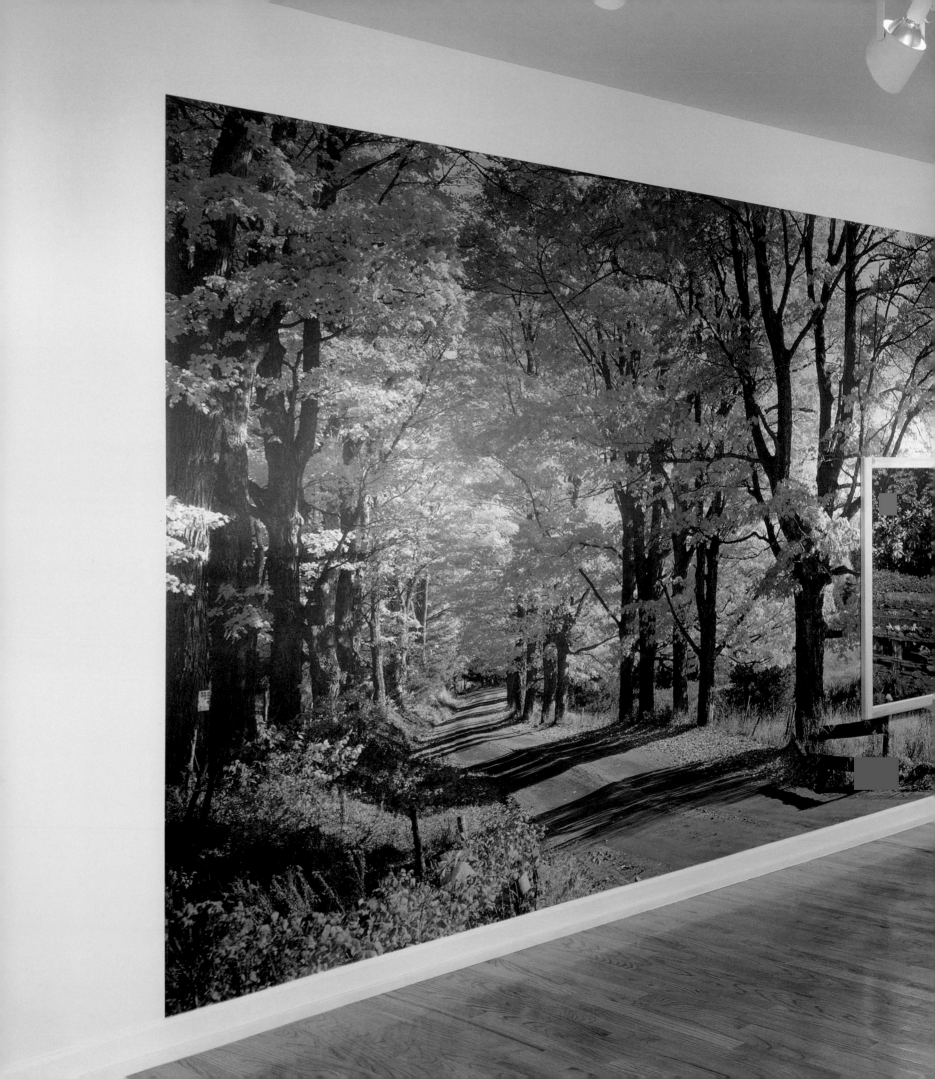

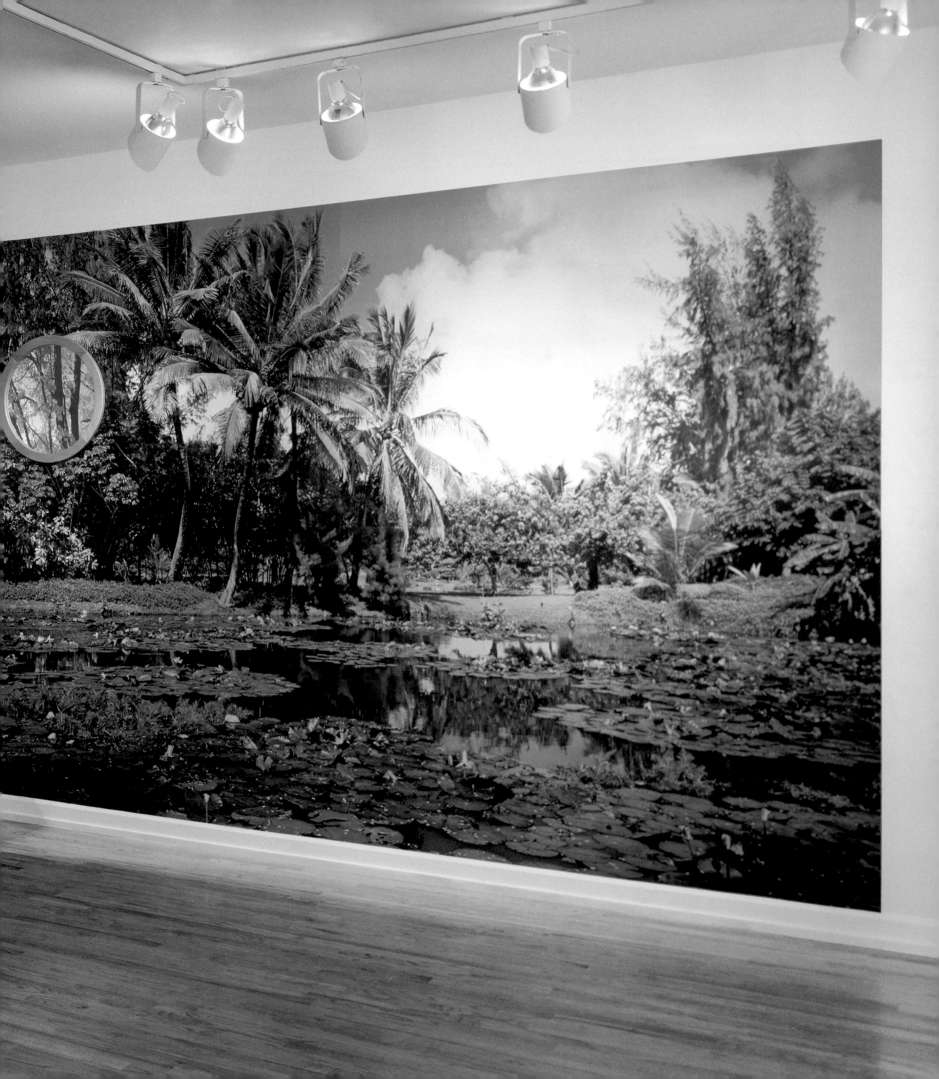

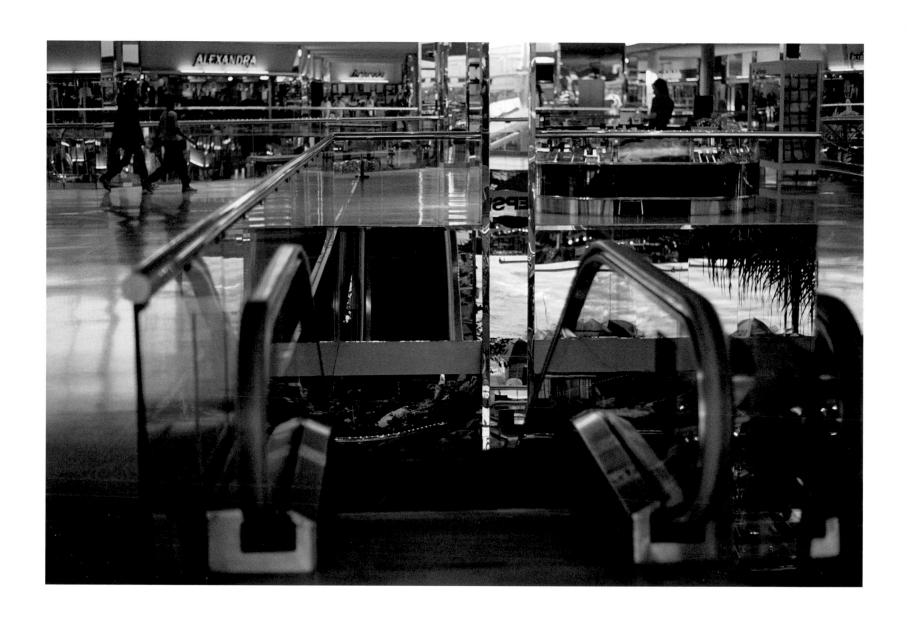

West Edmonton Mall #1, 1990, chromogenic print, 50.8 × 61.0 cm

the work through the one-to-one relationship to her body as she awakens to the false promises of the scene. *Interior Pavilion #4* (1989) fulfills this proposition even more directly. One of a series of four, it transforms the elements of *Lake in the Woods* — scenic mural and fake woodgrain — in a standalone hexagonal object. Outward-facing panels in these patterns and materials alternate to form the sculpture, with allusions to picture windows, Parisian kiosks, Dan Graham's utopic glass pavilions and perhaps even garden follies. Unlike Graham's pavilions, however, Alexander's cannot be entered. She designed them to be indoor sculptures meant to provide respite, the ultimate "staycation," to urban apartment dwellers.[6] With changing images, they could transport their viewers to a mountain valley (#3), to the mountains (#2) or to a tropical beach (#1). Theoretically, a collector could choose a standard view or even interchange vistas at will. In each case, however, Alexander arranged the panels cut from the scenic murals out of order. There is no complete landscape view, only fragments seen in slices as though through openings in a hoarding or wall.

Alexander chooses in the scenic murals familiar images of simulated nature that enlarge upon similarly constructed magazine photographs. Both come fully loaded with the manipulative visual rhetoric of advertising and marketing laid over prevailing social mores. In a conversation between David Salle and James Welling, published in 1980, the artists share their liking for magazine photographs because they are "images that understand us." According to Welling, "we have to agree that images compose our preconceptions and expectations of the possible, and in that sense we are their product." Salle clarifies that to work with them, "I have to understand what they mean." The reversal was "necessary" because "what is visible in the work results from this inverted understanding."[7] This inverted understanding of images and their unspoken doubles, which has taken her in different directions from Salle and Welling, is a concept around which Alexander's thinking has evolved.

The scenic murals, although they can be considered found images, can also be spoken of within the context of mass-produced industrial products Alexander sought out, selected and purchased; in this sense, they are closer to Duchampian readymades.[8] They also offered Alexander an enlarged range of conceptual and material possibilities. Self-adhesive and adhered directly to the wall, the scenic murals are simultaneously image and object, image and commodity. Large-scale simulations of an idealized natural world represented in stock photography, they exemplify artificial nature promoted commercially as "beautiful," as able to "satisfy your love of nature," as "haven." At the same time, the woodgrain contact papers turned a thing, such as a birch plywood panel, into something it was not by adding a new and

artificial skin. Alexander thus moved away from appropriation and toward simulation and what was then termed Neo-Conceptualism, with the result that she enlarged her by now well-established interests in already-encoded imagery and the ways in which the rhetoric of representation dissembles and persuades.[9]

Lake in the Woods is the pivotal work in Alexander's oeuvre in which she turned fully to the subject of artificial nature. Here she adopted scenic murals as the sources of found photographic images and employed contact paper to simulate natural products such as wood. The *Interior Pavilion* series (1988–89) inaugurated the object-image as sculpture, followed later by the glass furniture and mirror chairs with which Alexander has invoked the domestic utopia promised by modernist design. Once she recalibrated her focus, she represented human figures only incidentally in the complex imagery of her photographs of shopping malls, theme parks and high-end shops. After she had incorporated the viewer into her work, Alexander could decide whether to embody and displace or disembody the viewer altogether, in a world of phantasms in which she paradoxically materialized the dreams and fascinations of consumerism.

The deconstruction of artificial nature was particularly fruitful territory, not only because it was conceived to manipulate and assuage the viewer but also, for the artist, because it set up the conditions for allegorical and dialectical images. As described by critic Craig Owens, allegory occurs whenever one text is read through another. "Allegorical imagery is appropriated imagery; the allegorist does not invent images but confiscates them," he writes. "He lays claim to the culturally significant, poses as its interpreter. And in his hands the image becomes something other.… He does not restore an original meaning that may have been lost or obscured; allegory is not hermeneutics. Rather, he adds another meaning to the image.… The allegorical work is synthetic; it crosses aesthetic boundaries. This confusion of genre, anticipated by Duchamp, reappears today in hybridization, in eclectic works which ostentatiously combine previously distinct art mediums."[10]

Allegory has allowed Alexander to explore more deeply, and in the larger context of everyday life, the yearning and unrequited desires that run up the dreamer's bill in consumer culture. In the large and vividly coloured installation *Autumn/Spring* (1997), she juxtaposes two large scenic murals at right angles and hangs a mirror on each one. Placed near the corner of the installation where the two murals meet at right angles, each mirror reflects the other mural, so that the blazing red-orange autumnal foliage of trees along a country road is seen as an inset in the Edenic spring scene of green sward, palm trees and a water lily–covered pond, and vice versa. The *Autumn* mirror is rectangular and positioned low enough

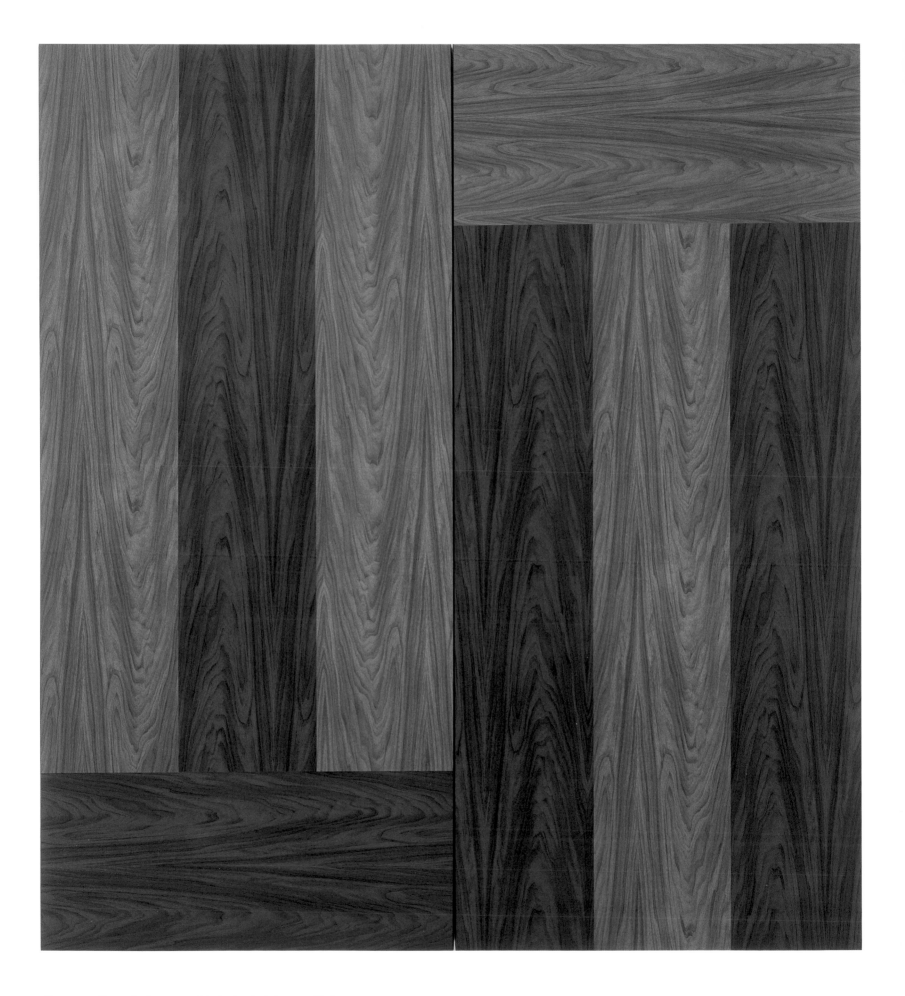

Court #2, 1987, contact paper on birch plywood, 203.2 × 182.9 × 5.1 cm

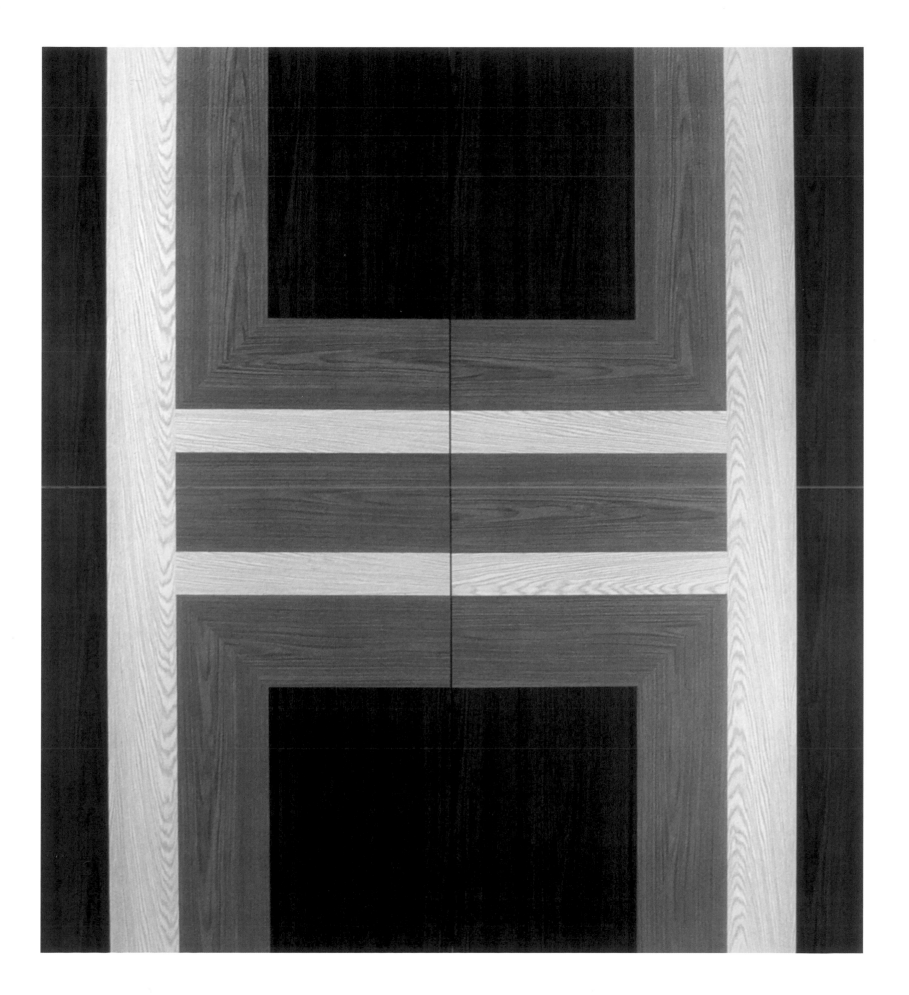

Floor #3, 1987, contact paper on birch plywood, 203.2 × 182.9 × 5.1 cm

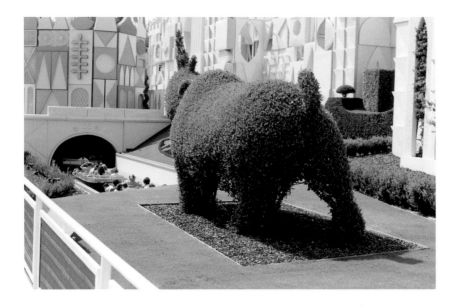

for the viewer to see herself, with *Spring* behind her, while the round *Spring* mirror is higher up, out of reach: no looking back. The mural images exalt the beauty of the seasons; however, the installation's title, juxtapositions and mirror images suggest an allegory of existential beginnings and endings, and the continuation and irreversibility of natural cycles. *Autumn/Spring* brightly delivers the allegorical message of the vanitas: life is transient, pleasure is futile and death is certain. Gather ye rosebuds. At the same time, *Autumn/Spring* alludes to the pre-industrial wallpaper decor of the great European houses of earlier centuries and to the North American suburban family room, vestiges of the past in the present, and to high-culture decorative arts and low-culture kitsch.

As an exemplar of artificial nature and the classification into which scenic murals and fake woodgrain fall, kitsch becomes an aesthetically ambiguous and more complex category in Alexander's work than might be thought. It is the linchpin, the supplement that adds meaning. In *The Artificial Kingdom*, Celeste Olalquiaga writes: "Despite appearances, kitsch is not an active commodity naively infused with the desire of a wish image, but rather a failed commodity that continually speaks of all it has ceased to be — a virtual image, existing in the impossibility of fully being. Kitsch is a time capsule with a two-way ticket to the realm of myth, the collective or individual land of dreams. Here, for a second or perhaps even a few minutes, there reigns an illusion of completeness, a universe devoid of past and future, a moment whose sheer intensity is to a large degree predicated on its very inexistence. This desperately sought moment...taints all waking experience with a deep-felt longing, as if one lived but to encounter once again this primal, archaic pleasure of total connection."[11]

The layered imagery of *Autumn/Spring* arrived readymade for allegory. This also is true of two large abstractions from 1987, *Court #2* and *Floor #3*. Their hard-edge geometric compositions are constructed from woodgrain contact paper in different colours and grain patterns. Made to hang on the wall, these objects are related to paintings. Each work plays on ideas about high art and low culture as well as authenticity and handcraft, the latter being the opposites of kitsch attributes. *Court #2* presents the two versions of a simple figure-ground exercise in positive and negative space. The T-shape on the left side of the composition is upright and darker than its background, while the inverted T on the right is light on dark. Their adjacency causes the two halves seen as a whole to become an abstract composition of dark and light interlocking shapes. The large size and verticality of this work suggest that architecture and wood veneer are potential additional references, as well as inlaid doors and floors and archaic architectural features. Again, one might imagine a great house as well as the rarified arts of parquetry and marquetry. The more elaborate geometric design of *Floor #3*, in particular, suggests the latter. Gym floors, game courts or the faux parquet floors common to high-rise apartments are also brought to mind. Art, architecture and design are all implicated, along with kitsch and popular culture, in these allegorical images of contrasts and contradiction.

The agent of allegorical representation in the scenic murals and the contact papers is, of course, photography. In *The Photographic Activity of Postmodernism*, cultural historian Douglas Crimp finds photography "to be always a representation, always already seen."[12] It speaks of the seemingly infinitely reproducible generic image, such as trees, lily pads or mountains, as readymade. Moreover, the photograph and its absent referent set out the conditions for allegory as well as for representation and its limits, be it kitsch or otherwise. Quoting Benjamin, Craig Owens writes, " 'An appreciation of the transience of things, and the concern to rescue them for eternity, is one of the strongest impulses in allegory.' And photography, we might add. As an allegorical art, then, photography would represent our desire to fix the transitory, the ephemeral, in a stable and

Disneyland, Anaheim, CA #5, 1991, chromogenic print, 41.0 × 60.3 cm

stabilizing image."[13] According to the artist Sherrie Levine, a well-known member of the Pictures Generation, whom Owens also quotes, "The desire of representation exists only insofar as it is never fulfilled, insofar as the original is always deferred. It is only in the absence of the original that representation can take place. And representation takes place because it is always already there in the world *as* representation."[14]

Photography, allegory and kitsch come together in powerful, playful and poetic ways, without irony, in Alexander's work. Is this the result of intuition or analysis, or both? She appreciates the poetry of the ephemeral and the possibility for a poetics of the commodity object; she sees the hollowness of the commodity's promises; she understands that it is human always to want what we cannot have and knows that consumer culture plays on and is fuelled by this desire. She extends this awareness in her own photography in three series of photographs of actual dissembling environments, *West Edmonton Mall* (1990), *Disneyland* (1991) and *Model Suite* (2005). In these works, which also can be read as allegories, the consumer is consumed by the phantasmagoria of the new nature present in public spaces as spectacle, entertainment and haven.

These are the environs of the waking dream. West Edmonton Mall, the contemporary corollary of Benjamin's Paris arcades, which in his words are "dream houses" and "temples of capitalism," is a huge multilevel edifice filled with commodities.[15] Alexander exposes and shatters the mall's calculating materiality by capturing the dazzling reflections and refractions bouncing off its myriad glass and mirrored surfaces. Inside this glittering Venus flytrap, it is the tiny shoppers who are consumed. Passive spectators, the very opposite of embodied viewers, consume the sights in *Disneyland* as they are moved, as if without volition, past attractions and through the theme park, by automated boats and trains. In both of these photographic series, the consumers become disembodied spectators who are all eyes.

Alexander's photographs of *Model Suite* turn to the simulation of domestic space represented by the sales model of a high-rise condo development. The model suite is a device of advertising. Although it is at ground level, the rooms are meant to give the feeling of being high up, overlooking blue water in a landscape. The views through the large windows are photographic images, like those of the scenic murals. Outside is cool, blue, remote; inside is bathed in the contrasting warmth of orange light, a refuge, a retreat into the illusory comforts of commodity. Other works, such as *Green Lake* (2006), which are collage images photographed and printed on canvas, reframe the domestic interior as a haven created by modernist art, architecture and design. In *Green Lake*, however, Alexander makes explicit as a treat the outside of the dream-world bubble, as the lake fills the floor-to-ceiling window and appears ready to engulf the room. In the impending catastrophe, she points out the failure of modernist ideals, such as the Gesamtkunstwerk, a total work of art that uses all of its forms, to achieve a domestic utopia and a new world order. But she does not discount the desire for transcendence.

Indeed, how could she? Alexander's work is animated by allegories of ineffable longing and desire. In his *L'Invitation au voyage*, the poet Charles Baudelaire imagines a dream world: "A singular country, superior to all the others, as Art is to Nature, where the latter is transformed by the dream, where it is corrected, embellished, recast."[16] Correcting, embellishing and recasting, through allegory and kitsch, nature transformed by the dream of capitalist consumerism is descriptive of Alexander's working methods. What is at stake are the ideals and desires of everyday life. Yet Alexander recasts the phantasmagoria of new nature, in her murals of 2017–19, as a seductive but openly destabilizing force. To construct these large and materially innovative works, she makes small collages from ephemeral materials such as fragments of scenic murals, woodgrain contact paper and patterned origami papers. The collages, whose shifts in internal

Model Suite: Dining Room, 2005, transmounted chromogenic print, 101.6 × 152.4 cm

83

scale among decorative patterns, woodgrain and images of nature already have an *Alice in Wonderland* surreality, are then greatly enlarged and transformed into inkjet prints on self-adhesive vinyl that mount directly onto the wall. The viewer of *Frozen Wall* (2018), *Soft Entrance* (2019) or *Teak Slice* (2019) is embodied and beckoned to enter scenes accessible only to the mind. This was true of the scenic murals Alexander chose for *Lake in the Woods* and *Autumn/Spring*. Unlike these earlier installations, however, her new images point not only to artificial nature but to new technology by suggesting a jetway or tourist skywalk. These are sleek, shiny structures embellished by images of such things as leaves and clouds that lead through an open portal with a precipitous edge to nowhere.

The waking dream that Alexander addresses has become a nightmare. Higher than a view from a condo window and seeming to float above a landscape or the tops of trees, the sharp edges of the portals are vertiginous. The tilted floor planes leading to them and the wild blue yonder pictured beyond appear to offer a thrilling possibility of transcendence. Yet almost simultaneously, they evoke the instability of this hybrid, balance-destroying space. The utopian ideal of a reunion between human beings and nature appears even further away. Artificial nature might seduce and fascinate the embodied viewer, who it has to be said is also a consumer, but this is a deception made in order to camouflage the perils of our present condition. Consumption is insatiable. We could fall over the edge reaching out for more.

NOTES

1 Susan Buck-Morss, *The Dialectics of Seeing: Walter Benjamin and the Arcades Project* (Cambridge, MA; London, England: MIT Press, 1989), 418.

2 Walter Benjamin, *Arcades Project*, trans. by Howard Eiland and Kevin McLaughlin (Cambridge, MA; London, England: The Belknap Press of Harvard University Press, 1999).

3 Abigail Solomon-Godeau, "Playing in the Fields of the Image" and "Living with Contradictions: Critical Practices in the Age of Supply-Side Aesthetics," *Photography at the Dock: Essays on Photographic History, Institutions, and Practices, Media & Society 4* (Minneapolis: University of Minnesota Press, 1991), 88, 127.

 Solomon-Godeau wrote about Alexander's early appropriation work in 1982, discussing it in relation to the work of artists Barbara Kruger, Richard Prince and James Welling, to whom Alexander was married from 1982 to 1998. In 1987, in the second essay cited above, Solomon-Godeau enlarged these associations to include other artists in the Pictures Generation: Louise Lawler, Sherrie Levine, Cindy Sherman and Laurie Simmons.

 "Pictures Generation" is the name given to a loosely knit group of young artists that emerged in the United States in the 1970s and early 1980s. These artists had in common their use of images appropriated from mass media. The group name was derived from the exhibition *Pictures*, curated by critic and art historian Douglas Crimp and shown at Artists Space in New York in 1977.

4 See Laura Mulvey, "Visual Pleasure and Narrative Cinema," *Screen* 16/3 (Autumn 1975): 6–18.

5 Benjamin, *Arcades Project*, Convolute H (H2, 3), 206.

6 *Interior Pavilion #4* displays sections of another version of a lake in the woods.

7 David Salle and James Welling, "Images That Understand Us," *LAICA Journal* 27 (June–July 1980): 54.

8 Marcel Duchamp made his influential readymades with commercially available, mass-produced products such as porcelain urinals and snow shovels.

9 Gary Indiana, "A Strange Role," *Hybrid Neutral: Modes of Abstraction and the Social*, with essays by Indiana, Tricia Collins and Richard Milazzo, ex. cat. (New York: Independent Curators Incorporated, 1989), 20.

 In his essay for the catalogue, which included Alexander's *Court #2* (1987), the art critic and filmmaker wrote about the difficulty of classifying the work of the exhibition's artists: "The subsequent resurgence of conceptual work was actually more consistent with an authentic historicizing 'eye' than Neo-Expressionism was, in the sense that Neo-Conceptualism extends certain logical developments arising out of Pop, Conceptual art, and Minimalism." He goes on to say that the kind of hybrid work Collins and Milazzo chose for the exhibition had "evolved beyond the reactive ironies of earlier Neo-Conceptualism; it can be viewed in contrast to earlier forms of both abstract and representational (art), or in terms of blurred boundaries between photography, painting and sculpture (a blurring typical of the work that proceeded from Pictures theory)."

10 Craig Owens, "The Allegorical Impulse: Toward a Theory of Postmodernism," *October* 12 (Spring 1980): 69.

11 Celeste Olalquiaga, *The Artificial Kingdom: On the Kitsch Experience* (Minneapolis: University of Minnesota Press, 1998), 28.

12 Douglas Crimp, "The Photographic Activity of Postmodernism," *October* 15 (Winter 1980): 98.

13 Owens, "The Allegorical Impulse," 71.

14 Crimp, "The Photographic Activity of Postmodernism," 98–99.

15 Benjamin, *Arcades Project*, Convolute A1, 2, 37.

16 Quoted in Allen Weiss, *Mirrors of Infinity: The French Formal Garden and 17th Century Metaphysics* (New York: Princeton Architectural Press, 1995), 8.

OPPOSITE: *Green Lake*, 2006, inkjet print on canvas, 164.6 × 137.2 cm
OVERLEAF: *Heike's Room*, 2004, inkjet print on canvas, 136.5 × 217.5 × 3.0 cm

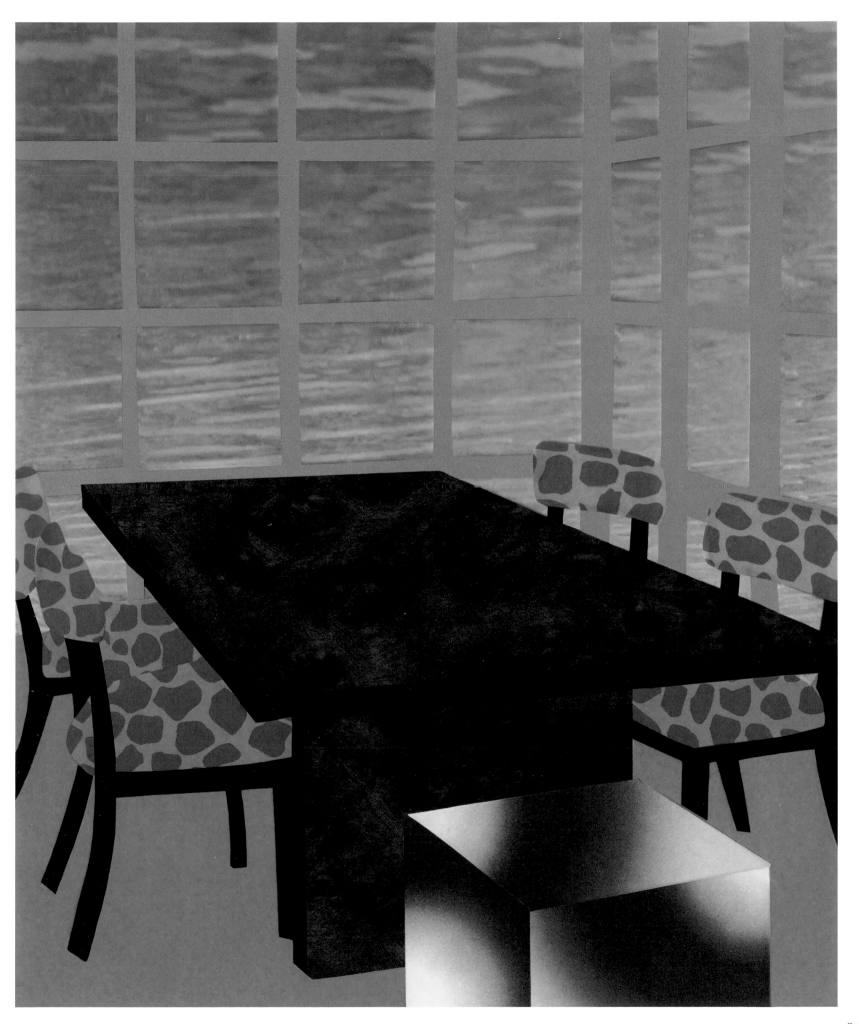

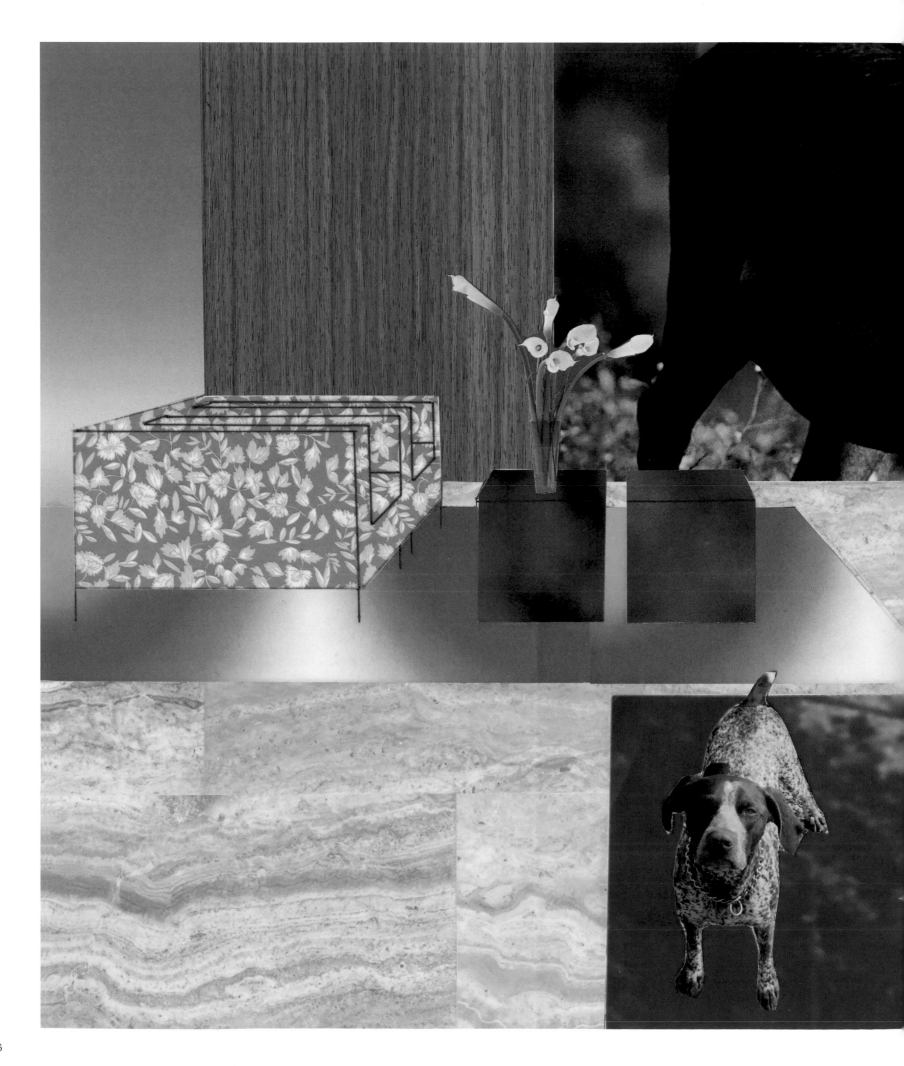

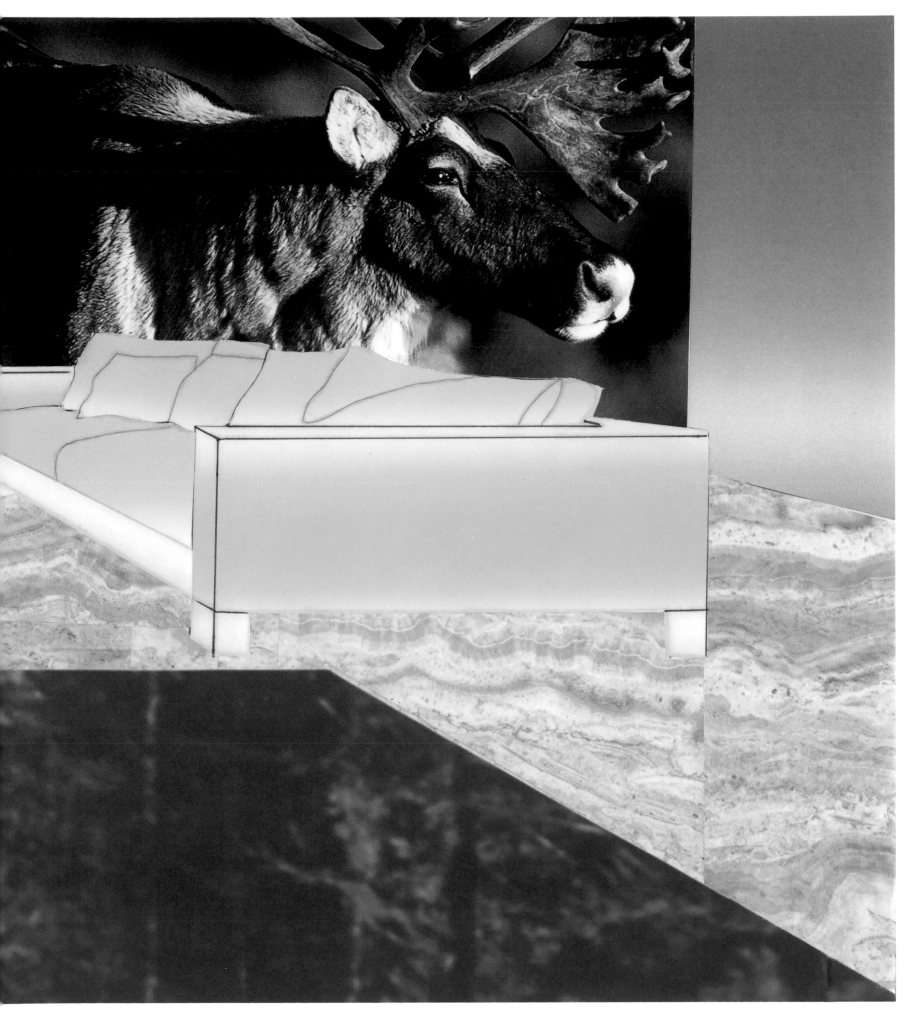

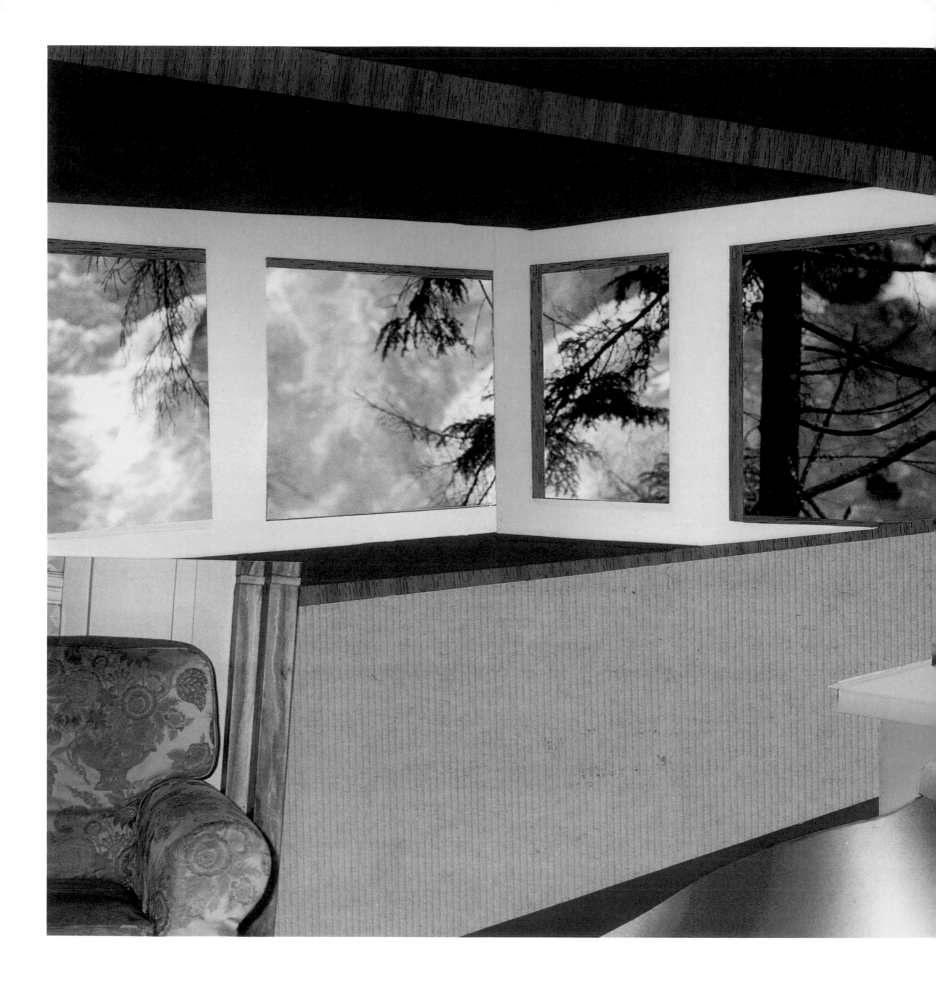

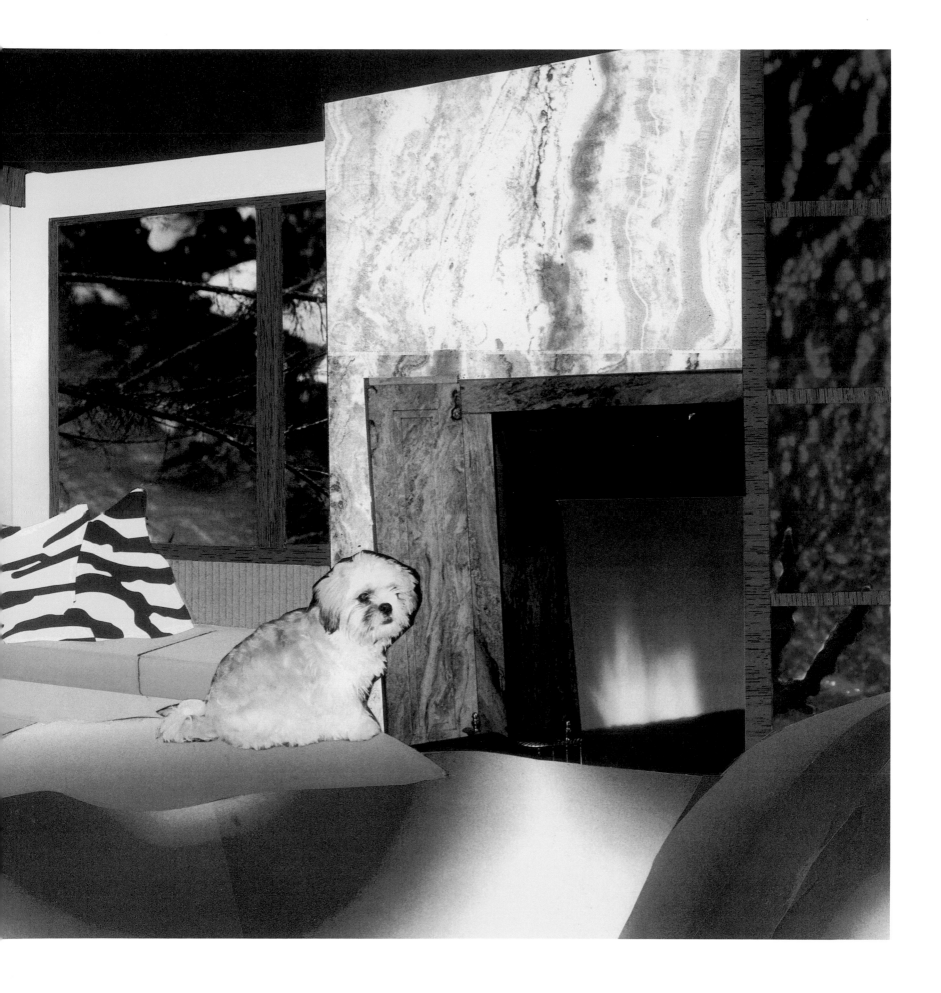

Magnus' Lair, 2004, inkjet print on canvas, 137.2 × 279.4 cm

Red Veined Floor, 2019,
inkjet print on self-adhesive vinyl, 396.2 × 562.6 cm

Teak Slice, 2019, inkjet print on self-adhesive vinyl, 750.3 × 697.2 cm

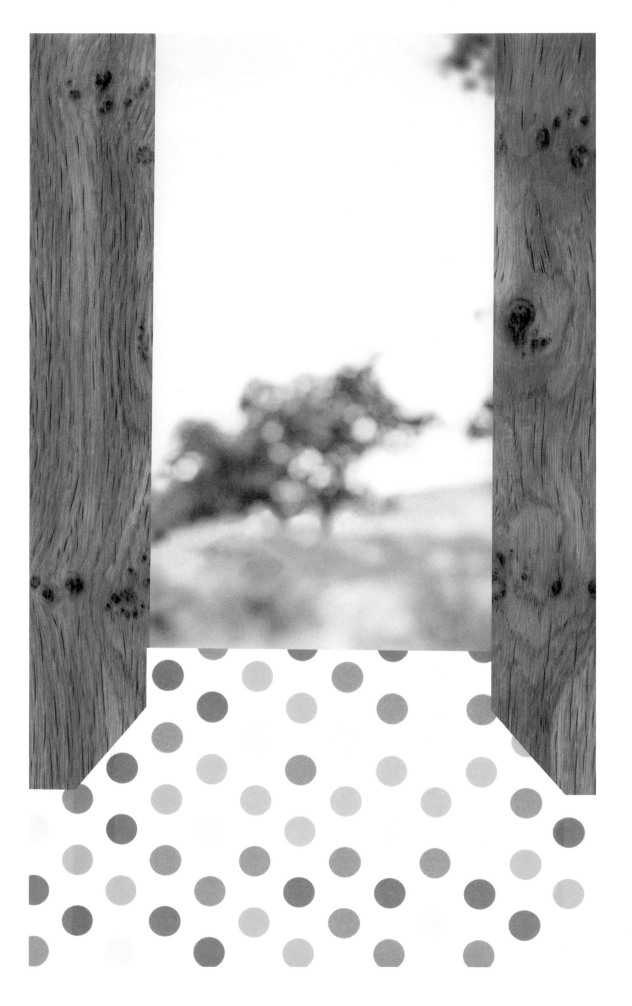

Soft Entrance, 2019, inkjet print on self-adhesive vinyl, 750.3 × 451.5 cm

OPPOSITE
Installation view of *Frozen Wall*, 2018 (LEFT) and *Soft Entrance*, 2019 (RIGHT), at the Vancouver Art Gallery, Vancouver, 2019

OVERLEAF
Installation view of *Silver Floor*, 2017 (LEFT) and *Rosy Corner*, 2018 (RIGHT), at Wilding Cran Gallery, Los Angeles, 2018

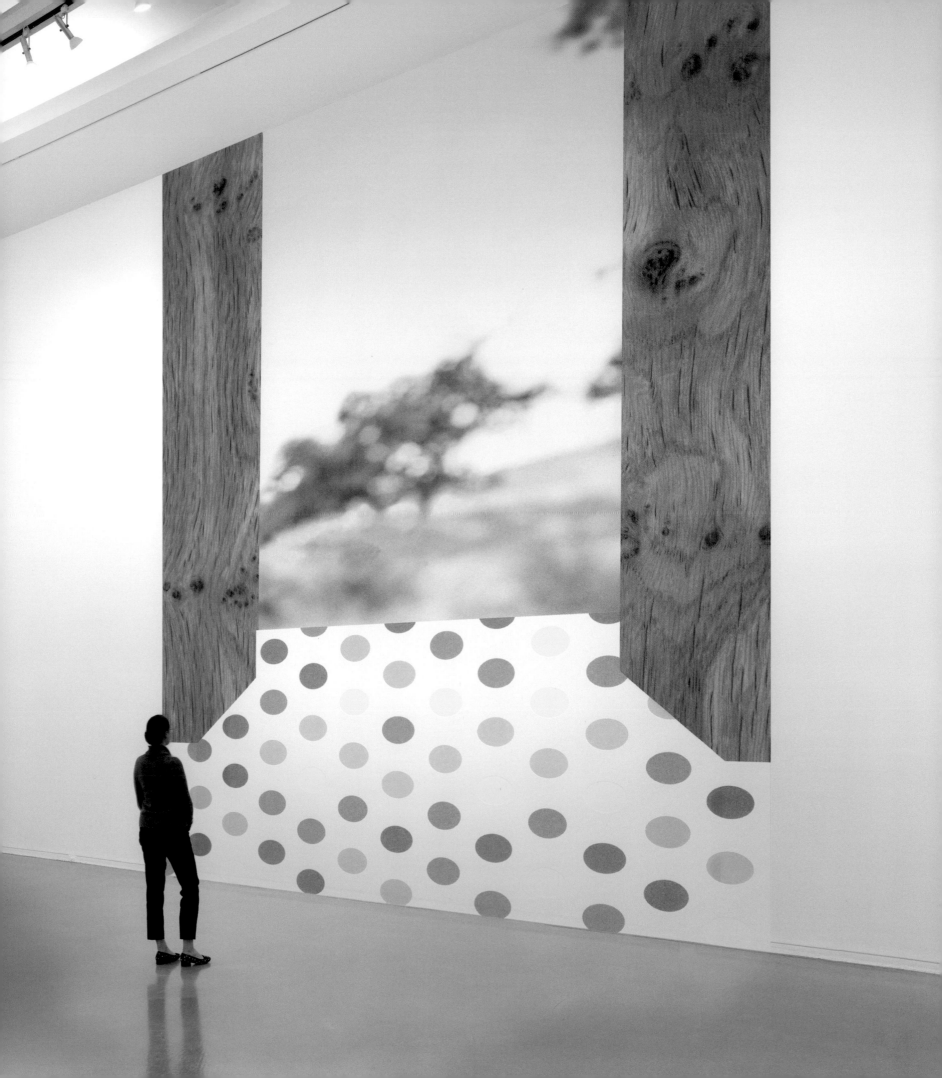

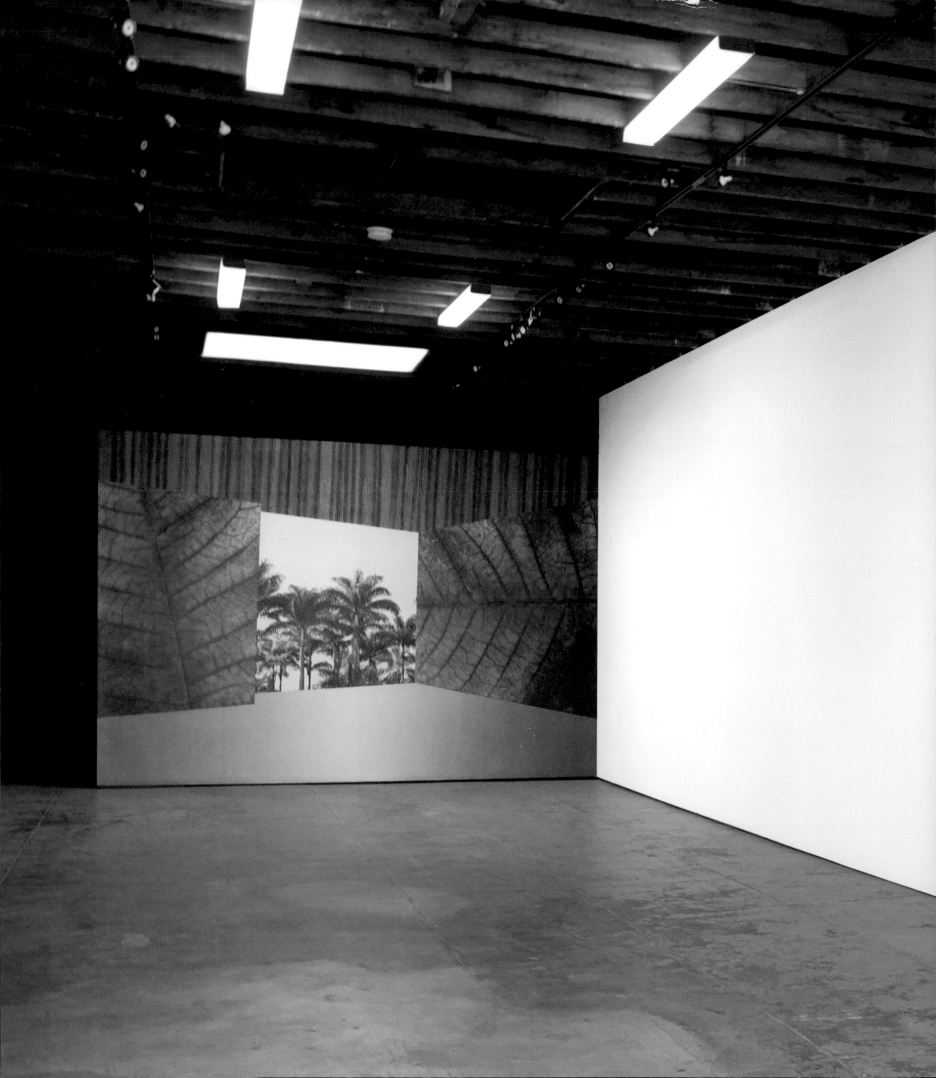

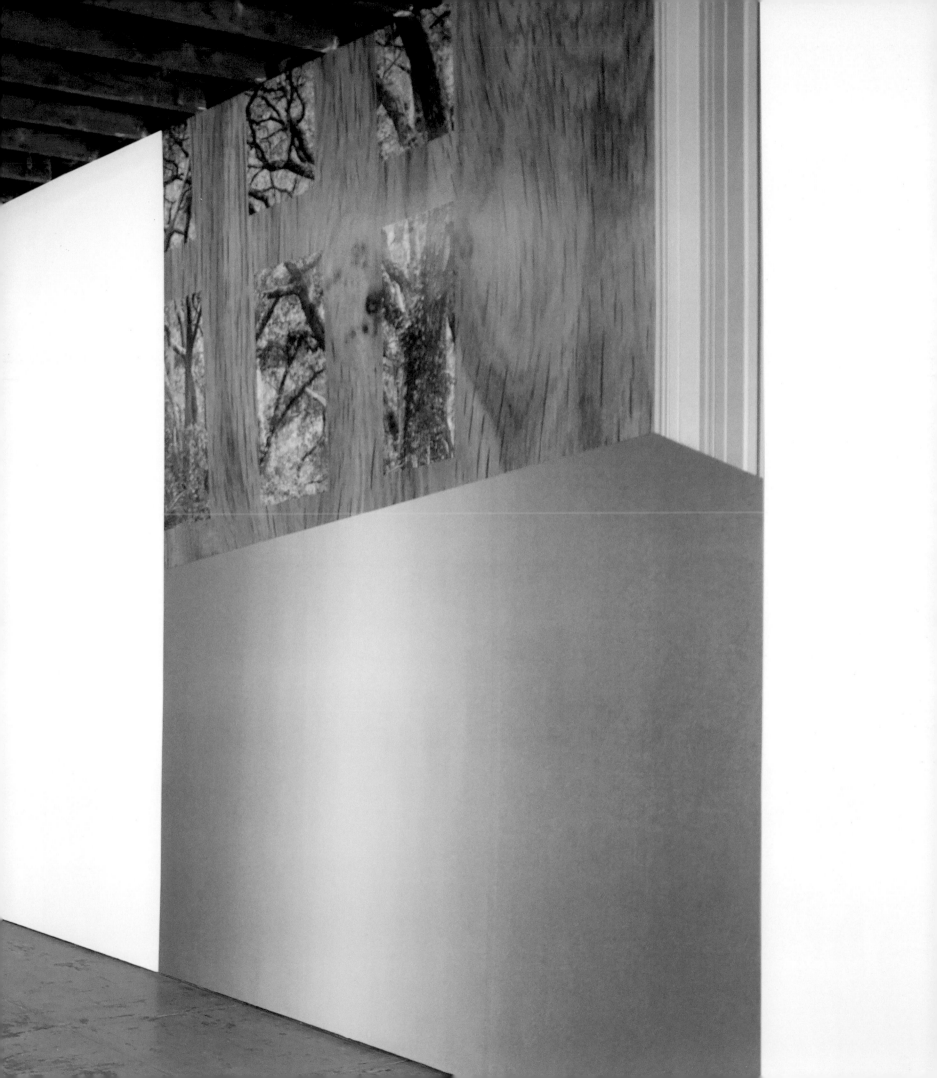

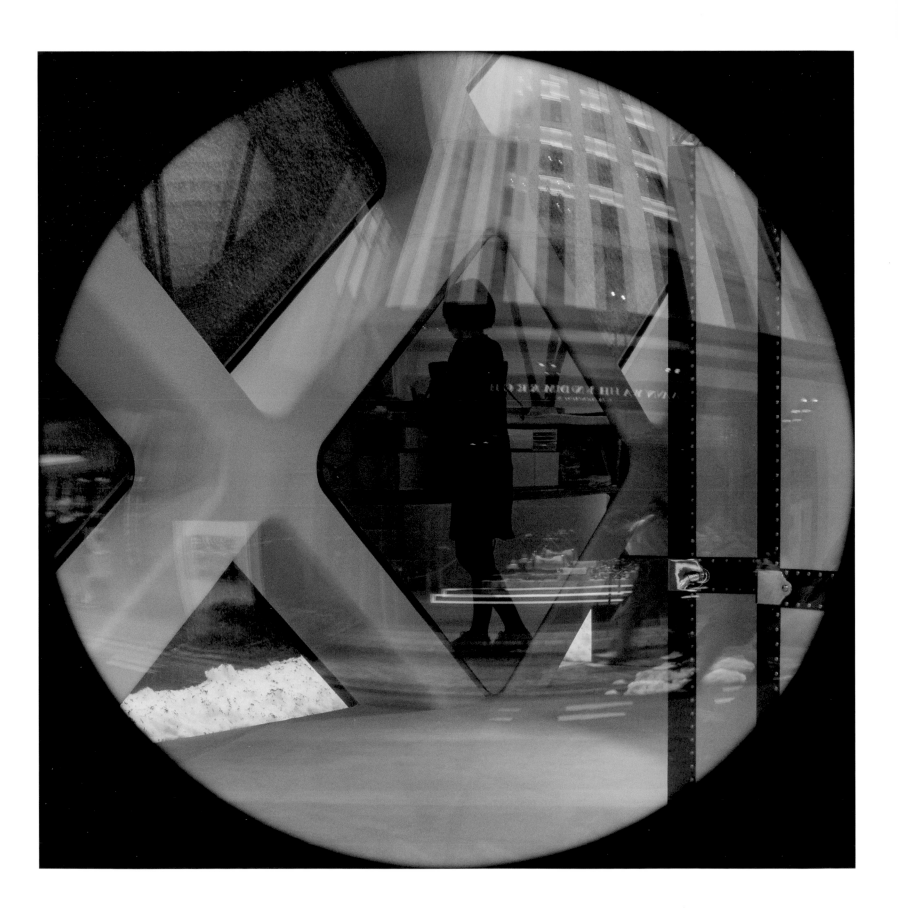

Vikky Alexander: Beyond the Seduction of Enclosures
Vincent Bonin

During the second half of the 1970s, Vikky Alexander attended the Nova Scotia College of Art and Design (NSCAD), where artist Dan Graham was among the invited faculty. In Halifax, Graham had exceptional access to video systems that allowed him to conceive several installations and performances in which his image or those of hypothetical visitors were captured by a Portapak camera and then broadcast on a monitor with a few seconds of lag.[1] The experimentation of this delay served to mark the difference between the ontology of continuous time and technological mediation. On a political level, it also announced the opening of a utopian gap in broadcast television.[2] In 1977, with *Field of Vision*, Alexander tested this apparatus for herself by placing a camera at the entrance of the Shooting Gallery in Halifax with a monitor at the end. Her exhibition was accompanied by a statement in which she said: "My definition of vision was an activity guided by the past and demonstrated in the present."[3]

A year later, Alexander started to investigate the relationship between mass media and architectural enclosures of consumption; a dialectical pair of terms that would become prominent in her work of the eighties and nineties.[4] Her installation *Viewing Space* (1978), located on the top floor of an unoccupied office building, consisted of a series of video stills taken from ABC captioned news for the hearing impaired, which were tacked directly to the room's concrete columns. Alexander underlined the building's supporting structure while these visual markers, dispersed in an almost empty space, redirected the viewers' gaze to the large windows offering a panoramic view of Halifax and its harbour. *Viewing Space* was the first project in which Alexander used the technique of rephotography. In the appropriation-based work Alexander made afterward, from the early to mid-1980s (further described in Leah Pires' essay in this volume), the interstice between the camera and the source became visible, while anchoring the fact that a female subject was taking, once more, the picture through operations such as cropping or revealing the grain of the photograph.

At the beginning of the 1980s, as many theoreticians of postmodernism turned to the study of the compression of space and time in late capitalism,[5] Alexander, like some of her interlocutors, including Dan Graham and John Knight amongst others, had identified a lingering modern taboo of the decorative in 1960s and 1970s Conceptualism.[6] Curator Brian Wallis reported that Alexander bypassed this dead-end as she extended the analytical method of Robert Venturi, Denise Scott Brown and Steven Izenour's famous 1972 study of mass architecture *Learning from Las Vegas* to address the ambivalence of design itself in the field of art.[7]

Artist and art historian Ian Wallace noted that, in parallel to her questioning of the political regimes of scopophilia,[8] Alexander also explored the rubrics of "extreme beauty" or sublime kitsch, at the confluence of the codes of minimalism and popular culture. In a transitional work, *Lake in the Woods* (1986), Alexander blurred these categories to such an extent that she took the risk of making the author function — her signature as an artist — disappear into the anonymity of the decor. She covered one of the walls of New York's Cash/Newhouse Gallery with a photomural depicting a landscape scene, similar to the type found, as a comforting visual foil, on the walls of confined spaces — offices, hospital or dentists' waiting rooms, dive bars or suburban dens. On the opposite wall, she placed simulated wood

Tokyo Showrooms: Hindmarch Prada, 2014, inkjet print, 40.6 × 40.6 cm

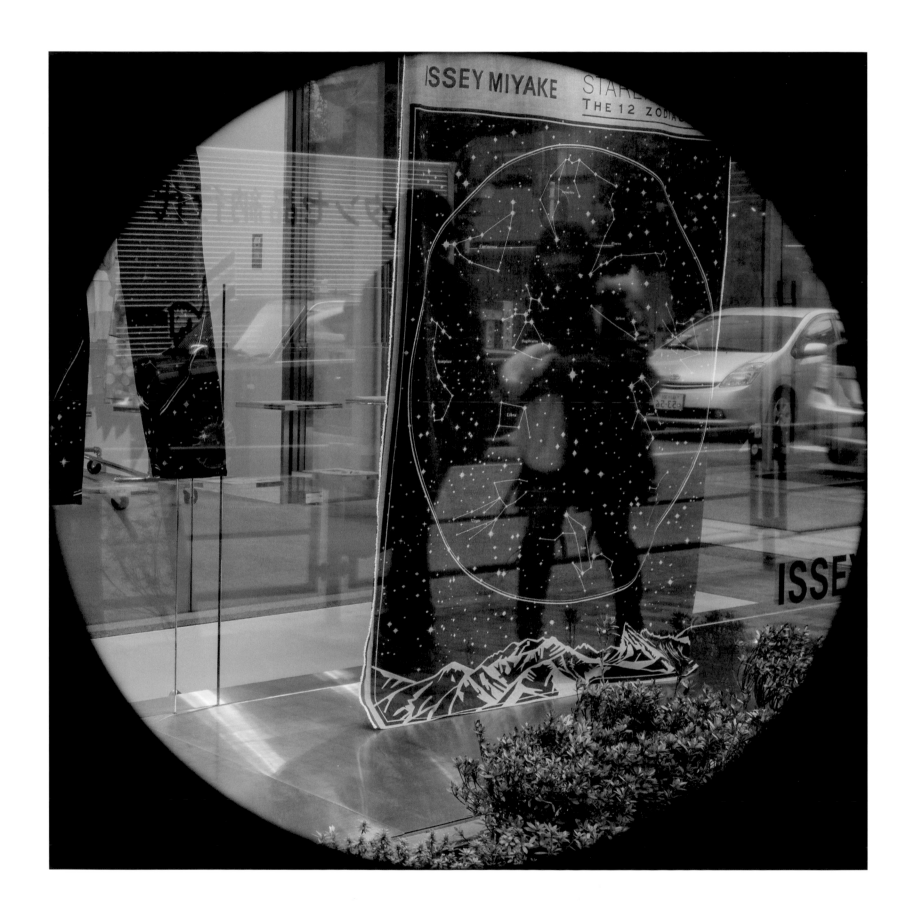

Tokyo Showrooms: Miyake Constellation, 2014, inkjet print, 40.6 × 40.6 cm

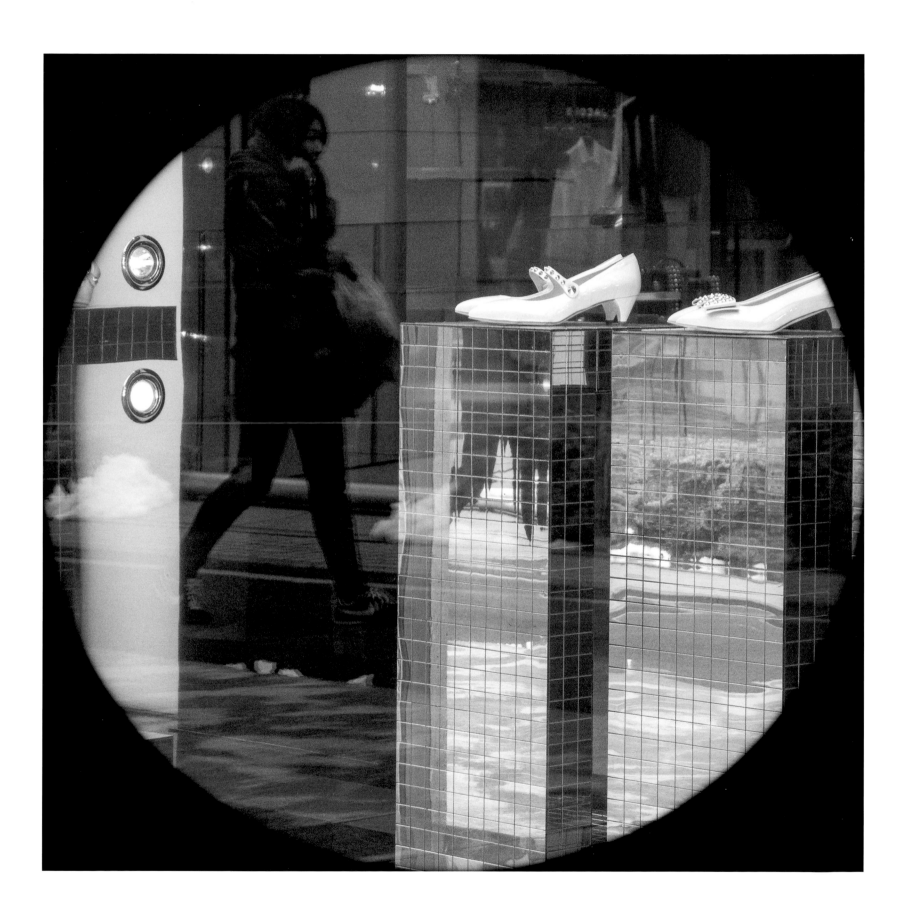

Tokyo Showrooms: White Shoes and Cellphone, 2014, inkjet print, 40.6 × 40.6 cm

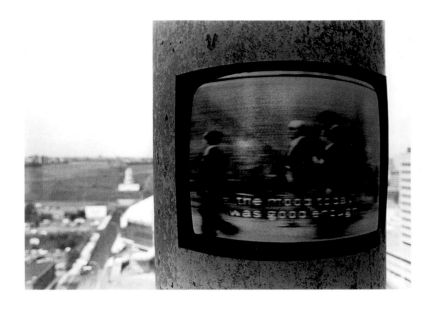

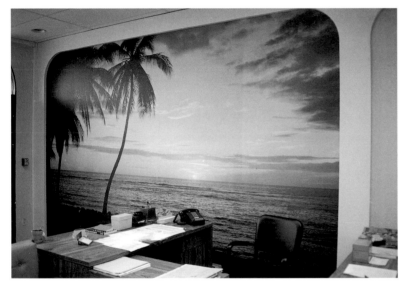

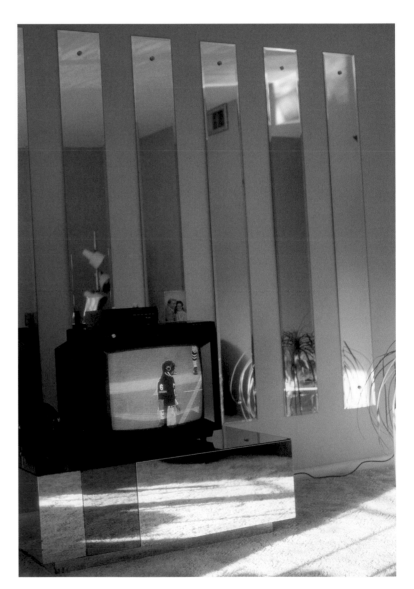

CLOCKWISE, FROM TOP LEFT

Viewing Space, site-specific installation in a vacant office building, Halifax, 1978
Condo, Naples, Florida, 1989, azo dye print, 60.9 × 40.6 cm
Fish Tank, Sun City, Florida, 1989, azo dye print, 40.6 × 60.9 cm
Real Estate Office, Naples, Florida, 1987, chromogenic print, 40.6 × 60.9 cm

panels with a band of inlaid mirrors that allowed the viewers to see details of this landscape and to glance at their reflections. Alexander explained that the idea of a bipartite scenography for *Lake in the Woods* came to her as a response to the constraints of the site itself: a long corridor flanked by zig-zagging irregular walls leading to the gallery office. Beyond accentuating the characteristics of this site, she also aimed to offer a counterbalance to figuration and heroic artistic subjectivity that dominated the market at this particular moment (Julian Schnabel, David Salle, German Neo-Expressionism, Italian Transavanguardia).[9] Alexander said that collectors passed through the gallery, seemingly without seeing anything, and walked directly to the office. Bemused, they asked the staff why there was no exhibition.[10]

As if Alexander had assimilated and diverted this phenomenology of inattention, she then undertook sculptural works that could just as easily have gone unnoticed. In the mid-1980s, while visiting Chamonix, in the French Alps, she purchased two postcards, the first depicting a snowy landscape and the second representing an anonymous attempt to carve ice furniture inside a glacier of the region. Using these postcards as source material, Alexander's initial idea was to realize furniture in ice. She later decided to instead draw axonometric[11] plans of the chairs, coffee tables and beds and had the objects fabricated in glass.[12] These almost platonic forms, evoking the clean, simple lines of early computer animations, were arranged on an ad hoc basis or in front of theatrical coloured backgrounds. Like the setup of decorative elements in the *Lake in the Woods* installation, these objects do not fit either the rubric of design or of minimalist art and, in their hybridity, they escaped as well the simple mimicry of the commodity logic in Neo-Geo sculpture in fashion at the time.[13] Moreover, Alexander pursued here the analysis of gendered representation she had begun in the early 1980s with sequences of rephotographed images of models found in the pages of magazines. But this time she almost completely abandoned the human figure and offered instead a representation of the hollow body, in absentia. It could be said that the "subject positions," which she indexed in her rephotography works, still haunted this parodic reorientation of the aspirations of minimalist artists during the 1960s to attain a zero degree of visuality. In front of a configuration

of these icy anthropomorphic residues, the viewer has just the necessary vocabulary (the bed, the bedside tables, the coffee table) to extrapolate the presence of the primary components of the petit bourgeois interior. Furthermore, when these objects blended into their surroundings in group exhibitions, they also sometimes underlined the arbitrariness of the cohabitation of the works as well as the normativity of the display strategies.

Alexander underwent another shift in her practice during a 1987 visit to Florida where she took photographs of various architectural motifs, prefiguring works to come and referring to the optical strategies put in place in her earlier installations. *Real Estate Office, Naples, Florida* (1987) segments portions of a space in which one wall is covered with a tapestry similar to the exotic landscape of *Lake in the Woods*. *Condo, Naples, Florida* (1989) shows mirrored panels on a partition in an apartment, behind a television installed on a base also covered with mirrors. In *Fish Tank, Sun City, Florida* (1989), Alexander isolated another visual trap, an aquarium in the lobby of a restaurant. Beyond offering a microcosm of marine life, the fish tank, like the mirrored panels, is a strategic visual foil used by interior decorators to redirect people's attention and cushion boredom while waiting.

Mirrors and aquariums, such as these, feature prominently in the 1990 series entitled *West Edmonton Mall*. As if the gigantic size of the shopping centre, designed in 1982 by the architectural firm of Maurice Sunderland, did not contain enough visual stimulation, reflective columns were used everywhere in the mall in order to prevent the gaze from falling on a flat surface or drifting toward the exit. Alexander framed her pictures of this space in such a way as making the perception of this panoptic strategy even more perverse so that all open portions of the sprawling building are saturated with the signs of commodity and consumption.[14] As soon as we cast our gaze somewhere, believing that we are getting out of an abyss, our eye is directed into a second reflection that reveals a new closed universe and ultimately, an abstract, unintelligible detail confused with the grain of the photograph. The tiny bodies of consumers are diminished by the architecture and visible here as a kind of negligible quantity.

In the early 1990s, when Alexander was working on her series on the West Edmonton Mall, the French anthropologist Marc Augé

OVERLEAF: Installation view of *Glass Bed with Tables*, 1988, at Kunsthalle Bern, Bern, Switzerland, 1990
Installation view of *Crystal World #1* and *#2*, 1996, at TrépanierBaer, Calgary, 1996

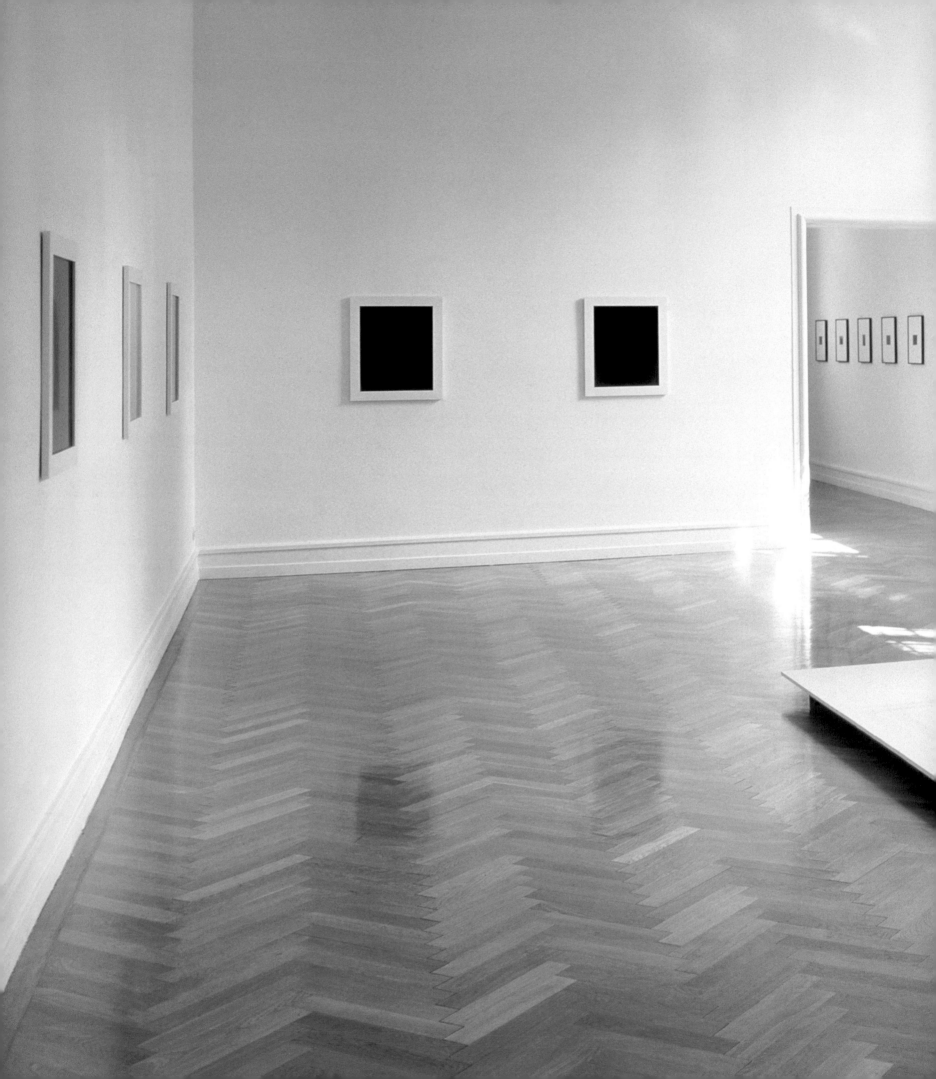

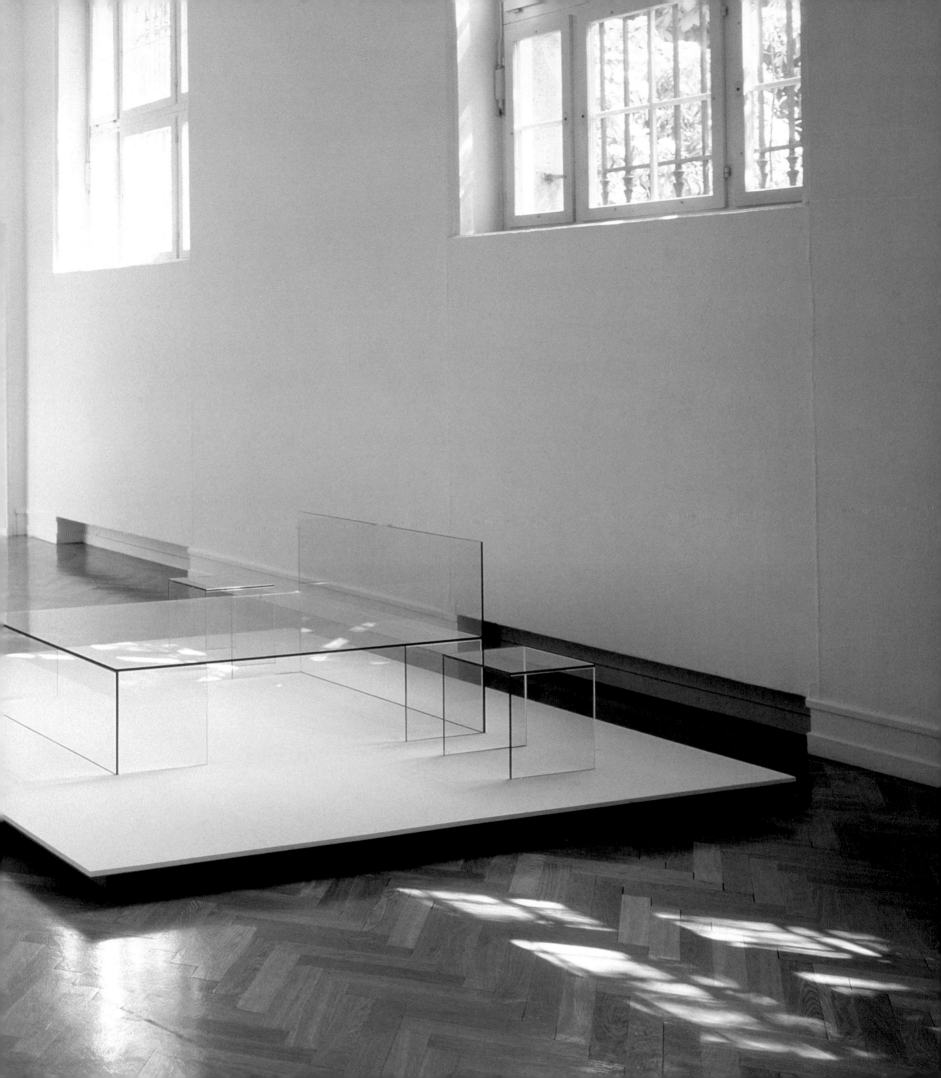

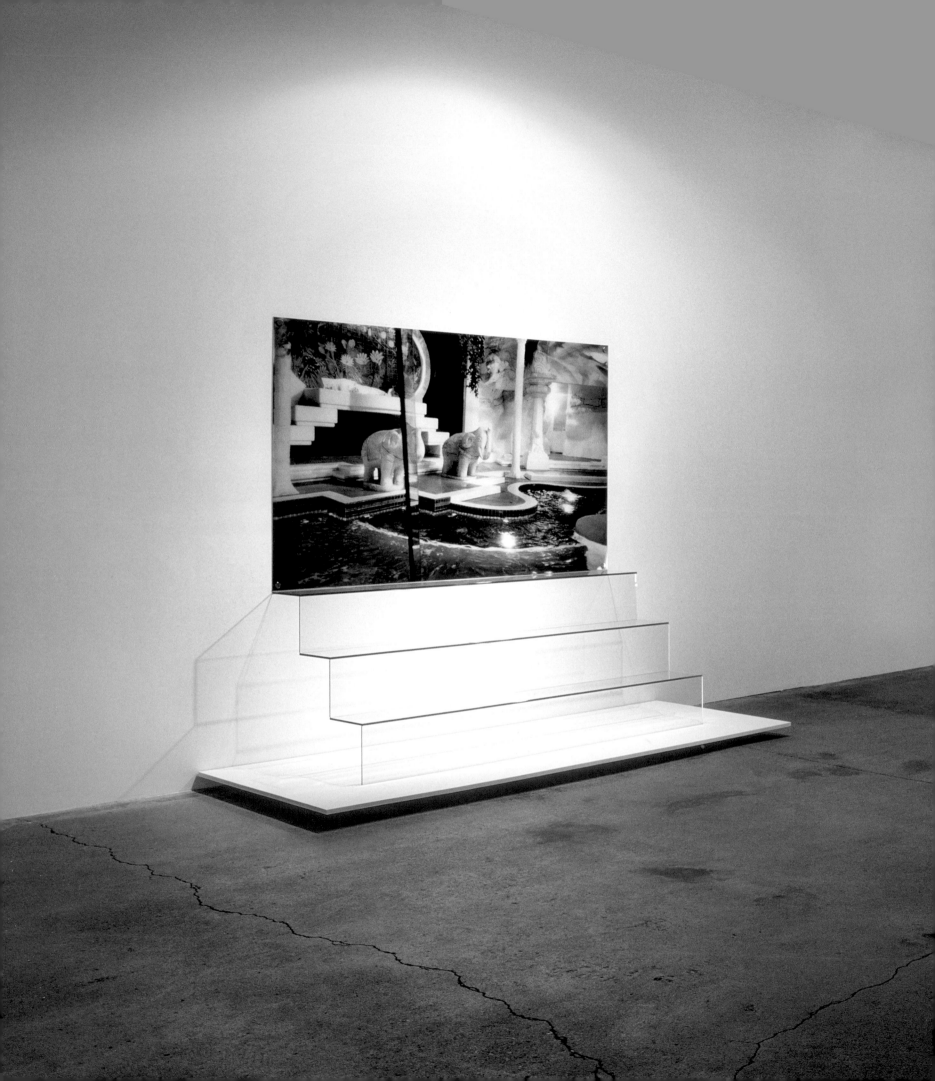

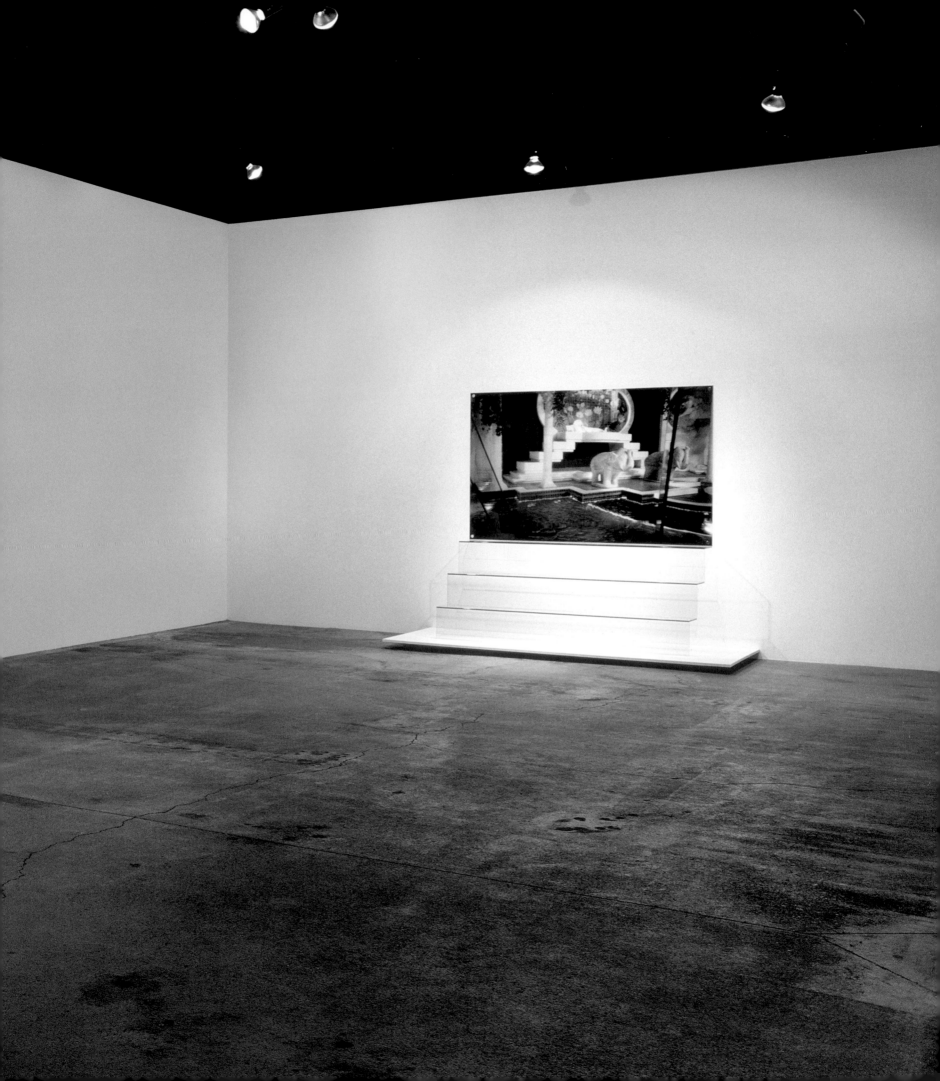

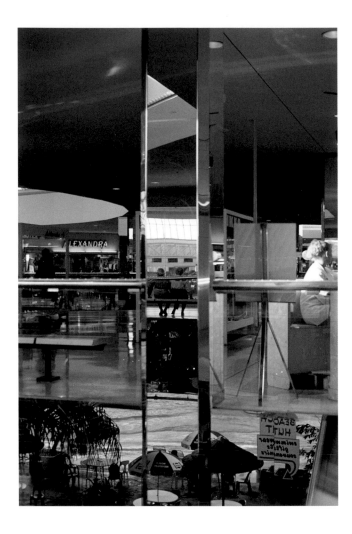

published his book *Non-Places: Introduction to an Anthropology of Supermodernity*.[15] With the methods of his discipline, Augé insisted on the transactional nature of liminality in these functionalized architectures of consumption where the consumer establishes contact with a machine or an agent — cashier or attendant — whose work is then reduced to the digital recording of goods or services exchanged for money. Conversely, other "non-places" evoked by Augé are locales on the fringe of cities such as Disneyland, Las Vegas and other touristic destinations loaded with kitsch decor that veil those depersonalized transactions. We could say that Augé described these non-places by confining himself to language, while since the *West Edmonton Mall* series, Alexander raises the problem of their photographic representation and the desire that these images generate.

In 1991, Alexander photographed Disneyland, which is in fact one of the models that inspired the integration of attractions in the West Edmonton Mall. Endowed with photogenic qualities, each portion of Disneyland was designed to be frozen in a family cliché equivalent to its representation already in circulation through advertising and the like. Alexander, on the other hand, positioned herself in small transition zones (from the top of platforms peering down, or on the side) to provide slightly remote views. They show the uncanny landscape

architecture while capturing the trajectory of visitors as they queue to enter an attraction or sit obediently on the monorail. Like the West Edmonton Mall consumers, visitors to the theme park seem to be overwhelmed by the surrounding environment, an enclosure from which they will be expelled at the end of their visit to recover their cars in the parking lot and go back to their lives.

In 1995, Alexander visited Las Vegas to make a series of photographs based on views of casinos as well as liminal areas. For a solo exhibition at TrépanierBaer gallery in Calgary (1996), two nearly identical photographs from this series (contiguous in the original sequence of the negative), entitled *Las Vegas, Royal White Tigers 1* and *2* were mounted directly on the walls. Glass modules in the form of staircases were added in front of the images. Conceived with the same axonometric technique Alexander used to make her sculptures in the 1980s, those appended framing devices alluded to some architectural features of the site and became a tridimensional extension of the space that Alexander depicted by using photographic means. Conversely, the objects also acted as guardrails, while emphasizing a detail in the images: a living tiger seemingly abandoned on a platform remote from the viewer (the motif of the interpolated animal within a man-made environment would later resurface in a series of collages

West Edmonton Mall #19, 1990, chromogenic print, 61.0 × 50.8 cm

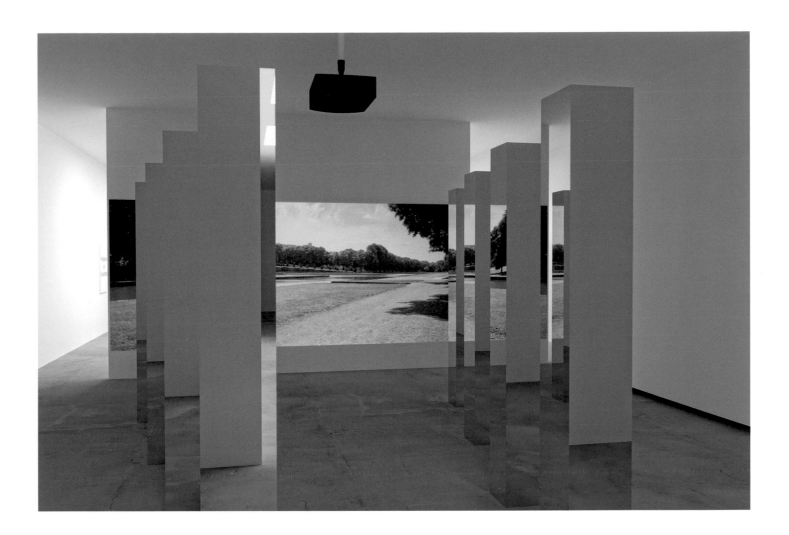

made in the 2000s). She titled the installation of the exhibition at TrépanierBaer, *Crystal World*, citing J.G. Ballard's 1966 novel of the same name chronicling, among other things, the slow transformation of vegetation and life into minerals in a forest, to which the sculptural components also referred in their inhuman form.

Like the obscure force in Ballard's novel swallowing everything in its vicinity to turn it into an allegorical figure of decay, on one hand, each of Alexander's series exacerbates our complicity with the seduction of the enclosure's saturated attractions and luxury merchandise. On the other hand, the function of these heterotopias goes beyond the rubric of luxury, as they consist mainly in placing subjects in suspension between their true economic condition and their aspiration to access the social status of another class.

Although it is possible to correlate some of Alexander's work during the 1980s and 1990s to the tautological and pessimistic thesis of Jean Baudrillard about the simulacrum,[16] her method of documenting sites while adding an affective layer to the indexicality of "being there" was much closer to a reflexive approach shared by peers such as artist Lynne Cohen, artist-writer Judith Barry or artist Louise Lawler, who are also interested in the spatial turn of post-structuralism. These artists often accessed guarded places — including private spaces and those of mass entertainment where the movement of bodies are closely monitored — without always having formal permission to photograph. By seemingly taking hold of these enclosures, the artists extended the scope of the feminist gestures of appropriation whose first aims in the early 1980s were to transgress the concept of patriarchal originality and offer a critique of modernism's trope of the author as a possessive individual.[17] Except, in this case, gaining access to the architecture, and representing it, also involved a rerouting of the gaze to produce a specific form of knowledge about dispossession and the poverty of experience.

In 1998, with the installation *Vaux-le-Vicomte Panorama* at TrépanierBaer, Alexander created a queer interior by superimposing two seemingly ideologically opposite architectural enclosures in the over-determined space of the commercial gallery. She photographed the baroque gardens of the Château de Vaux-le-Vicomte, designed by André Le Nôtre, and edited the images in a sequence cumulating anchoring points in the peregrination of the walker, a trajectory that could have been filmed rather than photographed.[18] Glancing at the projection, the viewer, who is positioned as a surrogate of this pedestrian tourist, first notices that the gardens look smaller when seen from a distance. It then becomes clear that it would take a long

ABOVE: Installation view of *Vaux-le-Vicomte Panorama*, 1998, at the Vancouver Art Gallery, Vancouver, 2019
OVERLEAF: Installation view of *Vaux-le-Vicomte Panorama*, 1998, at TrépanierBaer, Calgary, 1998

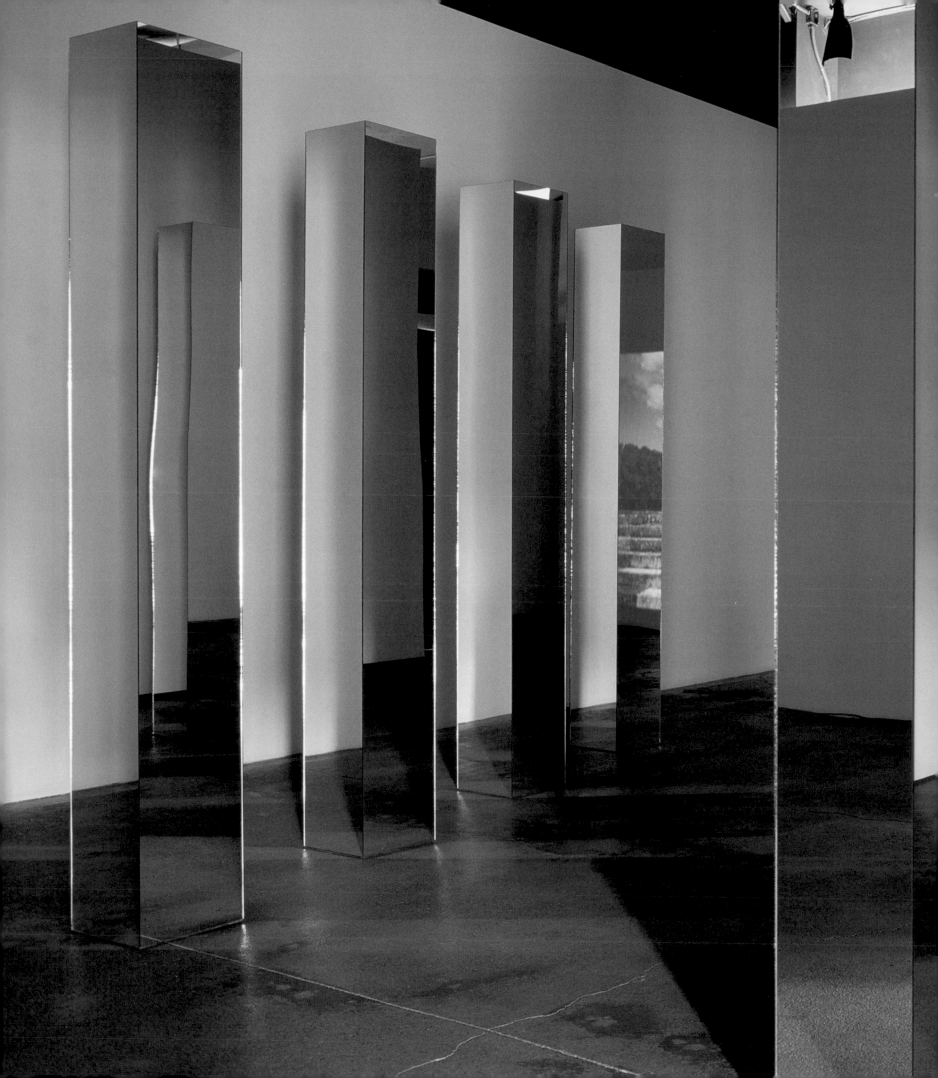

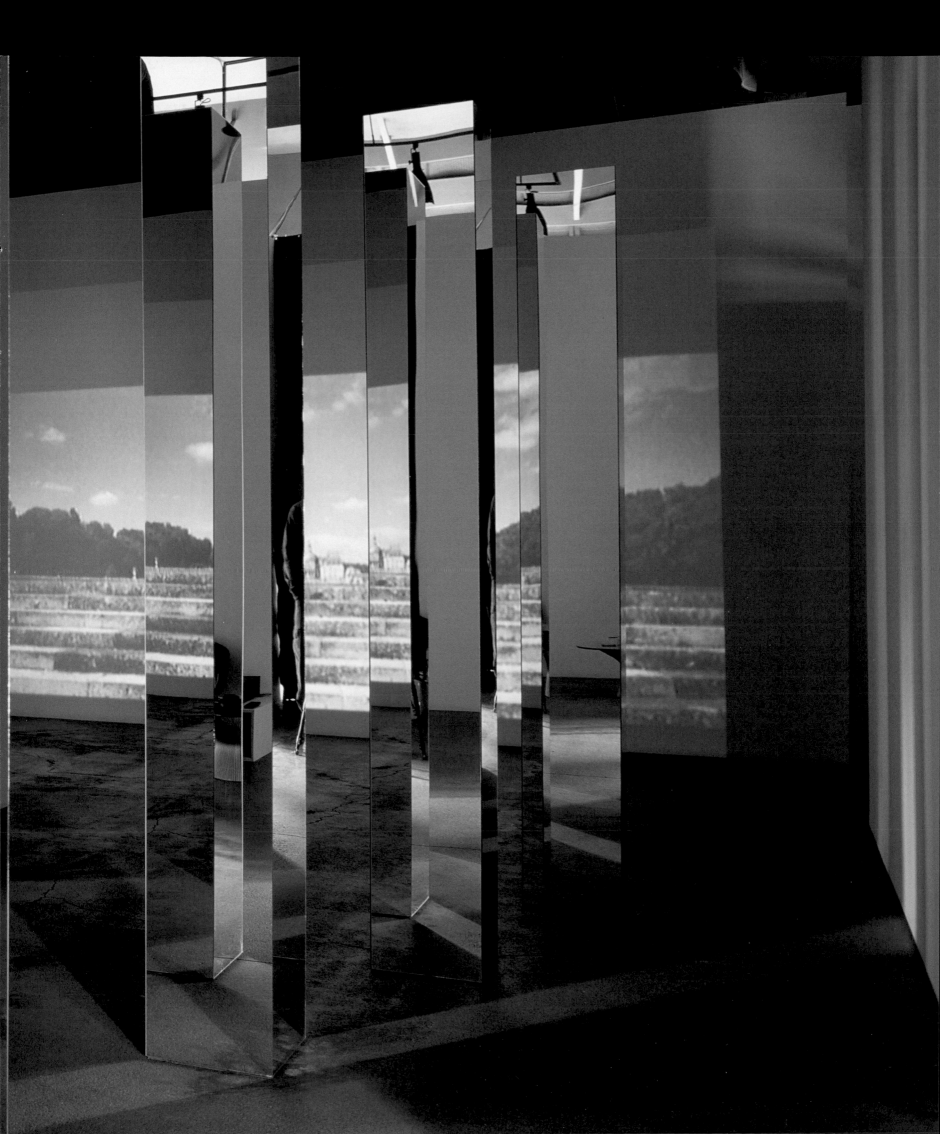

time for the walker to follow the winding paths leading to the end of the designated territory. The images of the gardens were shown in a video loop with mirrored pillars, similar to those in the West Edmonton Mall, installed before the projection so that they appear to radiate out from the wall. Alexander recently recounted how the idea of placing these mirrored pillars in a symmetrical triangular pattern came to her after she visited a gay club on Denman Street in Vancouver.[19] Unlike Le Nôtre's garden, the counter-utopia, or rather, the heterotopia of the cruising site, does not appear as an explicit referent in any of the didactic materials accompanying the work, but as ghostly architectural matter experienced at the level of the unconscious by certain viewers. Mentioning the spectral presence of this reference as backdrop helps us to understand how with the simple addition of mirrors, a given locale, here a commercial gallery, could be metamorphosed into a temporary zone of autonomy.

In 1997, one year before making the installation *Vaux-le-Vicomte Panorama*, Alexander came back to her investigation of cul-de-sac capitalism by photographing the pre-sale showroom of a condominium project in Vancouver. She captured segments of each room — living room, dining room, kitchen, bedroom — from all angles. She used a 35 mm camera without a wide-angle lens and limited herself to capturing the space with only the ambient light. In 2005, while selecting which images to print, she retained mainly the sample showing the gaps within an otherwise routine documentary process. Unlike publicity pictures of such mise-en-scène, her selected images don't reveal important information needed for the sale but rather speak of an uncanny dimension of the dwellings.

Moreover, the initial configuration of these "model suites," meant to be looked at rather than inhabited, was already odd before being photographed by Alexander. They were built to give the potential homeowner an overview of the landscape as if beholding the street from the top of a penthouse. To achieve this, the marketers of the home reduced the scale of the actual showroom by two-thirds, and various optical effects were deployed so that the narrowness of this set was less noticeable. In each image, one sees window bays in the background that offer improbable yet clichéd views of the city and

Model Suite: Overview, 2005, transmounted chromogenic print, 101.6 × 152.4 cm

Model Suite: Sliding Door, 2005,
transmounted chromogenic print, 101.6 × 152.4 cm

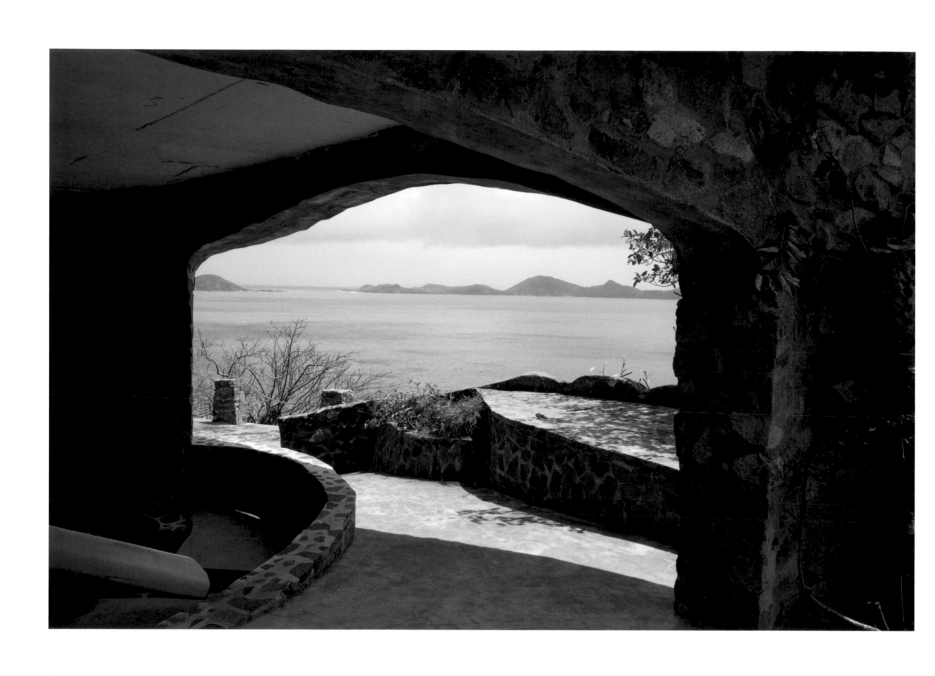

Idyll Series: Entrance, 2019, inkjet print, 71.1 × 101.6 cm

mountain vistas further off on the horizon. In fact, these windows are backlit boxes, immediately evoking those used by artist Jeff Wall between the late 1970s and the early 1990s.[20] With her *Model Suite* series (2005), Alexander puts this artifact back in its place. Woven once more into the fabric of everyday life, the boxes again become an ordinary accessory or prop, just like the wallpaper of *Lake in the Woods* at the Cash/Newhouse Gallery.

Alexander's more recent series of furniture and fashion storefronts in Paris, Istanbul and Tokyo (2009–) could be considered a follow-up of *Model Suite* as well as an extension of her perverse reckoning of the rematerialization of the art object in her glass sculptures of the mid-1980s. Here, rather than the arbitrary props in the showrooms to propel the salesperson's pitch or the ironic scarcity of ornamentation of the axonometric drawings as barely there floating signifiers, Alexander deploys the many permutations of the neo-bourgeois interior in an era of the plutocracy of the 1 percent.

With the *Idyll Series* (2019), Alexander explores a much less emblematic architecture than her previous projects, but still maps out the tastes of the hyper-privileged. In *Idyll Series: Entrance*, we see a landscape from the vantage point of the inside of a property in an undisclosed site near the sea, as if one partition had been removed, signaling that the contingency of the weather is no longer menacing. A few years prior to making this work, in 2010, Alexander photographed Kew Gardens in the suburbs of London to make her *Island Series*. Rather than impose itself against nature in the manner of the simulacra, the architectural structure seems unable to contain the tropical plants, which for years have pushed against the limits of the enclosure of the site, as if they wanted to escape from this inside that is also an outside. In *Island Series* and *Idyll Series*, by choosing to hide the excess and kitsch of colour in black and white, Alexander created a foil with the codes of pictorialist photography.

In *Idyll Series: Border*, Alexander photographed a small wall with a wooden parapet before a rock escarpment that leads to the waterfront of this property. Far from the visual traps of her other works, which first displayed a horizon revealing itself after as a vicarious fold of architecture, this image of the water ultimately offers the semblance of a figure of exteriority (though not an archetype that gives us an oceanic feeling or suggest a line of flight, allowing the imaginary to take over the symbolic). Besides its function of protecting the guests from falling over, the wooden parapet underlines the desperate need of the owner of the place to separate the world of privilege from that of anonymous transactions, economic forces and human flow. Rather than a blank slate, the seascape is the area of international transit of goods and of bodies, thus a territory that, in principle, does not belong to anyone.

Alexander often said that she aspires to make her work almost invisible, camouflaged within a decor that, despite its visual excess or kitsch, is also designed to make us forget its existence. The viewer would remember it later, as an aftermath. Alongside a feminist critique of representation, one of the artist's aims, since *Lake in the Woods*, has been to mimic and displace the symptoms of the optical unconscious, alluded to by Walter Benjamin in his famous 1936 essay "The Work of Art in the Age of Its Technological Reproducibility." He proposed this association of terms to describe a phenomenology of technological mediation that, like the human psychic apparatus, also functioned according to a logic of absorption, condensation and the return of the repressed.[21] As an example, Benjamin mentioned the hypothetical shooting of a film in which the distant camera performs a cutout of the real, such as a close-up, without a subject within its frame being able to see it in action. Alexander on her part is fixing us to her side within the perimeter of the points of view that she has chosen to exhibit. This calls for a particular kind of reflexivity, which is not only an attempt at critical distance or a statement of ambivalence but also an acknowledgement that our looking is entangled with the shaping into existence, and reproduction, of capitalism at a larger scale. We might try to distinguish ourselves from this fact, like a figure from ground, but then it comes back as a stain inside of our field of vision. However, in these mise-en-scènes of "horror vacui" in which we often get lost, Alexander also brings back the experience of lack at the root of consumption, thus showing the melancholy of our desire to desire beyond the seduction of these enclosures.

NOTES

1 The Portapak video system, which was a portable unit made of a camera and a recording component, was marketed by Sony around the world in 1967. Artists such as Vito Acconci, Bruce Nauman and Joan Jonas began to use it to make durational performative works and installations that integrated the viewer's presence. The Nova Scotia College of Art and Design purchased a Portapak system in 1969 and made it available to students in the classroom as well as professors, who often used it to create new works.

2 This is the author's main thesis in David Joselit, *Feedback: Television against Democracy* (Cambridge, MA: MIT Press, 2007).

3 Vikky Alexander, statement written for the project *Field of Vision*, August 12, 1977. Archive of Vikky Alexander.

4 This change in Alexander's work also occurred during a shift in critical discourse on the medium of video and Conceptualism; a moment when some of her instructors at NSCAD were putting aside the orthodoxy of language-focused art of the 1960s and early 1970s in favour of a semiotic analysis of mass media images. Two of the many artists who broadened the tenets of Conceptual Art at the time to embrace feminist preoccupations about representation, class and sexual difference, were Martha Rosler and Dara Birnbaum, who were guest lecturers at NSCAD in the 1970s and 80s.

5 These include Fredric Jameson's writings of the 1980s on postmodernism amongst many others. However, it was David Harvey who, later on, coined the expression "time-space compression" through a reading of Karl Marx's Capital. See: David Harvey, *The Condition of Postmodernity: An Inquiry into the Origins of Cultural Change* (Oxford, Cambridge: Blackwell Publishers, 1989).

6 On the blurring of the borders between art and design since Pop, see Dan Graham, "Art as Design/Design as Art," *Rock My Religion: Writings and Art Projects*, 1965-1990 (Cambridge: The MIT Press, 1993), 208-21.

7 Brian Wallis, "Vikky Alexander," *Vikky Alexander* (Calgary: Stride Gallery, 1998), n.p.

8 Ian Wallace, "The Mirage of the Sublime," *Vaux-le-Vicomte Panorama* (Vancouver: Contemporary Art Gallery, 1999).

9 Vikky Alexander, email to the author, October 30th, 2018. The Transavanguardia, with protagonists such as painters Sandro Chia, Francesco Clemente and Enzo Cucchi was the Italian manifestation of the movement of Neo-Expressionism that dominated the art market in the 1980s.

10 Ibid.

11 A pictorial representation of a three-dimensional object, showing the verticals and horizontals projected to scale but with diagonals and curves distorted, so that the whole appears inclined.

12 She often exhibited the postcards alongside the sculptures as a referential ghost or an index of the unrealized ice project, humorously bringing back the vicissitudes of the post-studio ethos of subcontracting manual labour to third parties.

13 The short form "Neo-Geo," referring to Neo-Geometric Conceptualism, gathered under the same rubric the sculptural and installation works of a diverse group of artists, Peter Halley and Jeff Koons amongst others, although their work was distinctive from one another, in form as well as in content. However, these artists had in common that they underlined the conflation of abstraction in art with the status of the commodity in the so-called post-industrial society of the 1980s. Halley, for instance, distinguished the industrial mode of minimal art, still relying on the skills of workers and the stocking of merchandises, to the serialization of his diagrammatic paintings, mimicking the "just-in-time" production of goods for a given niche-market. On Neo-Geo, see Amy L. Brandt, *Interplay: Neo-Geo Neoconceptual Art of the 1980s* (Cambridge: The MIT Press, 2014).

14 Advertisements in light boxes, carefully designed storefront displays, and last but not the least, entertainment spaces usually not included in a shopping centre — fake tropical beach, skating parlor, etc. — in which the shopper can take a leisurely break before going back to spending more money.

15 Marc Augé, *Non-Places: Introduction to an Anthropology of Supermodernity* (New York: Verso, 1995). Originally published in 1992.

16 During the 1980s, fragments of Jean Baudrillard's writings on simulation were translated into English and widely read by artists, who often turned it into Marxist vulgate to justify the irreversible swelling of the art market and the end of the political. The philosopher's most accessible text in English at the time was *Simulations* (New York: Semiotext(e), 1983), a montage of excerpts from *Simulacres et Simulation*, originally published in French in 1981.

17 Parts of these environments are trademarked and protected by copyright law, just like other images these artists took hold of.

18 Alexander alludes to the long takes of the gardens in the Alain Resnais film *L'année dernière à Marienbad* (1961). Vikky Alexander, conversation with the author, September 2018.

19 Vikky Alexander, conversation with the author, September 2018.

20 Although Wall was not the only artist to make use of this technology, he nevertheless sanctioned its value/form within the field of art, first by divesting it of its initial advertising function (a "delivery system," as he called it) and then using it as a substrate for large-scale allegorical tableaux.

21 Walter Benjamin, "The Work of Art in the Age of Its Technological Reproducibility," (second version, 1936), *Walter Benjamin: Selected Writings, vol. 3, 1931–1938* (Cambridge, MA; London: Belknap, 2002), 117. See also Rosalind Krauss, *The Optical Unconscious*, (Cambridge, MA: MIT Press, 1993), and as an expanded reading of Benjamin's concept, *Photography and the Optical Unconscious*, Shawn Michelle Smith and Sharon Sliwinski, eds. (Durham, NC; London: Duke University Press, 2017).

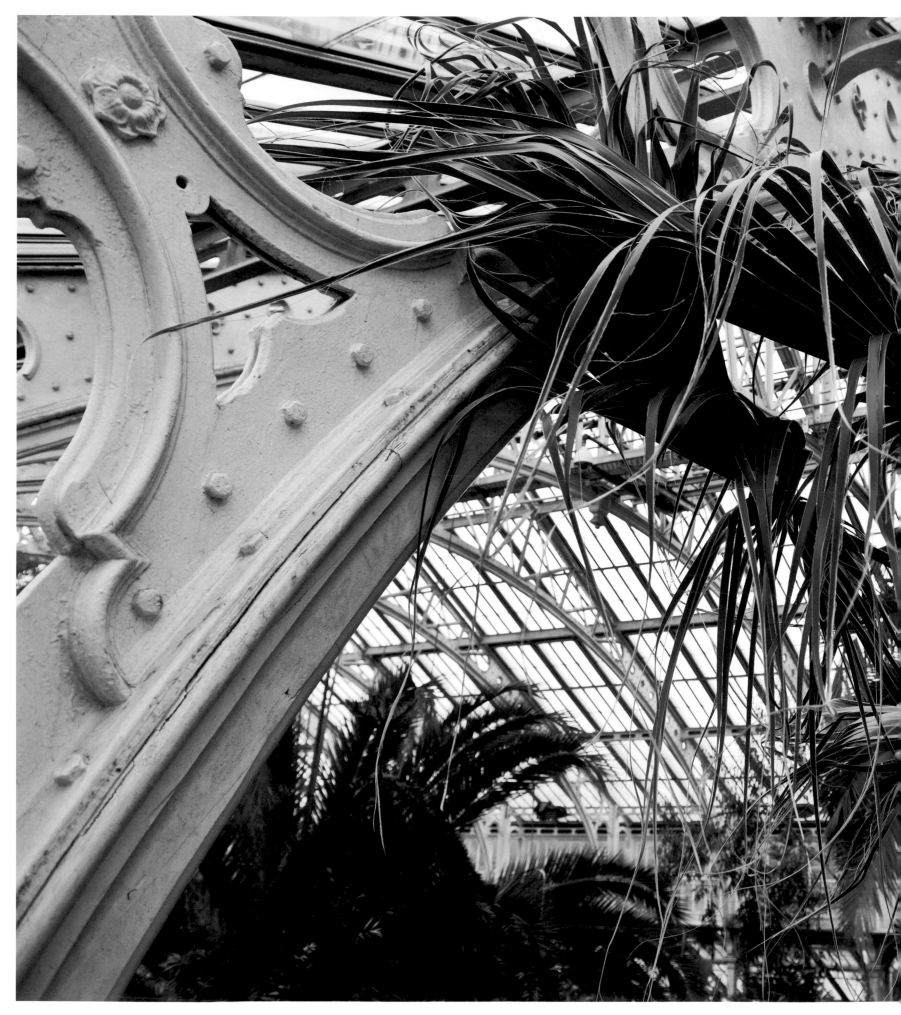

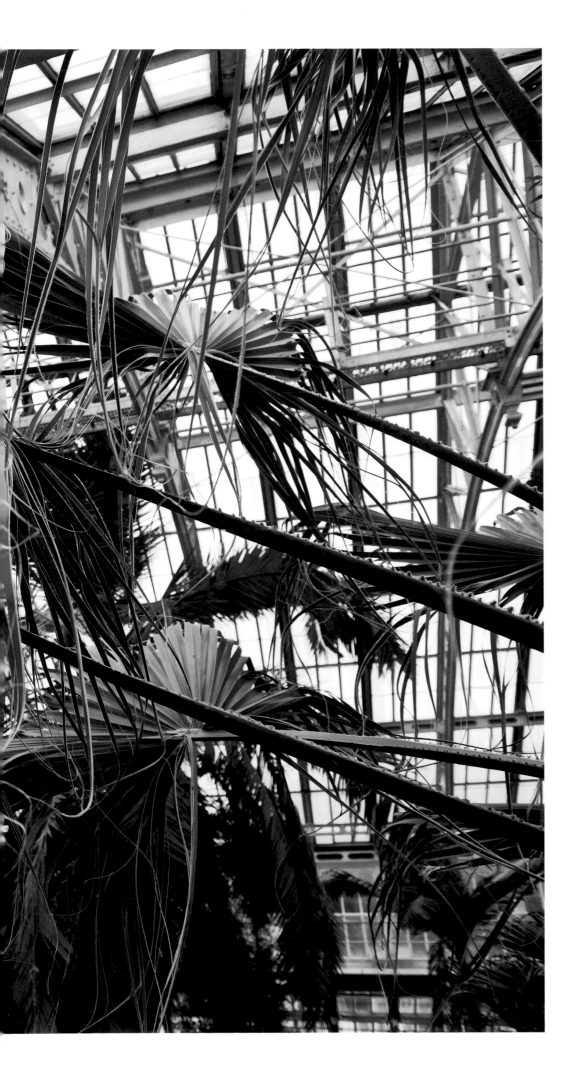

Island Series: Collision, 2011, inkjet print, 103.0 × 152.3 cm

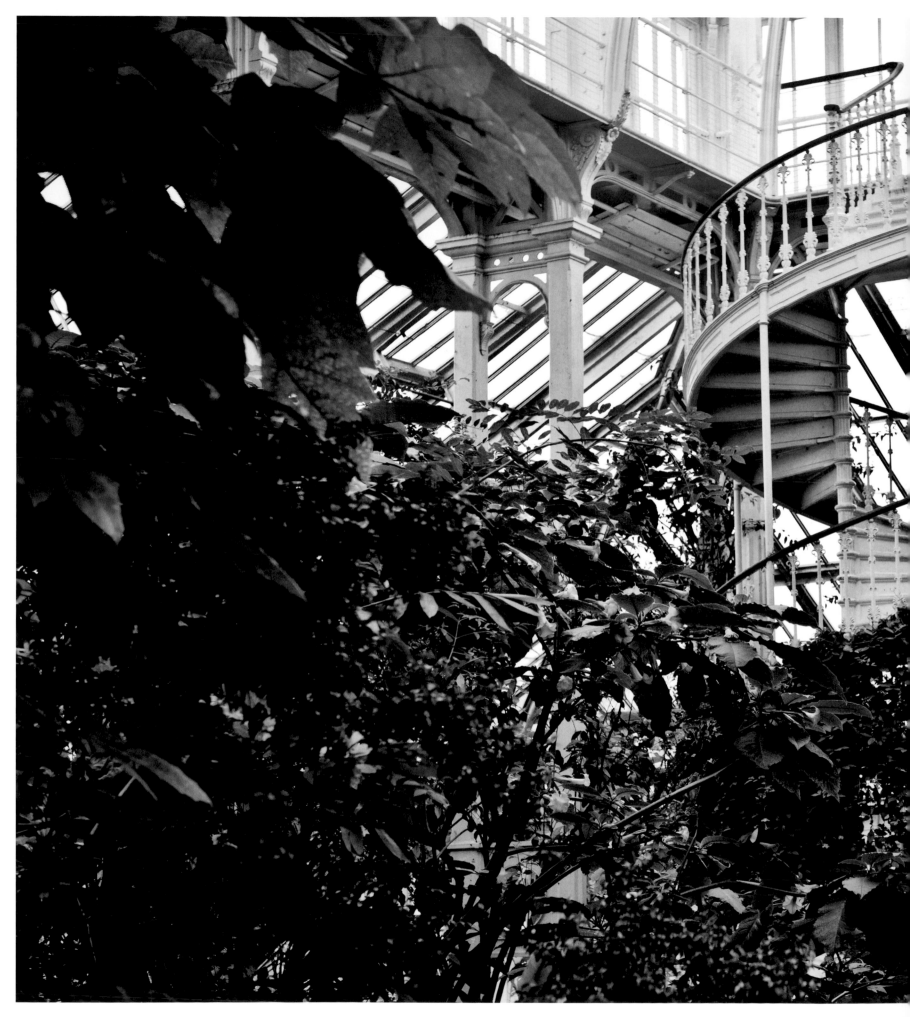

Island Series: Tower, 2011, inkjet print, 103.0 × 152.3 cm

Island Series: Overgrowth, 2011, inkjet print, 103.0 × 152.3 cm

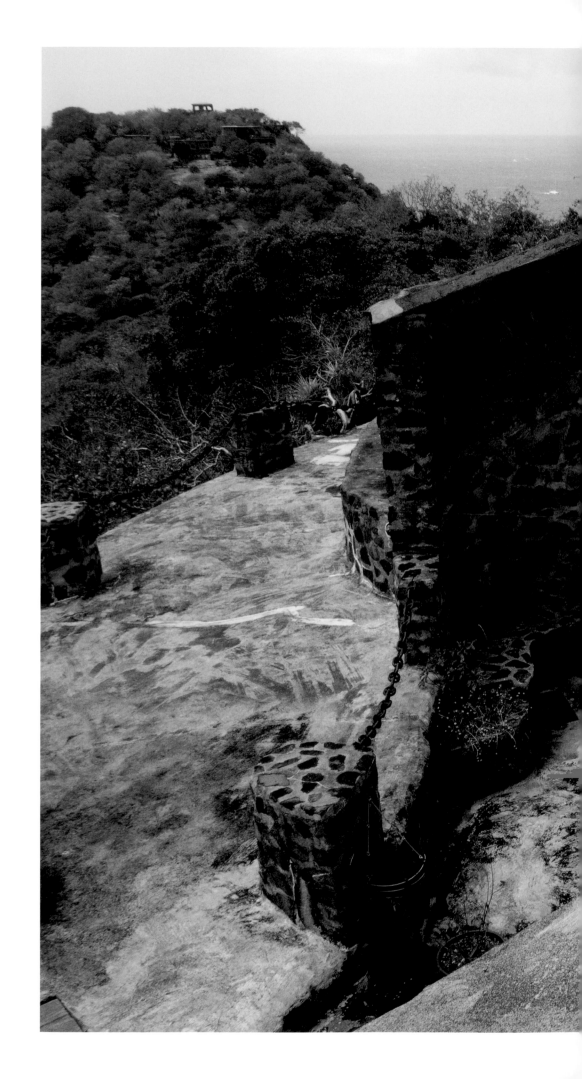

Idyll Series: Doorway, 2019, inkjet print, 71.1 × 101.6 cm

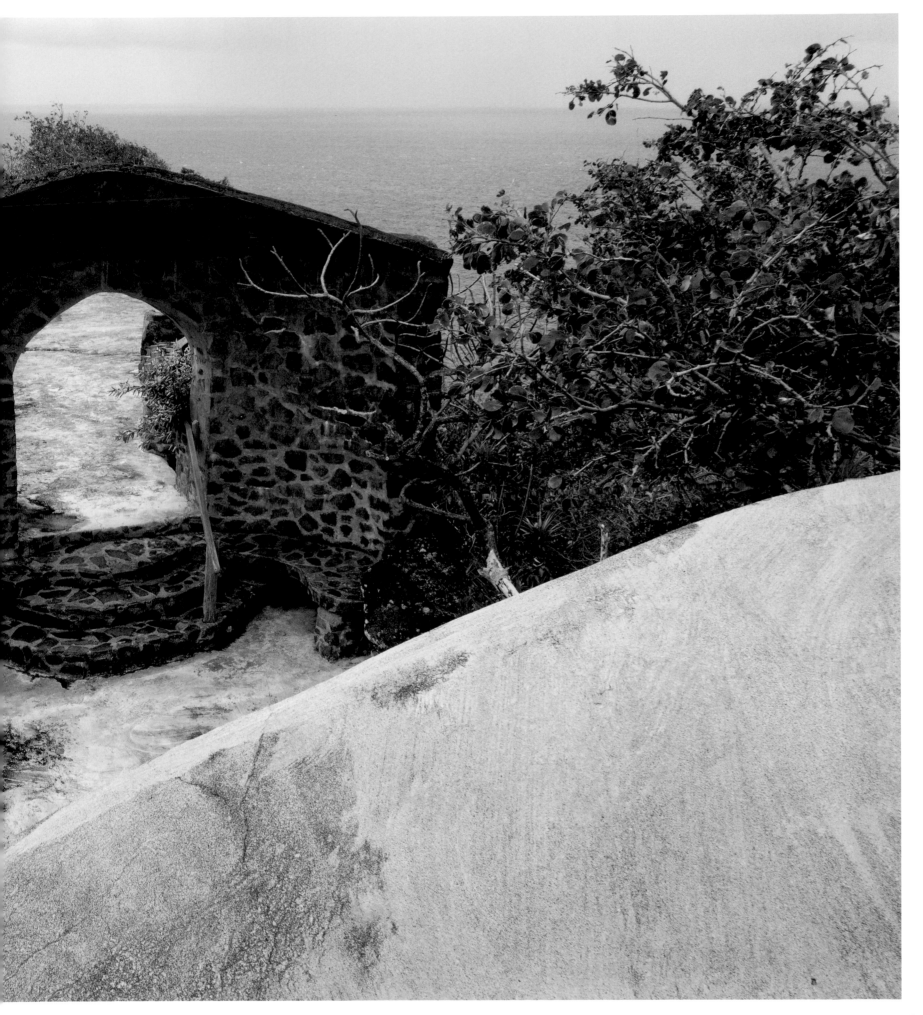

Idyll Series: Roof, 2019, inkjet print, 71.1 × 101.6 cm

Idyll Series: Border, 2019, inkjet print, 71.1 × 101.6 cm

CONTRIBUTORS

DAINA AUGAITIS is an independent curator and Chief Curator Emerita at the Vancouver Art Gallery where she was Chief Curator/ Associate Director from 1996–2017, leading a team of curators to conceive and develop the Gallery's exhibitions, publications, collections and public programs. Among the 130 plus exhibitions she has curated or co-curated are solo projects of Rebecca Belmore, Douglas Coupland, Stan Douglas, Charles Edenshaw, Geoffrey Farmer, Alicia Henry, Bharti Kher, Kimsooja, Muntadas, Brian Jungen, Ian Wallace, Gillian Wearing and Zhu Jinshi. Her exhibitions have been presented across Canada and internationally in Madrid, Lisbon, Paris, Johannesburg, New York, Los Angeles, Sao Paulo and Shanghai. She was formerly Director of Visual Arts at the Banff Centre for the Arts, where she organized thematic residencies as well as spoken word, pirate radio and performance art projects, and has held curatorial positions at Walter Phillips Gallery, Banff; Western Front, Vancouver; Convertible Showroom, Vancouver; and Franklin Furnace, New York.

VINCENT BONIN lives and works in Montréal. With curator Catherine J. Morris, in 2012–13 he co-organized *Materializing 'Six Years': Lucy R. Lippard and the Emergence of Conceptual Art* at the Elizabeth A. Sackler Center for Feminist Art, Brooklyn Museum. In 2014–15, he conceived the two-part exhibition *D'un discours qui ne serait pas du semblant/Actors, Networks, Theories* for the Leonard & Bina Ellen Art Gallery and Dazibao, Montréal, followed by a book-length publication, on the reception of "French Theory" in Anglophone art milieus. In 2015, he was the curator of a survey exhibition on the work of Geneviève Cadieux at the Musée d'art de Joliette, and on tour at Dalhousie Art Gallery and Mount Saint Vincent University Art Gallery, in Halifax. In 2016, he organized *Response*, a dialogue in the form of an exhibition with the French philosopher Catherine Malabou, at the Musée d'art contemporain des Laurentides, Saint-Jérôme. His essays have been published by *Canadian Art*, *Fillip*, the Musée d'art contemporain de Montréal, the Presses du réel and Sternberg Press, among others.

LEAII PIRES is an art historian based in New York whose research centres on identity, power and critique in artistic practices from the 1960s to the present. Her writing on art and politics has appeared in *Triple Canopy*, *4Columns* and *Art in America*, and she recently contributed essays to exhibition catalogues and artist monographs including *Brand New: Art and Commodity in the 1980s* (Hirshhorn Museum and Sculpture Garden, Washington, DC, 2018), *Carissa Rodriguez: The Maid* (Sculpture Center, New York, 2018), *Virginia Overton: Built* (Socrates Sculpture Park, New York, 2018), *Finesse* (which she curated at Columbia University's Wallach Art Gallery, New York, 2017) and *Rochelle Goldberg: The Cannibal Actif* (2016). She holds a PhD in Art History from Columbia University and is an alumna of the Whitney Independent Study Program. Her work has been supported by the Canada Council for the Arts and Humanities New York.

NANCY TOUSLEY, recipient of a Governor General's Award for Visual and Media Arts for outstanding contribution, is an award-winning senior art critic, arts journalist and independent curator. Tousley was art critic of the *Calgary Herald* for more than thirty years and the first Critic-in-Residence at the Alberta College of Art & Design, now the Alberta University for the Arts. Her writing has appeared in art magazines since the early 1970s and in more than forty-five public art gallery and museum exhibition catalogues. In recognition of her work, she has twice received the Ontario Association of Art Galleries award for best curatorial writing on contemporary art, in 1999 and 2001; the Canadian Museums Association's award for outstanding achievement in arts journalism (2002); and the medal of the Royal Canadian Academy of Art (2009). Her recent curatorial work is the exhibition series *One New Work*, ongoing at the Glenbow Museum since 2016.

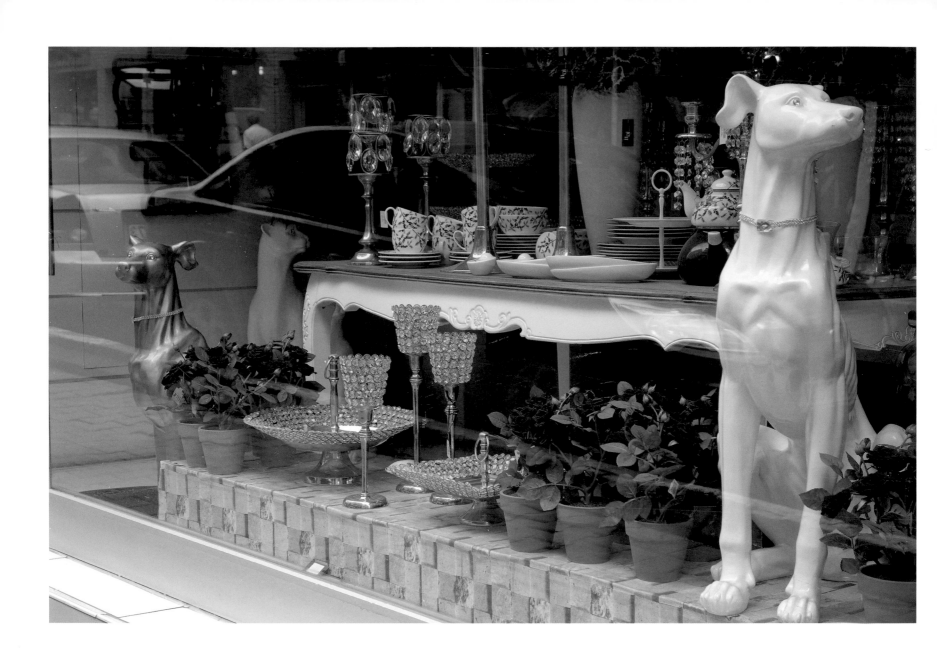

Istanbul Showrooms: White and Gold Greyhounds, 2013, transmounted digital print in light box, 71.1 × 101.6 × 8.9 cm

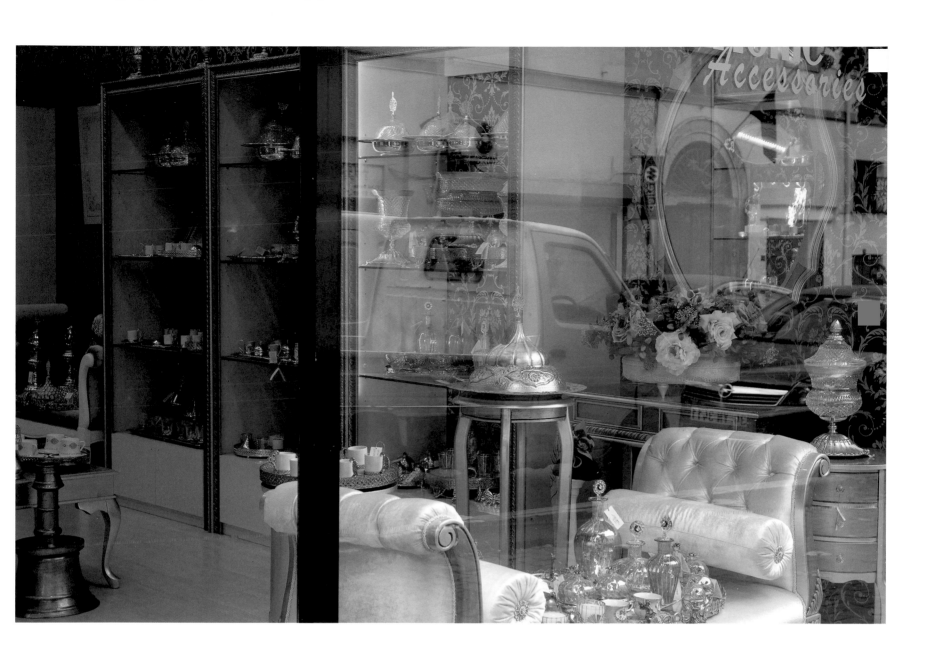

Istanbul Showrooms: White and Gold Chaise, 2013, transmounted digital print in light box, 71.1 × 101.6 × 8.9 cm

Ginza Series: Repetto, 2018, inkjet print, 71.1 × 101.6 cm

Ginza Series: Flowers, 2018, inkjet print, 71.1 × 101.6 cm

Ginza Series: Earrings, 2018, inkjet print, 71.1 × 101.6 cm

Ginza Series: Butterflies, 2018, inkjet print, 71.1 × 101.6 cm

WORKS IN EXHIBITION

———

Height precedes width then depth

Pieta, 1981
chromogenic print
165.1 × 68.6 cm
Courtesy of the Artist and Downs & Ross, New York
P. 56

Numero Deux, 1982
chromogenic prints
94.0 × 317.5 cm
National Gallery of Canada, Ottawa. Purchased 2017
P. 58

Yosemite, 1982/2017
inkjet print on metallic paper
55.9 × 101.6 cm
RBC Art Collection
P. 68

Portage Glacier, 1982/2017
inkjet print on metallic paper
45.7 × 101.6 cm
RBC Art Collection
P. 66

Ecstasy, 1983
type R print
60.1 × 261.0 cm
Collection of Sheldon Inwentash and Lynn Factor, Toronto
P. 57

Entertainment, 1983
chromogenic prints, vinyl type
88.9 × 335.3 cm
Courtesy of the Artist and Downs & Ross, New York
P. 50

Family, 1983
azo dye prints, vinyl type
121.9 × 132.1 cm overall
Courtesy of the Artist and Downs & Ross, New York
P. 54

Paris Showrooms: Red CD, 2009,
inkjet print on metallic paper, 71.1 × 101.6 cm

Obsession, 1983
silver gelatin prints, vinyl type, Plexiglas
91.5 × 61.0 cm (each)
Collection of the Vancouver Art Gallery,
Gift of the Artist, Dr. Doug Foster, Bill Jeffries
and Ian Wallace
P. 6–14, 60

Grace, 1984
record covers, vinyl type
284.5 × 121.9 cm
Courtesy of the Artist, TrépanierBaer, Calgary,
and Downs & Ross, New York
P. 62

Between Dreaming & Living #1, 1985
silver gelatin print, Plexiglas
55.9 × 71.1 cm
International Center of Photography,
Gift of Vikky Alexander, 2000
P. 48

Between Dreaming & Living #2, 1985
silver gelatin print, Plexiglas
61.0 × 91.4 cm
International Center of Photography,
Gift of Vikky Alexander, 2000
P. 44

Between Dreaming & Living #3, 1985
silver gelatin print, Plexiglas
61.0 × 91.4 cm
International Center of Photography,
Gift of Vikky Alexander, 2000
P. 42

Between Dreaming & Living #4, 1985
silver gelatin print, Plexiglas
61.0 × 91.4 cm
International Center of Photography,
Gift of Vikky Alexander, 2000
P. 46

Between Dreaming & Living #5, 1985
silver gelatin print, Plexiglas
91.4 × 61.0 cm
International Center of Photography,
Gift of Vikky Alexander, 2000

Between Dreaming & Living #6, 1985
silver gelatin print, Plexiglas
91.4 × 61.0 cm
Collection of Robin and Malcolm Anthony
BACK COVER

Between Dreaming & Living #8, 1986
inkjet print, Plexiglas
91.4 × 66.0
Courtesy of the Artist and Downs & Ross, New York
FRONT COVER

Lake in the Woods, 1986
photographic mural, mirror, composition board
dimensions variable
Collection of the Vancouver Art Gallery,
Vancouver Art Gallery Acquisition Fund
P. 70, 72

Court #2, 1987
contact paper on birch plywood
203.2 × 182.9 × 5.1 cm
Courtesy of the Artist and COOPER COLE, Toronto
P. 80

Panel #1, 1987
contact paper on birch plywood
203.2 × 162.4 × 3.5 cm
Courtesy of the Artist and COOPER COLE, Toronto

Glass Bed with Tables, 1988
plate glass
71.1 × 121.9 × 152.4 cm (bed)
35.6 × 35.6 × 35.6 cm (table)
Courtesy of the Artist and Downs & Ross, New York
P. 104

Interior Pavilion #4, 1989
birch plywood, photographic mural
6 hinged panels, 213.4 × 63.5 × 4.4 cm (each)
Collection of the Surrey Art Gallery
P. 75

Glass Chair and Table, 1990
plate glass
91.4 × 40.6 × 40.6 cm (chair)
35.6 × 35.6 × 35.6 cm (table)
Adelaar Family Collection
P. 17

West Edmonton Mall #1, 1990
chromogenic print
50.8 × 61.0 cm
Collection of Surrey Art Gallery, Gift of the Artist
P. 78

West Edmonton Mall #6, 1990
chromogenic print
50.8 × 61.0 cm
Collection of Surrey Art Gallery, Gift of the Artist

West Edmonton Mall #17, 1990
chromogenic print
61.0 × 50.8 cm
Collection of the Surrey Art Gallery, Gift of the Artist
FRONT ENDLEAF

West Edmonton Mall #19, 1990
chromogenic print
61.0 × 50.8 cm
Collection of Surrey Art Gallery, Gift of the Artist
P. 108

Birch Square Tiles #1–3, 1991
paper on masonite on birch
60.1 × 182.9 cm (overall); 60.1 × 60.1 (each)
Collection of the Vancouver Art Gallery, Vancouver
Art Gallery Acquisition Fund

Disneyland, Anaheim, CA #22, 1991
chromogenic print
76.2 × 83.8 cm
Courtesy of the Artist

Disneyland, Anaheim, CA #24, 1991
chromogenic print
76.2 × 83.8 cm
Courtesy of the Artist

Disneyland, Anaheim, CA #25, 1991
chromogenic print
83.8 × 76.2 cm
Courtesy of the Artist
TABLE OF CONTENTS

Crystal World #1, 1996
transmounted chromogenic print, glass
205.7 × 246.4 × 106.7 cm (overall)
Courtesy of the Artist and TrépanierBaer, Calgary
P. 106

Crystal World #2, 1996
transmounted chromogenic print, glass
205.7 × 246.4 × 106.7 cm (overall)
Courtesy of the Artist and TrépanierBaer, Calgary
P. 107

Autumn/Spring, 1997
photographic mural, mirrors
dimensions variable
Courtesy of the Artist and Downs & Ross, New York
P. 76

Vikky Alexander in her New York studio, c. 1980

CURRICULUM VITAE
—

b. 1959, Victoria, BC
BFA Nova Scotia College of Art and Design, 1979
Canada Council Paris Studio Residency, Paris, France, 1995
La Cité internationale des arts, Paris, France, studio residency, 2009

SELECTED SOLO AND DUO EXHIBITIONS
—

2019
Vikky Alexander: Extreme Beauty, Vancouver Art Gallery,
 Vancouver, BC

2018
Between Dreaming & Living, COOPER COLE, Toronto, ON
Other Fantasies, TrépanierBaer, Calgary, AB
Vertical Dreams, Wilding Cran Gallery, Los Angeles, CA
Vikky Alexander: The Spoils of the Park, Canada House, London,
 United Kingdom

2017
Between Dreaming & Living, Chernoff Fine Art, Capture
 Photography Festival, Vancouver, BC
Commercial Curtain, site-specific installation commissioned
 by South Asian Canadian Histories Association (SACHA),
 Main St., Vancouver, BC
Model Suite (Sliding Door), site-specific installation commissioned
 by the Contemporary Art Gallery for the Yaletown–Roundhouse
 Canada Line Station, Vancouver, BC
Unnatural Horizon, L'Escalier, Montréal, QC
Vikky Alexander (1981–83), Downs & Ross, New York, NY
Vikky Alexander and Marie-Michèle Deschamps, Raising Cattle,
 Montréal, QC

2016
The Temptation of Saint Anthony, COOPER COLE, Toronto, ON

2015
Istanbul Showrooms, La Vitrine, Atelier Daigneault/Schofield,
 Montréal, QC
The Troublesome Window, TrépanierBaer, Calgary, AB

2014
Theatregarden Beastiarium, Wilding Cran Gallery,
 Los Angeles, CA
Vikky Alexander: The Temptation of St. Anthony, The Apartment,
 Vancouver, BC

2011
Island, TrépanierBaer, Calgary, AB

Paris Showrooms: Gold Torso, 2009,
inkjet print on metallic paper, 71.1 × 101.6 cm

2010
Houses of Glass, The Engine Room Gallery, Massey University, Wellington, New Zealand
Paris Showrooms, TrépanierBaer, Calgary, AB
Paris Showrooms, Luz Gallery, Victoria, BC

2009
Lobby Mural, Camera condominium, Vancouver, BC

2008
Lost Horizons, TrépanierBaer, Calgary, AB

2007
Model Suites (w/ Micah Lexier), TrépanierBaer, Calgary, AB

2004
Vikky Alexander, State Gallery, Vancouver, BC
Vikky Alexander: The West Edmonton Mall Series, Surrey Art Gallery, Surrey, BC

2003
New Works, TrépanierBaer, Calgary, AB

2000
Vaux-le-Vicomte Panorama, National Gallery of Canada, Ottawa, ON
Vikky Alexander, Catriona Jeffries, Vancouver, BC

1999
Recent Acquisitions: Vikky Alexander, MacKenzie Art Gallery, Regina, SK
Vaux-le-Vicomte Panorama, Contemporary Art Gallery, Vancouver, BC

1998
Garden City, TrépanierBaer, Calgary, AB
Vikky Alexander, Art Gallery of Windsor, Windsor, ON

1997
Vikky Alexander, Edmonton Art Gallery, Edmonton, AB
Vikky Alexander, Catriona Jeffries, Vancouver, BC

1996
À la recherche du temps perdu, Catriona Jeffries, Vancouver, BC
Between Dreaming & Living, Presentation House Gallery, North Vancouver, BC
Vikky Alexander: Crystal World; New Works, TrépanierBaer, Calgary, AB

1994
Vikky Alexander and Robert Youds, Project, Vancouver, BC
Vikky Alexander and Uta Barth, Domestic Setting, Los Angeles, CA

1993
Modern Landscapes, TrépanierBaer, Calgary, AB
Vikky Alexander, Mercer Union, Toronto, ON

1992
Lake in the Woods, Vancouver Art Gallery, Vancouver, BC
Vikky Alexander (w/ Roger Bellemare), Galerie Brenda Wallace, Montréal, QC

1991
De Natura: Collaborative Works by Vikky Alexander and Ellen Brooks, travelling exhibition: Dorothy Goldeen Gallery, Los Angeles, CA, 1991; Ansel Adams Center, San Francisco, CA, 1992; Wooster Gardens, New York, NY, 1992

1990
Vikky Alexander and James Welling, Kunsthalle Bern, Bern, Switzerland

1989
Petrosino Park Project, for Lower Manhattan Cultural Council, New York, NY
Vikky Alexander, Galerie Brenda Wallace, Montréal, QC

1988
Vikky Alexander, Stride Gallery, Calgary, AB
Vikky Alexander and David Cabrera, De Lege Ruimte, Bruges, Belgium

1987
Ace Contemporary Exhibitions, Los Angeles, CA
Vikky Alexander, Cash/Newhouse Gallery, New York, NY
Vikky Alexander, Julian Pretto, New York, NY

1986
Vikky Alexander, Cash/Newhouse Gallery, New York, NY
Vikky Alexander and Ian Wallace, Coburg Gallery, Vancouver, BC

1985
Vikky Alexander, Axe Neo 7, Centre d'art contemporain, Hull, QC
Vikky Alexander, Cash/Newhouse Gallery, New York, NY
NEW, site-specific installation, The New Museum, New York, NY

1984
Metro Bus Show, CEPA, Buffalo, NY

1983
Artificial Miracles: Vikky Alexander and Jim Welling, SFU Studio, Vancouver, BC
Family Entertainment, A&M Artworks, New York, NY
Obsession, A&M Artworks, New York, NY
Obsession, CEPA, Buffalo, NY
Obsession, Coburg Gallery, Vancouver, BC

1978
Separate Tables, Anna Leonowens Gallery, Halifax, NS
Viewing Space, Toronto–Dominion Bank Building, Halifax, NS

SELECTED GROUP EXHIBITIONS

2019
On Location: Artists Explore a Sense of Place, Glenbow Museum, Calgary, AB

2018
Cabin Fever, Vancouver Art Gallery, Vancouver, BC
Guarded Future, Downs & Ross, New York, NY

2017
Group Show, Project Native Informant, London, United Kingdom
Making Pictures: Vikky Alexander, IAN BAXTER&, Fred Herzog, Geoffrey James and Danny Singer, TrépanierBaer, Calgary, AB
Narrative Art, Musée d'art moderne et contemporain, Geneva, Switzerland
Past Imperfect: A Canadian History Project, Art Gallery of Alberta, Edmonton, AB
Song of the Open Road, Contemporary Art Gallery, Vancouver, BC
Trauma, Memory and the Story of Canada, SACHA, Vancouver, BC

2016
Aujourd'hui Encore, TrépanierBaer, Calgary, AB
Away: the Artist as Traveller, Surrey Art Gallery, Surrey, BC
Collection Connections, Art Gallery of Alberta, Edmonton, AB
Haunting Holbein, TrépanierBaer, Calgary, AB
MashUp: The Birth of Modern Culture, Vancouver Art Gallery, Vancouver, BC
Three Kinds of Abstraction, Access Gallery, Vancouver, BC

2015
Beasts, Vieux Presbytère, Saint-Bruno-de-Montarville, QC
Still Life: Looking at the Overlooked, TrépanierBaer, Calgary, AB
Store/Fronts, National Gallery of Canada at the Museum of Contemporary Canadian Art, Toronto, ON
Traces that Resemble Us, Monte Clark Gallery, Vancouver, BC

2014
Decade: Celebrating Exposure's First 10 Years, Christine Klassen Gallery, Calgary, AB
Exposure: Photography Festival 2014, TrépanierBaer, Calgary, AB
Inaugural Show #1, Wilding Cran Gallery, Los Angeles, CA
Through the Looking Glass: A Modern Story from the Collection of the Art Gallery of Greater Victoria, Art Gallery of Greater Victoria, Victoria, BC

2013
Macho Man, Tell It To My Heart: Collected by Julie Ault, travelling exhibition: Museum für Gegenwartskunst, Basel, Switzerland; Culturegest, Lisbon, Portugal; Artists Space, New York, NY
Paradox, Legacy Art Gallery, Victoria, BC
Passion & Panache–Remembering Brenda Wallace, Western McIntosh Gallery, London, ON
Unreal, Across the Province touring exhibition organized by the Vancouver Art Gallery: Evergreen Cultural Centre, Coquitlam, BC, 2013; Kelowna Art Gallery, Kelowna, BC, 2014; Kamloops Art Gallery, Kamloops, BC, 2014

2012
Builders: Canadian Biennial 2012, National Gallery of Canada, Ottawa, ON
C.1983, Part 2, Presentation House Gallery, North Vancouver, BC
Collector's Choice, Winchester Modern, Victoria, BC
Crystal Palace, 2011, Nuit Blanche Toronto, Toronto, ON
Cut and Paste: An Exhibition of Canadian Collage, Equinox Project Space, Vancouver, BC
Street Life: The City as Muse, Museum of Contemporary Art (MOCA), Calgary, AB
Untrue North, Yukon Art Centre, Whitehorse, YK

2011
An Autobiography of Our Collection, Vancouver Art Gallery, Vancouver, BC
Cultural, Temporal and Imagined: Landscape in Recent Contemporary Acquisitions, Art Gallery of Greater Victoria, Victoria, BC
Monomania, Trench Gallery, Vancouver, BC
Unreal, Vancouver Art Gallery, Vancouver, BC
Vancouver/Vancouver, 1965 Gallery, Vancouver, BC
You Would, Kathleen Cullen Gallery, New York, NY

2010
The Last Frontier, Art Gallery of Nova Scotia, Halifax, NS

2009
Heartland, Art Toronto, Toronto, ON

2008
I have (no) issues, Lawrence Eng Gallery, Vancouver, BC
Let Me Be Your Mirror, MacKenzie Art Gallery, Regina, SK
The Tree: From the Sublime to the Social, Vancouver Art Gallery, Vancouver, BC
Through the Looking Glass, Glenbow Museum, Calgary, AB

2007
Recent Acquisitions: artists exploring photographic and digital media, Surrey Art Gallery, Surrey, BC

2006
75 Years of Collecting: The Road to Utopia, Vancouver Art Gallery, Vancouver, BC
Found in Pop: 6 Artists, TrépanierBaer, Calgary, AB

2005
20 Years of Contemporary Art, Gossip and Lies: 1985–2005 at Stride, Stride Gallery, Calgary, AB
From New Image to New Wave: Legacy of NSCAD in the Seventies, Art Gallery of Nova Scotia, Halifax, NS
Intertidal: Vancouver Art and Artists, Museum for Contemporary Art Antwerp (MuHKA), Antwerp, Belgium
Mirror, Mirror, Canadian Clay and Glass Gallery, Waterloo, ON
Private View, 1980–2000: Collection Pierre Huber, Le Musée Cantonal des Beaux-Arts de Lausanne, Switzerland

2004
State Gallery, Vancouver, BC

2003
Drawing on Architecture, Atelier Gallery, Vancouver, BC

2002

Photo Roman, Medicine Hat Museum and Art Gallery, Medicine Hat, AB

Supporting Roles: Photo-based work of the 1990s, MacKenzie Art Gallery, Regina, SK

This Place: works from the collection, Vancouver Art Gallery, Vancouver, BC

2001

Group Exhibition, TrépanierBaer, Calgary, AB

2000

Pictures, Positions and Places, Vancouver Art Gallery, Vancouver, BC

The Single Tree, London Regional Art Museum, London, ON

1999

Recollect, Vancouver Art Gallery, Vancouver, BC

1997

Environments, Pittsburgh Center for Contemporary Art, Pittsburgh, PA

1996

Modus Operandi, Kenderdine Art Gallery, Saskatoon, SK

The Culture of Nature: Art and its Practices (An Investigation of Contemporary Art), Kamloops Art Gallery, Kamloops, BC

Vancouver Perspective, Yokohama Civic Art Gallery, Yokohama, Japan

1995

Held in Trust: A Cultural Record for Surrey, Surrey Art Gallery, Surrey, BC

It's Only Rock and Roll: Rock and Roll Currents in Contemporary Art, travelling exhibition: Contemporary Arts Center, Cincinnati, OH, 1995; Lakeview Museum of Arts and Sciences, Peoria, IL, 1996; Virginia Beach Center for the Arts, Virginia, VA, 1996; Tacoma Art Museum, Tacoma, WA, 1996; Jacksonville Museum of Contemporary Art, Jacksonville, FL, 1996; Dean Lesher Regional Center for the Arts, Bedford Gallery, Walnut Creek, CA, 1996; Phoenix Art Museum, Phoenix, AZ, 1997; Lowe Art Museum, Coral Gables, FL, 1997; Milwaukee Art Museum, Milwaukee, WI, 1998; Arkansas Art Center, Little Rock, AR, 1998

Last Chance for Eden: The Contemporary Sublime, Part I, TrépanierBaer, Calgary, AB

From the Floating World to the Street, part of *Documents Northwest: The PONCHO Series*, Seattle Art Museum, Seattle, WA

Wall to Wall, Or Gallery, Vancouver, BC

1994

Group Exhibition, TrépanierBaer, Calgary, AB

1993

Arcadia/Paradise/Utopia, Surrey Art Gallery, Surrey, BC

Artropolis '93, Artropolis, Vancouver, BC

Beneath the Paving Stones, Charles H. Scott Gallery, Vancouver, BC

Commodity Image, International Center of Photography, New York, NY

Reflecting Paradise, Expo 93, Taejon, Korea

1992

Annina Nosei Gallery, New York, NY

The Art Mall: A Social Space, The New Museum, New York, NY

Wasteland: Landscape from Now On, Rotterdam Photo Biennale 3, Rotterdam, the Netherlands

1991

Cruciformed: Images of the cross since 1980, Cleveland Center for Contemporary Art, Cleveland, OH

Just What Is It That Makes Today's Homes so Different, So Appealing?, The Hyde Collection, Charles R. Wood Gallery, Glenns Falls, NY

Practicing Beauty, Art Gallery of Hamilton, Hamilton, ON

Un-Natural Traces: Contemporary Art from Canada, Barbican Art Gallery, London, United Kingdom

Young Contemporaries, London Regional Art Gallery, London, ON

1990

Berland Hall Gallery, New York, NY

Grids, Vrej Baghoomian Gallery, New York, NY

In the Beginning, Cleveland Center for Contemporary Art, Cleveland, OH

Louver Gallery, New York, NY

Marta Cervera Gallery, New York, NY

PastFutureTense, Vancouver Art Gallery and Winnipeg Art Gallery, Winnipeg, MB and Vancouver, BC

Toward a History of the Found Object, Mendel Art Gallery, Saskatoon, SK

Up The Garden Path, Wolff Gallery, New York, NY

With the Grain: Contemporary Panel Painting, Whitney Museum of American Art, Roni Feinstein, Phillip Morris branch, NY and Stamford, CT

1989

Abstraction in Contemporary Photography, Emerson Gallery, Hamilton College, Clinton, NY and Virginia Commonwealth University

Linda Farris Gallery, Seattle, WA

The Experience of Landscape: Three Decades of Sculpture, Whitney Museum of American Art Downtown at Federal Reserve Plaza, New York, NY

1988

Cultural Participation, DIA Art Foundation, New York, NY

Fabricated Photographs, Carpenter Center for the Visual Arts, Harvard University, Cambridge, MA; Museum of Art, Haifa, Israel

Galerie Pierre Huber, Geneva, Switzerland

Hybrid Neutral: Modes of Abstraction and the Social, travelling exhibition: University Art Gallery, The University of North Texas, Denton, TX, 1988; J.B. Speed Art Museum, Louisville, KY, 1988; Alberta College of Art Gallery, Calgary, AB, 1989; The Contemporary Arts Center, Cincinnati, OH, 1989; Richard F. Brush Art Gallery, St. Lawrence University, Canton, NY, 1989; Santa Fe Community College Art Gallery & Museum, Gainesville, FL, 1990; Mendel Art Gallery & Museum, Saskatoon, SK, 1990

Media Post Media, Scott Hanson Gallery, New York, NY

Mutations, Annina Nosei Gallery, New York, NY

Sequence(Con)Sequence: Photographic Multiples of the Eighties, Blum Art Institute, Bard College, Annandale-on-Hudson, NY

1987

Invitational Exhibition, Cold City Gallery, Toronto, ON

Material Fictions, travelling exhibition: 49th Parallel, New York, NY, 1987;
 University Art Gallery of the State University of New York at Binghamton,
 New York, NY, 1987

Modern Art Since 1984, Nexus, Atlanta, GA

New Territories in Art: Europe-America, Fondazione Michetti, Francavilla
 al Mare, Italy

Perverted by Language, Hillwood Art Gallery, CW Post Campus, Long Island
 University, Brookville, NY

Reconnaissance: Three Panoramic Views, travelling exhibition: Walter Phillips
 Gallery, Banff Centre, Banff, AB, 1987; Art Gallery of Windsor, Windsor, ON,
 1988

Robbin Lockett Gallery, Chicago, IL

Spatial F/X, Annina Nosei Gallery, New York, NY

The Art of the Real, Galerie Pierre Huber, Geneva, Switzerland and Lyon, France

The Castle, Documenta 8, installation by Group Material, Kassel, Germany

1986

Arts and Leisure, The Kitchen, New York, NY

Cash/Newhouse Gallery, New York, NY

Greenberg's Dilemma, Loughelton Gallery, New York, NY

New New York, Cleveland Center for Contemporary Art, Cleveland, OH

1985

303 Gallery, New York, NY

A Summer Selection, Castelli Uptown, New York, NY

Persona non Grata, Daniel Newburg Gallery, New York, NY

Photo Object, Postmasters, New York, NY

Polaroid Deux, Axe Neo-7 Centre d'art contemporain, Hull, QC

Seduction: Working Photographs, White Columns, New York, NY

1984

Rediscovering Romanticism in New York in 1984, New Math Gallery,
 New York, NY

The New Capital, White Columns, New York, NY

1983

Appearing, Mount Saint Vincent University Art Gallery, Halifax, NS

Fashion Fictions: Absence and the Fast Heartbeat, White Columns, New York, NY

The Stolen Image and Its Uses, Light Work, Syracuse, NY

1982

Record Covers for Show, White Columns, New York, NY

Resource Material, Bard College, Annandale-on-Hudson, NY

Trouble in Paradise, A&M Artworks, New York, NY

Worlds Apart, Johnson State College, Johnson, VT

1981

Photoworks, A&M Artworks, New York, NY

OVERLEAF: *La Fenêtre, Versailles*, 1996, chromogenic print, 101.6 × 152.4 cm

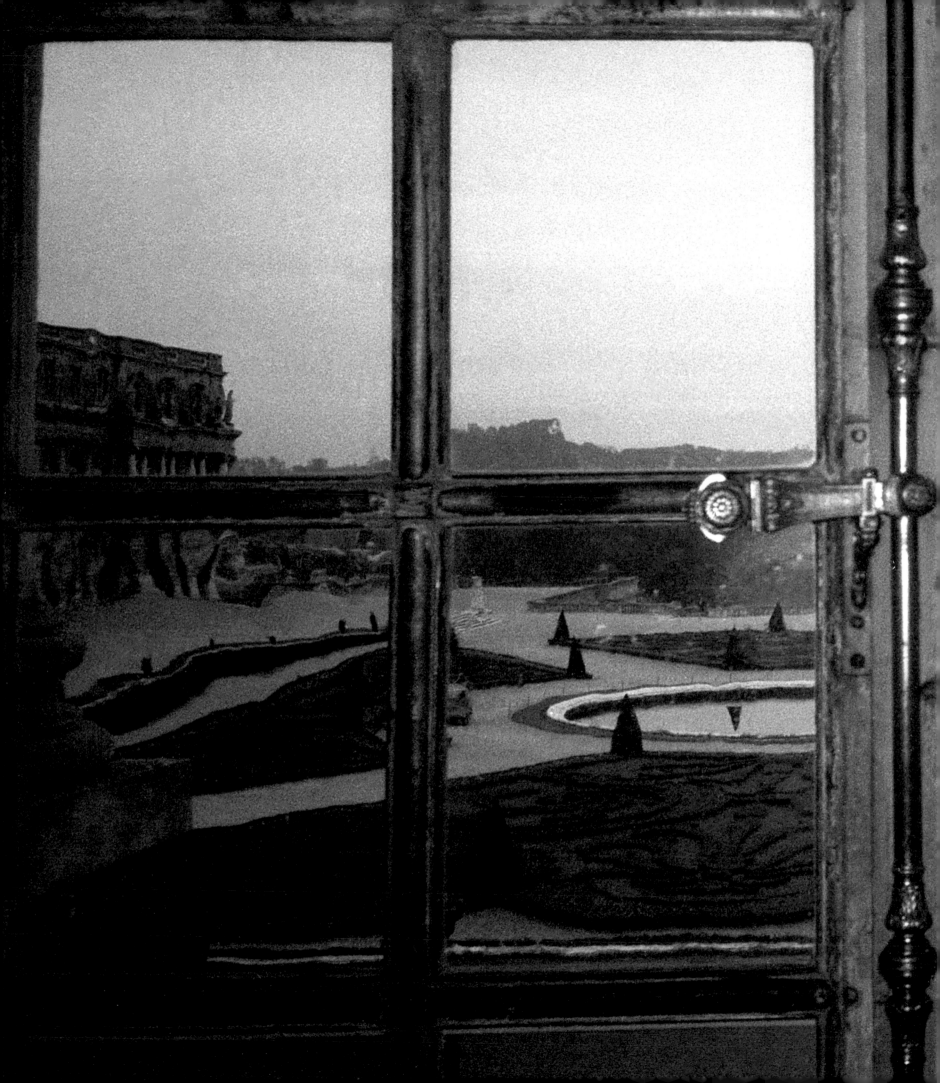

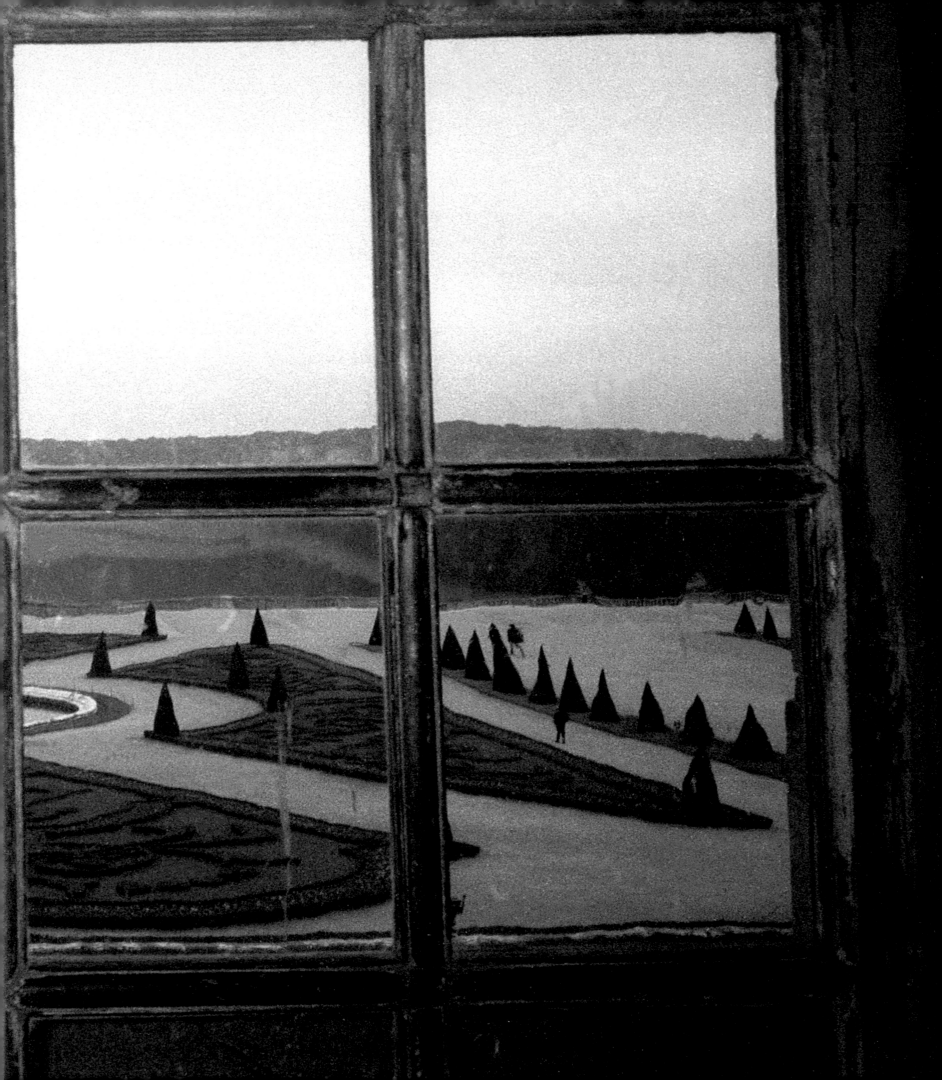

SELECTED BIBLIOGRAPHY

"Alexander, Vikky. Modern Landscapes. Trepanier Baer Gallery. Calgary." *Canadian Art*, v. 10, no. 3, Fall 1993, p. 86

Alexander, Vikky and Annabel Osberg. *Vikky Alexander: The Spoils of the Park.* London: Canada House Gallery, 2018.

Augaitis, Daina. *Reconnaissance: Three Panoramic Views: Vikky Alexander, Ray Arden, Jamelie Hassan.* Banff: Walter J. Phillips Gallery, 1987.

Augaitis, Daina, and Emmy Lee. *The Tree: From the Sublime to the Social.* Vancouver: Vancouver Art Gallery, 2008.

Ballerini, Julia. *Sequence (con)sequence: (sub)versions of Photography in the 80s.* New York: Aperture, in association with the Edith C. Blum Art Institute, Bard College, 1989.

Builders: Canadian Biennial 2012. Contrib. Jonathan Shaughnessy, Heather Anderson, Andrea Kunard, Christine Lalonde, Ann Thomas. Ottawa: National Gallery of Canada, 2011.

Cameron, Dan. *Just What Is It That Makes Today's Homes So Different, So Appealing? An Exhibition and Catalogue, September 7–November 17, 1991: Vikky Alexander [and Others].* Glens Falls: The Collection, 1991.

Campitelli, Maria. "Vikky Alexander." *Juliet Art Magazine*, no. 33, 1987, p. 27.

Collins, Tricia and Richard Milazzo. *Media Post Media: Vikky Alexander [and Others].* New York: Scott Hanson Gallery, 1988.

Curatorial Laboratory Project #5, Practicing Beauty. Hamilton: Art Gallery of Hamilton, 1991.

Decter, Joshua. "Vikky Alexander." *Arts Magazine*, v. 60, no. 7, March 1986, p. 135.

Dufour, Gary. *Vikky Alexander: Lake in the Woods.* Vancouver: Vancouver Art Gallery, 1993.

Ess, Barbara, Glenn Branca and Trey Speegle. *Thought Objects.* New York City: JAA Press, 1987.

Ferguson, Bruce W. *Appearing.* Halifax: Mount Saint Vincent University, Art Gallery, 1983.

––. *Vikky Alexander: Glass Sculpture.* Bern: Kunsthalle, 1990.

Ferguson, Bruce W., and Gary Dufour. *Pastfuturetense: Vikky Alexander, Kari Cavén, Ronald Jones, Rui Sanches, Erwin Wurm … [et al.].* Winnipeg, Winnipeg Art Gallery; Vancouver: Vancouver Art Gallery, 1990.

Fillmore, Sarah. *The Last Frontier.* Halifax: Art Gallery of Nova Scotia, 2011.

Grenville, Bruce G. *Toward a History of the Found Object: Vikky Alexander [et al].* Saskatoon: Mendel Art Gallery, 1990.

––. "Vikky Alexander." *Cabin Fever.* Vancouver: Vancouver Art Gallery, 2018, pp. 276-81.

Hagen, Charles. "Vikky Alexander, Cash/Newhouse." *Artforum*, v. 24, no. 8, April 1986, p. 112.

Handy, Ellen. "Group, Cash/Newhouse." *Arts Magazine*, v. 61, no. 1, September 1986, pp. 122-23.

––. "Sunset at the Lake: Looking for Landscape Photography in the New Millennium." *Camerawork: A Journal of Photographic Arts (U.S.A.)*, v. 28, no. 2, 2001, pp. 4-11.

––. "Vikky Alexander." *Arts Magazine*, v. 60, no. 7, March 1986, pp. 141-42.

Hoone, Jeffrey, and Amy Hufnagel. *@artists in Residence: Charles Biasiny-Rivera, Vikky Alexander, Mel Rosenthal, Detlef Henrichs, Willie Middlebrook.* Syracuse: Light Work, 1992.

Hoy, Anne H. *Fabrications: Staged, Altered, and Appropriated Photographs.* New York: Abbeville Press, 1987.

Hughes, Mary Jo. *Paradox: Vikky Alexander, Lynda Gammon, Daniel Laskarin, Sandra Meigs, Jennifer Stillwell, Paul Walde, Robert Youds.* Victoria: University of Victoria Art Collections, Legacy Gallery, 2013.

Hurtig, Annette. *Art and Its Practices: An Investigation of Contemporary Art: the Culture of Nature.* Kamloops: Kamloops Art Gallery, 1996.

Kleyn, Robert. *Beneath the Paving Stones: Vikky Alexander [and Others].* Vancouver: Charles H. Scott Gallery, 1993.

Kron, Cat. "Vikky Alexander, Downs & Ross." *Artforum*, v. 55, no. 9, May 2017, p. 335.

Laurence, Robin. "The Advantage of being Vikky: As an Artist, Vikky Alexander Can Move in Realms Where Architects Might Fear to Tread." *Canadian Art*, v. 16, no. 1, Spring 1999, pp. 62–65.

Lichtenstein, Therese. "Fashion Fictions." *Arts Magazine*, v. 57, no. 7, March 1983, p. 40

––. "Trouble in Paradise." *Arts Magazine*, v. 57, no. 6, Feb. 1983, p. 33.

Long, Timothy, Nancy Tousley and Elizabeth Matheson. *Theatroclasm: Mirrors, Mimesis and the Place of the Viewer.* Regina: MacKenzie Art Gallery, 2009.

Morin, France. *Material Fictions: Vikky Alexander, Alan Belcher, Jennifer Bolande, Jack Goldstein, General Idea, Ken Lum.* New York: 49th Parallel, Centre for Contemporary Canadian Art, 1987.

Muchnic, Suzanne. "Uta Barth and Vikky Alexander, Domestic Setting." *ARTnews*, v. 93, no. 9, Nov. 1994, p. 166.

Nickas, Robert. *The Art of the Real: Vikky Alexander, Beth Brenner, Michael Corris [und Weitere]: June–July 1987, Galerie Pierre Huber, Geneva.* Geneva: Galerie Pierre Huber, 1987.

O'Brian, Melanie, and Vikky Alexander. *Vikky Alexander.* Vancouver: Catriona Jeffries Gallery, 2000.

Reconnaissance, March 26–April 28, 1987, Three Panoramic Views: Vikky Alexander, Ray Arden, Jamelie Hassan. Banff: Walter Phillips Gallery, 1987.

Reust, Hans Rudolf. "James Welling, Photographs 1977–1990: Vikky Alexander, Glass Sculptures; 12.5.–24.6.1990, Kunsthalle Bern." *Berner Kunstmitteilungen / Hrsg.: Kunstmuseum Bern ; Bernische Kunstgesellschaft ; Verein Der Freunde Des Berner Kunstmuseums*, 1990, pp. 22–23.

Salle, David and James Welling. "Images That Understand Us." *LAICA Journal*, 27 (June–July 1980), p. 54.

Sandals, Leah. "The Many Lives of Vikky Alexander. *Canadian Art* [Web edition], April 16, 2018. https://canadianart.ca/interviews/vikky-alexander-interview/ Accessed March 6, 2019.

Solomon-Godeau, Abigail. "Living with Contradictions: Critical Practices in the Age of Supply-Side Aesthetics." *Photography at the Dock: Essays on Photographic History, Institutions, and Practices.* Minneapolis: University of Minnesota Press, 1991, p. 127.

--. "Playing in the Fields of the Image." *Afterimage*, v. 10, nos 1–2, Summer 1982, pp. 10–11.

--. "Playing in the Fields of the Image." *Photography at the Dock: Essays on Photographic History, Institutions, and Practices.* Minneapolis: University of Minnesota Press, 1991, p. 88.

--. "Winning the Game When the Rules Have Been Changed: Art Photography and Postmodernism." *New Mexico Studies in the Fine Arts* 7 (1983): pp. 5–13.

Tousley, Nancy. "Focus on Vikky Alexander." *Canadian Art*, v. 5, no. 3, Fall 1988, p. 127.

--. "Images of Desire." *Calgary Herald*, April 19, 2003, p. ES7.

--. "Vikky Alexander." *Border Crossings*, v. 37, no. 3, September 2018, pp. 146–47.

Wallace, Ian. "The Mirage of the Sublime." *Vaux-le-Vicomte Panorama.* Vancouver: Contemporary Art Gallery, 1999, pp. 19–28.

Wallis, Brian. *Vikky Alexander.* Calgary: Stride Gallery, 1988.

Welling, James, Ulrich Loock and Catherine Quéloz. *James Welling: Photographs 1977–90; [ausstellung Vom 12. Mai–24. Juni 1990 Zusammen Mit Glas-Skulpturen Von Vikky Alexander].* Bern: Kunsthalle Bern, 1990.

Zion, Amy. "Vikky Alexander, Downs & Ross, New York, USA." *Frieze*, no. 188, June 2017, p. 203.

ACKNOWLEDGEMENTS

LENDERS TO THE EXHIBITION

Adelaar Family Collection
Claridge Inc.
COOPER COLE
Downs & Ross, New York
International Center of Photography
Karen and Greg Pedersen
Michael Smith and Lorraine Simms
National Bank Art Collection
National Gallery of Canada
RBC Art Collection
Robin and Malcolm Anthony
Sheldon Inwentash and Lynn Factor
Surrey Art Gallery
TrépanierBaer, Calgary
Vancouver Art Gallery
Wilding Cran Gallery
And those who wish to remain anonymous

ARTIST AND CURATORIAL ACKNOWLEDGEMENTS

We are very grateful to all of the generous lenders — the institutional, corporate and private collections who parted with their works for the duration of this exhibition — and to the generous government support and private donors who make such projects possible.

Thank you to the dozens of people who assisted on this exhibition and publication in so many crucial ways.

GALLERISTS:
Simon Cole, Christina De Marchi and Elsa Delage at COOPER COLE, Toronto
Tara Downs and Alex Ross at Downs & Ross, New York
Yves Trépanier, Kevin Baer and Judy Ciccaglione at TrépanierBaer, Calgary
Anthony Cran and Naomi Wilding at Wilding Cran Gallery, Los Angeles

The writers who engaged with the artist's practice in a deeply considered manner: Vincent Bonin, Leah Pires and Nancy Tousley.

Kelsey Blackwell, inspired book designer.

Jacques Bellavance, studio assistant extraordinaire.

Jenn Jackson and Jaclyn Arndt for enthusiastic curatorial and editorial support.

Maryon Adelaar, Roy Hartling, Dennis Hrubizna, Lyse Lemieux and Al McWilliams for their generous friendship.

All of the dedicated and professional staff of the Vancouver Art Gallery who worked diligently on this book and exhibition: everyone from Curatorial and Museum Services (Audio Visual, Conservation, Graphics, Photo Imaging, Preparation, Registration) to Administration and Finance, Building Services, Development, Director's Office, Education and Public Programs, Gallery Store, Library, Marketing, Security, Visitor Services and Volunteers. We especially acknowledge Emmy Lee Wall, Emma Conner, Ashlee Conery, Jane Devine Mejia, Bruce Grenville, Susan Perrigo, Wade Thomas, Joanna Spurling, Trevor Mills, Ian Lefebvre, Maegan Hill-Carroll, Jim Stamper as our direct collaborators on this project, as well as Rochelle Steiner and Kathleen Bartels for their leadership.

An enthusiastic thank you to everyone — we deeply appreciate your involvement and support!

Vikky Alexander and Daina Augaitis

OVERLEAF: *Commercial Curtain*, site-specific installation commissioned by South Asian Canadian Histories Association (SACHA), Main St., Vancouver, 2017

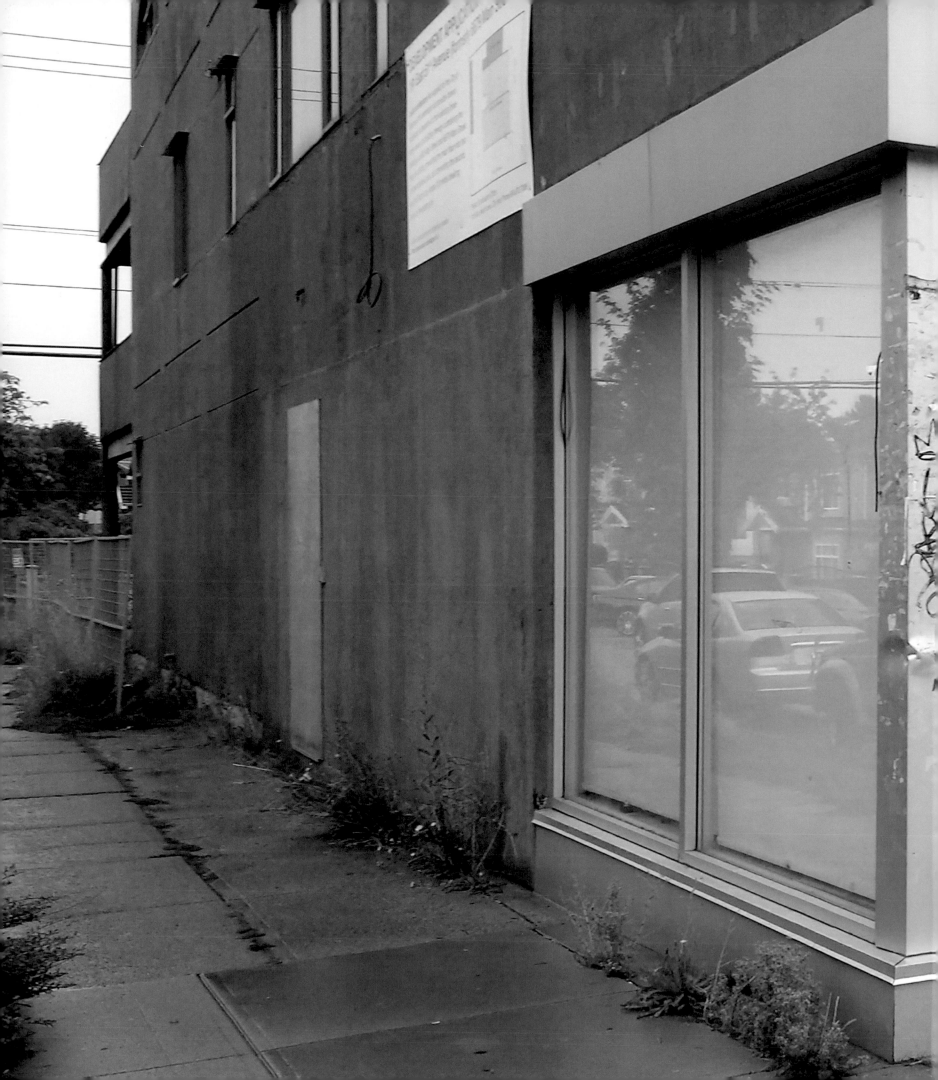

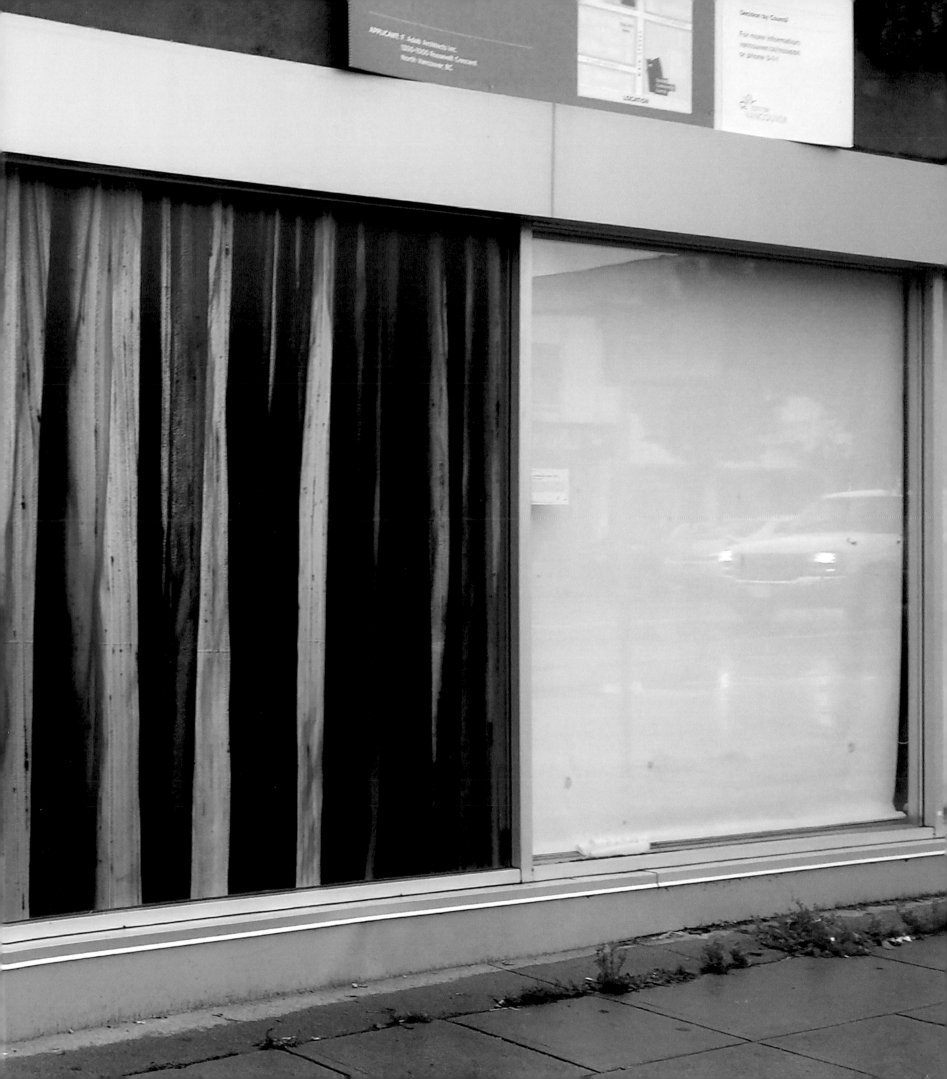

Published in conjunction with *Vikky Alexander: Extreme Beauty*, an exhibition organized by the Vancouver Art Gallery and curated by Daina Augaitis, Chief Curator Emerita at the Vancouver Art Gallery, and presented from July 6 to October 27, 2019.

PUBLICATION SUPPORT

VISIONARY PARTNER FOR SCHOLARSHIP AND PUBLICATIONS
THE RICHARDSON FAMILY

JACK AND DORIS SHADBOLT
ENDOWMENT FOR RESEARCH
AND PUBLICATIONS

EXHIBITION SUPPORT

GENEROUSLY SUPPORTED BY:
Jane Irwin and Ross Hill
Phil Lind

WITH ADDITIONAL SUPPORT FROM:
The Adelaar Family
TrépanierBaer

The Vancouver Art Gallery is a not-for-profit organization supported by its members, individual donors, corporate funders, foundations, the City of Vancouver, the Province of British Columbia through the British Columbia Arts Council and the Canada Council for the Arts.

Vancouver Art Gallery
750 Hornby Street
Vancouver, BC V6Z 2H7
www.vanartgallery.bc.ca

Figure 1 Publishing Inc.
Vancouver, BC, Canada
www.figure1publishing.com

Editor: Daina Augaitis
Assistant Curator: Emmy Lee Wall
Editing: Emma Conner and Kathleen McLean
Proofreading: Alison Strobel
Design: Studio Blackwell; Kelsey Blackwell with Meredith Holigroski
Publication coordination: Emma Conner
Rights and reproductions: Danielle Currie
Digital image preparation: Trevor Mills, Ian Lefebvre, Maegan Hill-Carroll and Jacques Bellavance

Printed and bound in Canada by Friesens
Distributed in the U.S. by Publishers Group West
Distributed outside of North America by Prestel Publishing

Front cover image: *Between Dreaming & Living #8*, 1986
Back cover image: *Between Dreaming & Living #6*, 1985
Front endleaf image: *West Edmonton Mall #17*, 1990
Title page image: *Model Suite: Bedroom*, 2005
Table of contents image: *Model Suite: Bedroom*, 2005

IMAGE CREDITS
All images are courtesy of the artist unless noted below.

Page 16: Rachel Topham, Vancouver Art Gallery; 18 top: Courtesy of the Artist and Marian Goodman Gallery, Paris; 18 middle left: Gerhard Richter; 21 left, 145: James Welling; 23 right: Don Hall, Photography Department, University of Regina; 26: SITE Photography; 31: Kevin Baer; 52 top left: Courtesy Harun Farocki GbR and Greene Naftali, New York; 52 bottom left: Courtesy the Estate of Sarah Charlesworth and Paula Cooper Gallery; top right: Courtesy of the Artist and Metro Pictures, New York; bottom right: Courtesy of the Artist and Marian Goodman Gallery, New York, London, Paris; 63: Courtesy Mary Boone Gallery, New York; 70: Vancouver Art Gallery; 81: Ian Lefebvre, Vancouver Art Gallery; 158–59: Roy Hartling

Cataloguing data is available from Library and Archives Canada
ISBN: 978-1-77327-093-7
ISBN: 978-1-927656-45-7
© 2019 Vancouver Art Gallery